CHAPTER ONE
VICTORIA'S SECRETS

It's 14 December 1838, it's morning and we are in London, England. A young boy is arrested and taken to Queen's Square Police Office before being placed in a cell. He's covered with soot and smeared head to toe with bear's grease. He gives his name as Edward Cotton from Hertford, the son of a respectable tradesman, but the police suspect that this isn't true. He has been found inside Buckingham Palace.

When brought before the magistrate, Edward Cotton, real name Edward Jones – perhaps driven by nerves – went into what must have sounded like full-on fantasy mode. 'I came from Hertfordshire twelve months ago, and I met a man . . . who asked me to go with him to Buckingham-house. I went and have been there ever since,' he told the magistrate.

THE STUFF OF HISTORY

He insisted he had been hiding inside the chimneys during the day and sneaking out at night, hence his somewhat blackened appearance. As expected, a fourteen-year-old boy claiming to have been living in Buckingham Palace caused quite a sensation among the popular press. Jones quickly became a minor celebrity, simply referred to as 'The Boy' by journalists and the wider public, gaining one-name diva status before that was even a 'thing'.

That the first recorded stalker chose to pursue Queen Victoria may seem peculiar. But of course, while we think of her as an ageing symbol of Empire, a 'Diamond Queen' who never smiled nor wore anything other than black, or an old biddy on a biscuit tin, in 1838, the Queen was then only nineteen years old; portraits showed her sitting on her throne wearing her crown and trimmed in ermine. This queen was a young queen, upon whose shoulders the whole hopes of a nation, nay an empire, rested. In her, the public saw a mirror: one of majesty that could reflect greater days and stability.

Victoria's uncle and predecessor, King William IV, did not ascend to the throne until he was sixty-four, making him the oldest king to be crowned thus far. His short reign showed little hope for Britain. (This, when considered with his scaled-back coronation, age and reluctance to move from Clarence House to Buckingham Palace seems strangely familiar.) So, to the Great British Public and the Establishment, the accession of Queen Victoria was not just a relief, but a long-hoped-for end of a crisis that

THE STUFF OF HISTORY

THE STUFF OF HISTORY

A Curated Compendium of Curious Objects
and Forgotten People

STEVEN MOORE

First published in the UK in 2025 by Blink Publishing
An imprint of Bonnier Books UK
5th Floor, HYLO, 105 Bunhill Row,
London, EC1Y 8LZ

Copyright © Steven Moore, 2025

All rights reserved.

No part of this publication may be reproduced, stored or transmitted in any
form or by any means, electronic, mechanical, photocopying or otherwise,
without the prior written permission of the publisher.

The right of Steven Moore to be identified as Author of this work
has been asserted by him in accordance with the Copyright, Designs
and Patents Act, 1988.

A CIP catalogue record for this book is available from the British Library.

Hardback ISBN: 9781785126505

Also available as an ebook and an audiobook

1 3 5 7 9 10 8 6 4 2

Design and Typeset by Envy Design Ltd
Printed and bound in Great Britain by Clays Ltd, Elcograf S.p.A.

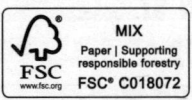

Every reasonable effort has been made to trace copyright holders of
material reproduced in this book, but if any have been inadvertently
overlooked the publishers would be glad to hear from them.

The authorised representative in the EEA is
Bonnier Books UK (Ireland) Limited.
Registered office address: Floor 3, Block 3, Miesian Plaza,
Dublin 2, D02 Y754, Ireland
compliance@bonnierbooks.ie

www.bonnierbooks.co.uk

CONTENTS

	PROLOGUE	vii
1.	VICTORIA'S SECRETS	1
2.	AN ELEPHANT IN THE OVAL OFFICE	21
3.	NANCY GETS HER WAY	43
4.	THE PEOPLE'S PRINCESS	61
5.	TOO BEAUTIFUL TO PAINT	85
6.	THE INVENTION OF CHRISTMAS	101
7.	THE ROBIN HOOD OF HOLLYWOOD	125
8.	THE WOMEN WHO WORKED ON THE MOON	145
9.	THE VASE IN THE CORNER	161
10.	THE BARONESS AND THE BABIES	183
11.	THE EGG IN THE CARRIER BAG	203
12.	THE BOYS WHO BEAT THE SHARK	231
13.	SAVING CATHERINE'S TEAPOT	247
14.	THE DEVIL'S TOOL	265
	ACKNOWLEDGEMENTS	289

PROLOGUE

You may know me from *Antiques Roadshow*, or more recently *Celebrity Antiques Roadtrip,* you may even remember me from *Going for a Song* in the 1990s. Yes, I'm the chap on TV who points at teacups. That well-dressed chap who the *Daily Telegraph,* not only declared to be 'wickedly charming', but one of the UK's best dressed people.

I'm the man who posed at Paris Fashion Week with a handbag so valuable it had its own handler, causing *Elle* magazine to declare me as an 'unlikely model'. Whether you know me or not, you probably know very little about the real me.

Whilst my birth certificate may say, 'place of birth Wallsend Hall' this was simply the grand name for the local maternity hospital. The clues to later pretension were there

❧ THE STUFF OF HISTORY ☙

from the start. I was born on the morning of 31 December 1965, at Wallsend, where Hadrian ended his wall and I began my little life.

I had an uneventful childhood, punctuated by long summer holidays spent at the local beach, days of windbreaks and tepid orange squash, and of sandy sandwiches, warm from their Tupperware tombs. It was a British childhood. It was the 1970s.

I was born with a natural curiosity. My own curiosity about everything and that of those who looked at me as a slightly awkward boy who loved his pink vinyl pencil case and didn't care what others said about it or about him. A boy who never quite fitted into the world he was born into. A boy who saw that not fitting in was actually a strength.

My fascination with the old, the different and the curious began long before my debut on *Antiques Roadshow*. I remember quite distinctly the power cuts of the early 1970s for one particular reason – an old oil-filled hurricane lamp that my father rescued from under the stairs and used to guide us up to bed. I can remember the smell and the glint of the galvanised surface which seemed to glitter as we followed behind, Dad leading the way as I peppered him with questions about this old lamp which made going to bed an adventure.

I had a desire – a need really – to know more, and my curiosity has remained a constant companion ever since.

My late maternal grandmother saw this desire in me and rather than stamp it out, she fanned it, and I adored her for

☙ PROLOGUE ☙

it. She was a great storyteller, a wit and a snappy dresser. A camp old bird. She was the proto me.

My life began to change – like many of the stories in this book – by an accident, or rather an accidental discovery. One day I dug up an old ceramic marmalade jar. I wasn't looking for it, I was after Victorian bottles, which I collected and could be dug up on old tips. One such tip was just behind my school and the jar, made by Maling, the Newcastle Pottery, sent me down a road I'm still travelling.

Over the next few years an obsession was born, culminating in the curation of my first exhibition of Maling pottery aged 16 which led to a book by 24 and, ultimately, to being a regular on *Antiques Roadshow*; to dealing in antiques and writing for *Miller's Guides*, for *Country Life* and for *World of Interiors*. A further accident saw me become an auctioneer, another one meeting the man who is now the King and putting a forgotten pottery back on the map, one that His Majesty helped to save.

So that is how it all began, or rather it was just one of many beginnings, way markers along the way that led me to where I am now. Those markers were often antiques or people, or things that simply fascinated me.

All of which brings me to today and this book, a book born by – yes – an accident. I began to make videos on YouTube. Talking about antiques, but with a fresh approach. Rather than lose attention and bore-on about hallmarks, I explained the seemingly little-known fact that

silver and silver-plate sound different when 'struck'. That silver made a clear 'bell' sound and silver-plate more of a 'thud' fascinated people.

In August 2023, I shared the video to my Instagram account which at that time had 5,100 followers. Within a day over 10,000 people had watched it and my followers began to grow.

I went back and uploaded another and it did rather well. Quickly my followers doubled, tripled and once they got over 200,000, I stopped counting. I had found 'my' audience.

Soon I began to branch out from identifying antiques to the other things that we've forgotten. The 'hidden people' who I felt were pivotal to our history; I wanted to illustrate and bring to life their forgotten stories – something that appears ordinary, that actually has an extraordinary story. Too often history focuses on the story of kings, those (often men) who were given the credit, yet what I found fascinated my followers were the stories of those who have passed through the cracks of history. Some men, but more often the women, whose contributions have somehow slipped out of the history books, people like: Alice Monet's role in her more famous husband's success. The women at Playtex and how their out-of-the-box thinking and incredible skill played a major role in getting the first man on the Moon, and the tale of the unknown war hero Tommy Brown, who helped the code breakers of Bletchley with his extraordinary act of bravery. It wasn't just people

PROLOGUE

either. My audience became fascinated – as I have always been – with the back stories to everyday objects: the humble fork, the china cup, and the real history of tea, to name but a few.

So I began to explore and to share the stories of those who have so far been mainly unheralded by historians. And I learnt something else: people are hungry, not just for stories, but for beauty; hungry for that shared thread of brilliance that joins us all and makes us human.

I found myself a worldwide audience, so it seemed time to turn my short-form stories into a longer form and bring to them that same enthusiasm, curiosity, beauty, wit and glint in my eye. It was time to write a book, because with a book I can weave new tales for new audiences and explore the stuff of history.

had gripped the Hanover dynasty for decades. Queen Victoria embodied what William IV could not. After years of lacklustre ruling, it is no surprise, then, that members of the public were quick to build a keen fascination with her.

So, Victoria was the acme to much of what her profligate predecessors had planned. And she was the first to live in the renovated Buckingham Palace, as orchestrated by her uncle George IV yet despised by her uncle William IV. She was even the first to enjoy two dessert services (a collection of tableware specifically for, you guessed it, desserts). That The Boy could have temporarily lived inside the chimneys of the principal palace of the British monarch – or even claimed to – may seem ridiculous to us, but it's worth remembering the Buckingham Palace that became Queen Victoria's home in 1837 was a very different building to the one we know today. Modern-day Buckingham Palace and its sombre, wedding-cake-white facade – the backdrop to so many state occasions we have seen on the TV – dates back a little over one hundred years; Victoria's palace home was a brand-new honey-coloured riot of carvings with the iconic Marble Arch as its 'front door'.

What began as 'Buckingham House' in 1703 was purchased for the mere sum of £21,000 (the equivalent to £2.5 million today) by King George III in 1761 to be used as a retreat for his wife, Queen Charlotte. Consequently, it became known as 'the Queen's House' and was a much more modest affair than the palace we see today. Back then,

it was a simple central block of brick and stone, flanked by two service wings.

Following his accession to the throne in 1820, King George IV (or 'Prinny' as he was widely known) had intended to turn the house into a small and comfortable home. However, our Prinny's mania for expressing himself via design led him towards a much more palatial structure. In 1826, he commissioned John Nash – daddy of Britain's campest building, the Royal Pavilion at Brighton – to wave his magic wand over the stolid structure.

Naturally, Nash revelled in the appointed title of 'Official Architect to the Office of Woods and Forests' and was a perfect fit for the King's growing ambitions. He had already transformed Brighton's motley pavilion into the Indo-Islamic pleasure dome we know today and at Buckingham Palace, his ambition was not curtailed, or at least not for the time being . . .

What Nash and George IV planned was described as a 'masterpiece' but this expansive vision inevitably came with spiralling costs. No sooner had the crown passed from George IV to his brother William IV than Nash was sacked by Parliament and replaced by the safer hands of Edward Blore. As mentioned earlier, King William was quite comfortable in Clarence House and showed no sign of moving up The Mall. Even when the state rooms were finished and furnished with pieces from royal residence Carlton House, demolished in 1827, the King could not be tempted to leave his home comforts.

❦ VICTORIA'S SECRETS ❦

It wasn't just the furniture from Carlton House that was saved, to stem the tide of the spending instigated by George IV; many of the chimney pieces were also moved to Buckingham Palace. Even the nearby National Gallery benefitted from the capitals and bases of the Carlton House columns, forming part of the east and west entrances. This wasn't the only largesse from the department for royal leftovers. Various sculptures had originally been intended for the grand Marble Arch in front of Buckingham Palace but made their way to the National Gallery – to this day, right above the entrance you can see statues that were once intended for the palace's short-lived triumphal entrance. Next time you visit the National Gallery, look above the main door and witness an empty laurel wreath that should have welcomed guests to a palace of kings and queens, not a palace of art.

When the Palace of Westminster burnt down in 1834, William IV saw an opportunity to divest himself of the burden of moving into it by offering it to the state as a new home for Parliament. Much to his dismay, the offer was declined. But just three years later, the King no longer needed to worry about moving. He was dead and a new monarch, his niece Victoria, ascended to the throne.

And so, this begs the question: how do the differing views of Victoria's uncles and the palace's jumbled past lead us to the new Queen and her 'stalker'? The story spun by Edward Jones that he'd lived there for a whole year might have been true – and for two reasons.

❧ THE STUFF OF HISTORY ☙

Firstly, whilst Victoria's palace was brand new, it was still ruled by archaic medieval standards. No one person was in charge. Secondly, the palace's complicated architecture made it perfectly feasible that a young lad could have been hiding in its many, many chimneys. It seems entirely possible that no one would have known he was there and certainly no one would have taken responsibility for failing to spot him.

To paint a picture of the palace's disorganised management: the office of the Lord Chamberlain was responsible for some things, whilst that of the Lord Steward others. The staff directed by the Lord Chamberlain cleaned the insides of the windows, whilst the Office of Woods and Forests cleaned the outsides. Neither coordinated which resulted in permanently opaque and steamy windows at the seat of Britain's monarch.

It didn't end with the windows. One department provided lamps, while one trimmed them and another lit them. Likewise with the fires. Those servants directed by the Lord Steward laid the fires, whilst the actual lighting of said fires came under the closely guarded sinecure of the Lord Chamberlain. Even when by chance or by providence a fire was lit, the cost-cutting and change of architects and monarchs meant that Buckingham Palace's fires smoked badly and no sooner was one actually lit then it was put out to save kippering the inhabitants.

No wonder Queen Victoria found the palace cold. No wonder her uncle never wanted to live there. No wonder

that when someone said that they had been living there undetected for a year, no one really disputed it. Which brings us back to The Boy and his actual claim of having lived in the chimneys of Buck House for 12 months. Could this be true? To those sources close to the matter, the same sources who knew of the domestic chaos at the very heart of the monarchy, it was entirely possible such a thing could happen and it terrified them. To make matters worse, The Boy was rumoured to have taken a portrait of the Queen, letters addressed to her and a pair of her 'undergarments'.

The garments were so intimate that Victoria's 'unmentionables' were left unmentioned in official court records. Whilst such things still seem highly salacious to our modern eyes (think if this had happened to a member of the Royal Family today?), they were 'unmentionable' in the stricter sense of the word. Had the court revealed that The Boy had taken the Queen's knickers, they would have conceded that intimate access to the very heart of the palace could also be gained by a much more threatening enemy. The Boy's potential theft was more than an invasion of privacy. It signalled something bigger.

The fact that Queen Victoria even wore underwear was a novelty. Prior to her proselytising of panties, both men and women rarely wore such things. If they chose to, they chose the genderless garment known as 'drawers'. Drawers came in pairs which is why, even today, we refer to our undergarments as a 'pair of knickers' or 'pair of underpants'. Two individual tubes of cotton or linen

were 'drawn' up each leg and tied at the front and back. Eventually, some bright spark thought of sewing them together to form a 'pair' of drawers that only needed to be tied at the front with a tape of ribbon sewn into the waistband. The small, centrally placed bow that many modern pairs of knickers exhibit today is a survivor of this method of putting on your pants.

Whilst drawers were now a thing, not many people wore them – especially women. Those that could afford an underlayer wore a 'chemise': a long cotton or linen shift which men would tuck between their legs and women would wear loose. For the Victorians, undergarments were practical as well as a luxury and were the preserve of the well off.

If you were rich, clothing was as much about status and display than merely keeping warm. Complex rules about dressing coupled with the difficulty of keeping clothes clean meant that most items of clothing consisted of separate sections that the wearer was laced, pinned or even sewn into. Thus, the seemingly simple act of attending to a 'call of nature' was plagued with difficulty. Adorned with multiple layers already, to the super rich, underwear seemed an unnecessary addition. Not that they were having to wash their own clothes anyway!

This persisted into the nineteenth century. Underwear was rare and Queen Victoria's early adopter status was something of a novelty. Speaking of which, did I mention that the knickers favoured by Queen Victoria were, well,

crotchless? The bloomers she chose were blooming medieval. The twin tubes of cotton, still open at the crotch, seemed even to the prurient Victorians a sensible, practical and correct choice.

So what did these many layers that any respectable woman of the era was already required to wear actually consist of? It began with a cotton or linen shift (the 'chemise' mentioned earlier) over which a corset was worn. Over the corset was the over corset – another shift-like garment with two purposes: to smooth out the lines of the whale bones in the first corset and to act as a barrier to the outer layers which were less easy to wash and keep clean.

Initially, when large skirts came into vogue, their enormity was supported by a multitude of thick quilted petticoats to hold up the bulk of fabric. These were, unsurprisingly, hot and heavy. With so many layers, there were restrictions to movement. In the 1850s, fashionable women began to wear a 'cage' of metal and fabric to support the voluminous skirts instead. Whilst modern eyes may see the cage as restrictive, it was in fact a more liberating garment than its predecessors. Who'd have thought that women could find a cage liberating?

With so much wrapping of a woman, unwrapping to answer nature's call was, well, complicated. Frankly, it was simpler to squat down and let go, and an open gusset allowed such freedom. And a little freedom was a valuable thing when daily life meant being trussed up like a Christmas turkey.

❦ THE STUFF OF HISTORY ❦

While The Boy had not only taken something intimate, he had also taken something that gave an insight into the Queen's values. But, in fact, Her Majesty Queen Victoria was quite relaxed about her knickers and often left them behind as gifts. The Bishop of Durham got a pair. Embarrassed hosts, on discovering that the Queen had left them a 'gift', had the dilemma of what on earth to do with them. It seems almost every museum in every corner of her far-flung former Empire has a set of her drawers tucked away in its drawers. Some have even turned up on *The Antiques Roadshow*. To us and our twenty-first-century eyes, any woman, let alone a Queen Empress, gifting their knickers seems odd, if not salacious. But Victoria even gifted a set of her undergarments to Newcastle's Royal Victoria Infirmary in 1899 and they often appear at auctions and cause great delight in the popular press with talk of 'big pants'. These 'big pants' can make even bigger prices. In case you were keen to invest, a pair of Queen Victoria's knickers will set you back around £10,000. Despite having a queen as their biggest fan girl, in the 1830s, drawers were still to catch on, but this was about to change.

It's 16 October 1834. A mother is giving birth. She safely delivers a healthy boy – a boy who is destined to change the world. He is given the name Pryce Jones.

Pryce was apprenticed to the local draper, Mr Davies. When his employer passed away in 1856, young Jones took over the store, which he promptly renamed The Royal

❧ VICTORIA'S SECRETS ☙

Welsh Warehouse. It was an ambitious name chosen by an ambitious man. Jones began to send out lists to the local gentry which outlined the goods that he sold. It brought in good business and very soon the lists morphed into a fully fledged catalogue, from which his customers could order goods to be delivered right to their homes.

It was a world first. Pryce Jones had just invented mail order shopping.

He delivered to any English address the very next day using the superhighway in the form of the railway network. He was doing all of this in 1861 – a good decade before the great-grandparents of Jeff Bezos were even born. A catalogue meant customers need not travel and need not be observed buying more intimate apparel. It took off (big time) and provided unfettered access to knickers – big Welsh flannel ones – which made them just a wee bit more normal and wearable. Soon, The Royal Welsh Warehouse grew and Mr Pryce Jones was supplying not only Queen Victoria with her undies but most of the crowned backsides of Europe too.

Those provided to the royal household were individually numbered and monogrammed 'VR' beneath a crown. Whilst to our modern eyes, this might look like a fancy affectation, it was in fact a practical and necessary addition, as even Her Majesty's smalls were washed in the communal Buckingham Palace laundry and would need to be clearly identified.

By 1879, business at The Royal Welsh Warehouse had

grown so big it was moved to a specially built premises with its own post office. Pryce Jones, supplier of knickers to the royals, was knighted and now went by Sir Pryce Pryce Jones. So good they named him twice.

The mail order catalogue was not the only contribution made to the world by Sir Pryce. His 'Euklisia Rug' which he patented in 1876, was essentially a blanket with a pocket where a pillow could be added. Thousands were sold, including 60,000 to the Russian army. He had just invented the sleeping bag.

We don't know if Edward – The Boy – Jones used a sleeping bag, or indeed any other comfort, when he was hauled up in his chimneystack home. Five days after his arrest, he was once more brought before the magistrates. On this occasion, his face and hands had been scrubbed, but his clothes were still stained black, by royal soot no less. Under questioning, he claimed to have spent his days in various rooms, concealed mainly behind furniture whilst not only the Queen was in earshot but her ministers too.

Whilst some papers toed the line and kept back details of the goings on at 'the New Palace', scandal sheet *The Satirist* did not and published the 'suppressed evidence' that the *Morning Post* could not, or perhaps would not, print. They reported that Jones told the court:

I used to wander from one part of the Palace to another, just as I liked: I had only to listen, before

getting into any of the rooms, whether anybody was there or not, and then I would march in as bold as brass. I travelled principally through the flues, sometimes up one chimney and sometimes down another. So I came to know most of the apartments, and to whom they individually belonged. I used to like it best when the Queen lived at the Palace. I have had such fun in listening to Melbourne and the Queen (I knew him because the Queen used to call him Mel for shortness). I used to hide myself in the flue in the Council Room when they were all there, and a precious deal of nonsense I have heard there I can assure you. I know which is the Queen's bed-chamber, and I used to hide myself in the chimney flue there, too, sometimes. The Baroness Lazy-un [Lehzen, we suppose he meant] *used to see her Majesty to bed, and put the candle out; but what I seed in that room is neither here nor there. Sometimes they used to stop, and have a bit of chat when her Majesty was undressing. I have heard the Baroness say to the Queen that, if she was a good girl, she should soon have a German husband, which her uncle Leopold would provide for her. Her Majesty said as how she warn't in no such a hurry, only she should like to get a good tin when she did have one. I have heard 'em talk about all her Majesty's sweethearts; but, as far as I could see, I thought as how her Majesty didn't*

THE STUFF OF HISTORY

seem no ways settled on the subject. The Baroness used to sleep in the next chamber to the Queen, and I sometimes went down her flue, too. The Duchess used to sleep the other side of the Palace, where there was a private staircase. Melbourne was everlasting at the Palace; and one night when I was up the chimney in the Duchess's room, I heard lots of whispering and kissing. Thinks I, I'll see who you are, my fine fellow, anyhow. So I bent forward, but, dash my buttons, I sent some of the soot down the chimney, and the chap, whoever he was, bolted down the private staircase.

I never saw Conroy but once at the Palace, and that was on this very staircase. Thinks to myself, a mighty convenient thing that staircase is, anyhow. The Queen used to snub the Duchess precious sometimes about Conroy; but Melbourne used to take her part, and soothe her down bit. That chap is a favourite, that's sartin. My precious eyes, how I have heard him, and the Queen, and the Duchess; and the Baroness, and Miss Pitt, and all on 'em, go on together stitch fun surely. I was fit to burst in the chimney all the while. I'm sure they must have heard sometimes. In short, your worship, I used to go up and down all the flues in the Palace, and I know where all the ladies in waiting, bed chamber women, and sitch-like, slept; but it would be unproper for me to tell

everything I seed, your worship, and so, if you please, I'll cut it short.

This was gelignite. Try to think of the modern equivalent and you'll find that there isn't one. It's way beyond the 'revelation' of the late queen's love of Tupperware.

The press smelt a sensation and papers of record and ribald wanted every detail. However, the authorities were at a loss as to what to make of him. The Boy was sent to Tothill Fields Bridewell prison, where at least there were no chimneys in the cells. Then they set about finding out exactly who he was.

The first line of enquiry was thus: he looked like a sweep; surely then he must be a sweep. But the royal chimney sweep, a Mr Williams, said he'd never seen The Boy. Besides, Williams claimed it was not possible to enter the palace by way of the chimneys due to their specific design.

The enquiry continued. Next, the many builders who were still working on Buckingham Palace – trying to stop the chimneys from smoking, for one thing – were sought out. One by one, they were paraded in front of young Jones, but none acknowledged him. Nor could it be proven that The Boy helped himself to palace food as he claimed, because the larders were apparently locked every night.

With lines of enquiry exhausted at the palace, the authorities resorted to the press for help and advertisements were placed under the line 'Has anyone lost a boy?' As expected, this elicited a huge response from the

❧ THE STUFF OF HISTORY ☙

public, but most were just sightseers who were keen to get a glimpse of this minor celebrity manque. No one seemed to recognise him, until a man named Henry Jones of Bell Yard, Westminster, eventually stepped forward.

Today, the address would suggest great wealth but then it was a hovel. Henry Jones was taken to the cell and immediately recognised his son Edward. After that, another witness, a builder to whom Jones was apprenticed, was also brought to confirm Edward's identity. Yes, he was the apprentice, The Boy had absconded and had been missing a week, not a year. Identified at last, Edward Jones of Westminster was brought back before the magistrates on 19 December.

No mention was made in court of the Queen's knickers, or her portrait and letters. In fact, Jones was only charged with the theft of items from Sir Charles Murray, the Master of the Household. The non-mentioning of the Queen's unmentionables was a clear move to lessen the impact and embarrassment to the authorities that a boy of just fourteen could freely enter the home of the sovereign. It did not take long for the magistrates to send The Boy to trial and on 28 December 1838, he appeared at the Guildhall before a grand jury.

Somehow, remarkably, Jones Senior had managed to secure the services of a barrister to whom he had paid five guineas. Here, our story takes on a Dickensian air. The entire Jones family, Henry, his wife and seven children, lived in a one-room apartment behind a pub called

VICTORIA'S SECRETS

The Bell. Bell Yard was what the Victorians would call a 'rookery' – that is to say, a slum composed of poorly maintained dwellings often owned by one landlord. That was the case here and the landlord in question was the not-so-convivial mein-host of The Bell public house, a Mr William James, who in our story would be cast as Scrooge. Jones had managed to cram fifty other souls into his rookery and we can only imagine that he would have had little sympathy if Henry Jones had asked him to lend him some money to save his son from jail or transportation to Australia. Scrooge, rather James, would be having none of that. His advice – if he indeed offered any – to Jones would have been to forget his son and concentrate on paying his rent, something Mr Jones was somewhat reluctant to do.

Where the charity of the landlord failed, the neighbours and wider populace triumphed and on the back of his son's notoriety, many of the local poor and assorted well-wishers loaned Jones Senior a penny here, a shilling there, until enough was raised and a barrister – named Mr William Prendergast – was employed.

The Boy was charged that on or around 14 December he had stolen a sword belonging to the Hon. Charles Augustus Murray and three pairs of trousers along with other articles which were the property of Frederick Blume, a German valet employed at Buckingham Palace. There was no mention of 'other items', witnesses clearly having been warned against mentioning anything that was

personal to the Queen. Mr William Bodkin, prosecuting, warned the jury not to take heed of any sensational stories in the press before calling the first witness, William Cox, the porter who had first spied Edward Jones in the palace, to the stand.

Cox regaled the jury and those assembled with his tale of discovery. He spoke of how The Boy was apprehended with a sword and 'several articles of wearing apparel'. This is the closest anyone came to mentioning the Queen's drawers. Cox was shown an inkstand and inkwells, grimy and black with soot from young Jones's attention, and confirmed that they did indeed belong to the Queen.

It was at this point that Jones's barrister spoke for the first time. Picking up the soiled inkstand in a theatrical manner and holding it aloft in case any of the filth might contaminate his person, he decried, 'Oh no! He cannot mean that? These things belonged to the Queen? Oh, I cannot believe it.' Given their condition, there was much laughter in the court.

Laughter was to be a theme of the proceedings as the series of unlikely events and circumstances was paraded before the incredulous jurors, press and crammed public gallery. Was it really to be debated that this most unlikely character, a boy of just fourteen and a nobody, could freely enter and dwell in the very heart of the Establishment and home of Britain's biggest somebody? It scared the Establishment and thrilled the press.

When questioned further, Cox admitted that when he

asked The Boy what he was doing in Buckingham Palace, he simply replied that he had wanted to see inside. By luck or incredulity, or, perhaps more likely, unconvincing witless witnesses who'd been told to keep quiet, Edward – The Boy – Jones was found not guilty. After all, tourism was not a crime.

CHAPTER TWO

AN ELEPHANT IN THE OVAL OFFICE

It is 27 July 2012 and we are in Washington DC. The White House is encouraged to issue a strongly worded statement. Certain sections of the British and American press are in uproar. The President has insulted not just a nation but an ally too. A seemingly small act has such a devastating impact that it becomes a bellwether for the 'Special Relationship'. Yes, President Obama has insulted Great Britain . . . by moving a bust.

It wasn't just any old bust. It was a bronze bust of 'Greatest Briton' Sir Winston Churchill – the very man who is credited with coming up with the phrase 'special relationship' – had been carved by the famous sculptor Sir Jacob Epstein to boot. By denying the bust its previous place in the Oval Office, Obama was implicitly stripping

ᑫ THE STUFF OF HISTORY ᑭ

Britain of its place at the top table (or, at least, that's how certain sectors of the press, on both sides of the pond, saw it).

Except it wasn't President Obama who had removed the bust, it was a man called William G. Allman. As the White House's bust-remover-in-chief (and curator), he had not committed an act of aggression but one of administration. Said bust was actually on loan to outgoing President George Bush for the length of his presidency. With the presidency over, Allman was just doing his job in removing any art that was on loan. That's all it was: admin.

But then things got complicated.

Let's fast forward four years.

It's 22 April 2016 and we are in London. The President and First Lady are guests of Her Majesty Queen Elizabeth II. President Obama and Prime Minister David Cameron are making a joint speech about the 'Special Relationship'. Whilst singing the praises of Winston Churchill, President Obama mentions a bust of Churchill, a bust he sees every day as it now sits outside his private office, otherwise known as the Treaty Room. He acknowledges that his predecessor had the bust located in the Oval Office, but admits he wanted a bust of Martin Luther King in the official working space instead. Two busts might make the room look cluttered and so one of them had to go.

This is where things get messy. Was the bust removed by Allman as part of his due diligence or had Obama actually

moved the bust and, at the same time, insulted both the legacy of Churchill and the very same Special Relationship that he was talking about?

Well, it's complicated.

To an American audience, the subtle difference between the Treaty Room and the Oval Office would be clear. The Oval Office is a formal and ceremonial space only used on official occasions, such as meeting heads of state or signing letters to the families of deceased American servicemen and women. In comparison, the Treaty Room is the de facto office used by the president every day. To an American audience, placing Churchill here makes sense. With the Treaty Room's frequent use by the president, the bust would be seen daily. However, to British observers, especially those looking to make mischief, the snub is clear: from the oval centre of power to a table in a corridor.

Had Obama just admitted to something that the White House's press office officially denied? Well, yes and no because there are – or rather were – two identical busts of Churchill in the White House. The bust of contention that had once resided in the Oval Office was removed in 2010. This was the property of the British government and was the same bust loaned to President Bush by Tony Blair in 2001, later returned by curator Allman.

The other, identical bust was actually given to President Lyndon B Johnson in 1965 by wartime friends of Churchill and it is precisely this bust that Obama had relocated outside the Treaty Room. So, the whole saga was a bust-

THE STUFF OF HISTORY

up over nothing, which seems to raise its head with each change of president.

Just before Christmas 2023, popular magazine *Architectural Digest* released a video on its website in which President Biden gives a tour of the Oval Office and other nearby rooms. Eagle-eyed viewers would no doubt have spied one of the Churchill busts not among the many busts now adorning the Oval Office, but next door in the president's private dining room. Overlooking a sea of silver framed photographs, the 'Greatest Briton' can be seen, a silent witness to presidential lunches. As a great *bon viveur*, Winston would most likely have approved.

Whilst the mainstream media was distracted by a bust, they ignored, or chose to ignore, something much more significant. Amongst the busts and the silverware stood an elephant in the room. It was solid, immovable proof of a longer and much more lasting Anglo-American friendship since 1880, and it came in the form of a huge carved oak desk.

Where did the desk come from? And why is it so important? This is really where our story begins.

It's 4 January 1850 and we are in Newcastle at St Peter's Shipyard along the River Tyne. It's a crisp, cold but sunny morning. A merchant vessel is about to be launched and is christened *Ptarmigan*, named after a bird found in northern regions. A bell tolls from nearby St Anne's church. Ropes are cut and, with a great creaking of timber,

the vessel slides down the wooden slipway. Men who had been applying grease to the rails begin to scarper like rats; they flee both the ship and its counterweights that slow its progress to a stately glide. People look on, breath held, as many months of hard work are finally given up to Neptune. Seconds that seem like minutes pass as the vessel glides into the river for the first time. As the ship shudders, lists and – finally – rights herself, breathing resumes. The men cheer and the flags flutter.

But despite the joy of a launching ceremony and the ship finally in water, the men know *Ptarmigan* is not quite ready to sail. They know, too, that they only have a short time to complete their tasks as the *Ptarmigan*'s destiny awaits her. In just three months, she is set to sail for Calcutta, laden down with coal.

When her time comes, the merchant vessel *Ptarmigan* is moored on Newcastle's quayside. She's already partly loaded with a cargo of coal and awaits a final addition of 'light goods' before setting sail for India. Only, *Ptarmigan* will never make it to Calcutta: fate has laid a very different path for her. Before the final cargo can be loaded, there is a dramatic change of plan. *Ptarmigan* is sold to the government's Department of Admiralty for over £1 million in modern money.

Ptarmigan was no longer destined for the East but headed to the West on a mission of mercy . . .

Ever since the Greek explorer Pytheas spoke in around 325 BC of a land where the sea and sky appear as one and

man's breath comes out as vapour, dreams of a western route to the East captured the hearts of adventurers. This perilous route of ice and hardship fanned the flames of imagination for centuries.

The fall of Constantinople in 1453 brought the legendary Silk Road – the famed route for transporting goods overland to the West – to an end, making the lengthy (though theoretical) Northwest Passage, from the Atlantic to the Pacific through the Arctic Sea, more lucrative. Its discovery would bring immense riches to whoever dared to find it, if it existed. There had never been a better, more rewarding time to discover this fabled route to riches.

Many men tried and many failed. The list reads like a who's who of exploration: Columbus, da Gama, Cabot, Frobisher, Cook. Failure did not stop those seeking success and as each mission failed, others stepped forward determined to take on the challenge. Each successive mission climbed on the shoulders of the previous one, each getting closer to that (frozen) pot of gold.

One of the men with dreams of the Northwest Passage fixed in his eyes was Captain Sir John Franklin, who set out from Greenhithe in Kent on 19 May 1845. But like so many before him, success was not within his grasp. In fact, Franklin was even less lucky than his predecessors. After a successful voyage across the Atlantic, he was last sighted in Baffin Bay in June 1845, before the captain and his men vanished.

Three years passed without a sighting of Franklin and

❧ AN ELEPHANT IN THE OVAL OFFICE ☙

his men. Many, including his devoted wife Lady Franklin, raised concerns. Rewards were offered, squadrons were formed and ships were bought. One of those ships was MV *Ptarmigan*.

The Royal Navy renamed the ship *Refuge* to pay homage to her new purpose. She headed to Woolwich to drop off her cargo of coal intended for India before undergoing a refit at the shipyard of Richard and Henry Green. HMS *Refuge* was strengthened with oak and fitted with an internal heating system (more to combat the problem of condensation than to warm the sailors' cockles).

Just before she set sail on her new career, two final changes were made: firstly, she was fitted with a new figurehead of a polar bear and secondly, she was once again renamed: Her Majesty's Discovery Ship *Resolute*. A third name in as many months. From a shipper of coals to a seeker of lost souls, it was time for the *Resolute* to live up to her new name.

For another three long, bitter and desperate years, HMS *Resolute* searched for Franklin and his crew to no avail. In April 1854, the search was given up. HMS *Resolute* was trapped in ice and its men given the order to abandon ship. But this would not be the ship's destiny.

It's 10 September 1855. A Monday. The American whaler vessel *George Henry* is in ice floes off Cape Walsingham, near Baffin Island. It's freezing cold. The *George Henry* is commanded by Captain James Buddington and he spots a

ship some miles off. He signals but no answer comes back. He ascends the rigging to get a better look with his spyglass. The ship is abandoned.

For seven days, the deserted HMS *Resolute*, still miles off the *George Henry*, seems to mirror the whaler's movement, as if some strange magnetic power is tying the two vessels together. On the eighth day, Captain Buddington succumbs to his curiosity and orders a search party to cross the ice – a journey of some seven miles. So John Quayle, the mate, and two other men from the *George Henry* set off towards the abandoned ship, now floating a whole 1,200 miles from where her original crew had left her.

Quayle and his compatriots find the vessel in remarkable condition. She's lying on her larboard side and drifting eastward. The three sailors pause a while as they consider the possibility of ghosts, but their natural superstitions evaporate as one man suggests there may be booty on board. Indeed, it is not long before they find the previous captain's cabin, matches and candles. What they see in the dim candlelight astonishes them: a massive table, a glistening teapot, a family Bible, and glasses and decanters still full of choice spirits. At the head of the table is a massive wooden chair draped with the British flag, signalling that only the captain was to sit here. They also see a curious stove in what looks like bronze or brass, still highly polished. Once the awe has struck and waned, thoughts return to those glasses of liquor. For two days, Quayle and his companions sought the

succour of the drinks cabinet and whence came there no more, their revels ended and they returned to the *George Henry* with a storm acting as the perfect cover for their prolonged absence.

When he reached the *George Henry*, Quayle announced to Captain Buddington that they had found the famous HMS *Resolute*. Buddington realised that they had stumbled upon a prize greater than whales: not only had he spied a ship worth a fortune but one that would surely bring him (and his men) glory. He had discovered a fine and famous British ship, one feared lost in the depths of the sea, right there, ready for his taking.

By splitting his men into two skeleton crews, Captain Buddington was able to command the *Resolute* with hopes to sail her back to port and glory. Within a week, the *Resolute*'s new crew had emptied her of water, refixed the rudder, and rehung the sails and rigging. Renown and a new home were in her sights. Somehow, against all the odds, Captain Buddington and his crew of just eleven men manned a ship designed for seventy-five and sailed her back to port.

When Connecticut's New London lighthouse came into view on 24 December, Captain Buddington knew it would not be long before he was recognised as the heroic captain who had discovered the lost British ship and be rewarded handsomely. At least, that's what he thought.

*

THE STUFF OF HISTORY

Whilst today, Britain and America are firm allies, this was not always the case. Following the Declaration of Independence in 1776 and the American victory in the Revolutionary War of 1783, the new nation and its old overlord had an uneasy relationship. For much of the nineteenth century, US–UK relations were in flux. They swung from the growing pains of a new nation working out its place in the world free of its former sovereign power to full-blown war. Tensions within the (less) United States itself didn't help either and many could sense a civil war on the horizon. These tensions were in the air as HMS *Resolute* sailed into New London on that Christmas Eve morning.

The febrile atmosphere between the UK and the USA around this time is perhaps best illustrated by the lesser-known but arrestingly named Pig and Potato War of 1859, some five years after the discovery of the drifting *Resolute*. At this point in time, the San Juan Islands, off the coast of the recently established state of Washington and just south of the yet-to-be-established city of Vancouver, were disputed territory, seen as British by the British (Canada was still a colony) and American by the Americans. Unclear wording in the 1846 Oregon Treaty that referred to the border being 'in the middle of the channel' was spectacularly unhelpful because there were in fact two channels – one on each side of the islands. Inevitably, both the US and UK interpreted the treaty to give preference to their respective channel, ultimately

allowing them each to claim territory. Eventually, an uneasy 'truce' left the islands as a kind of no man's land. For the years following the treaty, the islanders seemed happy to coexist on the islands . . . until they weren't.

On 15 June 1859, twenty-five-year-old Lyman Cutler was looking out of his log cabin at his potato patch. He was filled with pride and looking forward to the reward of his first harvest. He was one of eighteen Americans who had settled on the island a few months prior, vastly outnumbered by the British, Hawaiian and Native American settlers under the employment of the Hudson's Bay Company. The HBC had established itself in San Juan in 1853 and, with British backing, saw themselves as the de facto rulers. In their view, San Juan was theirs.

As Lyman surveyed his vegetable patch, he saw something troubling: a pig was eating his potatoes. And not just any pig – a British pig, owned by top local man, Charles Griffin. Outraged and incensed, Lyman took his gun and shot the pig dead. The pig had visited before, much to Lyman's annoyance. That day, Lyman Cutler made sure it was the last time the pig would help himself.

Later that day, Cutler heard a furious banging on his cabin door. Opening it, he was greeted by the pig's owner, Griffin of the Hudson's Bay Company. Who was fuming. In a (vain) attempt to calm down the furious Irishman, Cutler offered him $10. Unfortunately, this made things worse: this was not just any pig but a prize breeding pig. Griffin demanded at least $100 in compensation.

❧ THE STUFF OF HISTORY ☙

The young homesteader was having none of it and did an about-turn. 'Why should I pay you anything?' he retorted. 'YOUR pig was on MY land and if any pigs come back again, I shall shoot them and I shall shoot you too!'

Still raging from their encounter, Griffin returned to Lyman's cabin later that day on horseback, accompanied by three other men, to demand justice. It didn't go as planned. Griffin insisted that not only was the pig British but the land itself was British too. He demanded satisfaction and threatened to have Cutler arrested, but to young Cutler there was no debate: the land was American land. It was a classic impasse. When the homesteader reached for his gun, Charles Griffin and his three self-appointed deputies rode off, whilst making it clear that the matter was far from settled.

It would be something of an understatement to suggest that things escalated quickly from thereon in. Soon enough, the authorities were alerted to this porcine calumny. Within days, over sixty American soldiers arrived ready for battle. Britain in turn sent three warships. The two countries were on the brink of war . . . over a pig who had eaten some potatoes.

A couple of months after the incident, America had 461 men stationed on San Juan Island and fourteen cannons facing the British fleet anchored offshore. Britain had upped the ante to five men-o'-war with over 2,000 men that could return fire from seventy guns. You need not be a military strategist to see that America was

heavily outflanked and the British party could have taken control of this speck in the ocean without hesitation. There was, however, one thing stopping them: it turned out that both sides had been given strict instructions – 'Don't shoot first.'

Day after day passed and whilst insults were traded, no shots were fired. No further incursions were made by pigs and no more potatoes suffered harm. This war of attrition was more of a slanging match.

In those days before rapid communication, word was slow to get back to the capitals of the warring nations. When it did, cooler heads prevailed. Both Washington and London were shocked that tensions on San Juan Island, a dot in the middle of nowhere, had brought two great powers to the edge of war. President James Buchanan was particularly horrified. Already at war with Mexico on its southern border, America did not need a new war in the north, especially with the great naval power that was Britain. And definitely not over some potatoes. Buchanan dispatched American military commander General Winfield Scott, who arrived in San Juan in October hoping to pour oil on troubled waters.

Scott's plan was simple: de-escalation. Luckily, it was a plan to which both sides rapidly agreed. A withdrawal of troops and scaling back of firepower was ordered. For now, San Juan would be under joint British and American control, with both sides manning a garrison. Whilst this plan worked as a temporary fix, the war wasn't in fact

'won' until 1872, when an independent arbitration panel commissioned Kaiser Wilhelm I to reach a conclusion. He ruled in favour of America.

The US—UK border was set and peace had finally come to the forty-ninth parallel. America was quiet in its victory. And so lays forgotten a twelve-year 'war', in which only one shot was fired and the only victim was a pig (and some potatoes).

Word of *Resolute*'s arrival soon got around both New London and (old) London – twin points of the old ship's log. Journalists were quick to point out that the ship had come from the Thames of old London and was sailing back from oblivion along the Thames of New London. It was a heady mix. The bravery and skill of the Americans who found her masked any thought that the ship belonged to Britain, a recent and regular foe.

However, it quickly became apparent that a clash in legalities was going to make the path to glory less clear than Captain Buddington had assumed. Under British law, the rights of salvage were awarded to the captain who had found her. But under American law, the original owners of the ship were granted the rights. Just like in the pig war a few years later, each side had a strong opinion on who could claim ownership. Though in this case, common sense and political expediency prevailed far sooner.

Like the pig, *Resolute* was British. It was property of the Royal Navy and therefore Queen Victoria. At first, Britain

made its rightful claim on the ship under American law. But after some local advice from an Anglican priest based in New London was received, Britain did a volte-face, mindful of both the cost of repairs and the already uneasy diplomatic situation. To fight for the ship would exacerbate existing tensions between Britain and America – caused by, amongst other things, Britain's disapproval at America's arming of Russia, who the former was then fighting in Crimea, and their disappointment at America's continued support for slavery. On this occasion, withdrawal was simply the right thing for Britian to do.

With the Brits out of the picture, the US administration must have sighed with relief. Perhaps, they wondered, this was a gesture of goodwill on Britain's behalf. Others certainly saw it thus and a growing warmth towards the old enemy became apparent. Could it be that a ship brought in from the cold could thaw tense relations? Whilst most of America – who now owned *Resolute* – saw her as a money maker, a few saw her as a more symbolic meaningful opportunity. One of these optimists was Henry Grinnell.

Grinnell was a successful merchant in America who took up philanthropy on retirement. In fact, two of the expeditions that had previously searched for the lost Franklin crew were financed by Grinnell and he advised the owners of the *George Henry* on their claim for the *Resolute*. In this, Grinnell sought out the help of Senator LaFayette Sabine Foster. Both men saw the old British hulk as more than just a salvage prize; they saw her as

an unlikely ambassador that could sail back to the UK and calm troubled waters.

In league with fellow Senator James Mason, Grinnell and Foster put forward a joint resolution to the Senate. They proposed that America should buy and fix the *Resolute*, return her to Queen Victoria and – hopefully – mend UK–US relations for good. Remarkably, the bill passed and the *Resolute* was bought for $40,000. She was restored to her former glory, even down to reinstating the same books that had once sat in her library. The *Resolute* sailed back home, impressed both the Queen and her navy, and was successful in thawing the difficult relationship between old foes, who were soon to become firm friends. A brave little ship originally named after a bird with hairy feet had achieved what many men had failed to but this was not the end of the fairytale. No, the ship would go on to cement this relationship further.

As to be expected, the pomp that surrounded *Resolute*'s triumphant return to the Queen and her fleet soon died down. Whilst she enjoyed many more adventures, none came close to her earlier glory. In 1879, she was sent quietly to the breaker's yard to be reduced to timber. But the mighty *Resolute* lived up to her name and she was to embrace a new destiny. The old Queen fondly remembered her ship and had an idea.

It's 2 November 1880 and we are on the lawn in front of the White House. Several men are unloading a large wooden

AN ELEPHANT IN THE OVAL OFFICE

packing crate from a horse-drawn waggon. The crate is addressed to the President of the United States and has come from Britain. No one was expecting a large parcel, not even the President himself, who soon joins the expectant crowd gathering on the lawn. In these simpler times, before the formation of a secret service or before the threat of bombs, this large wooden crate could only be one thing: a gift to the President. But what is it?

Men with crowbars arrive promptly and the crate is opened to reveal a wall of tightly packed straw. The men used their crowbars to dig out the straw before revealing a beautifully carved wooden desk. It is only when the desk is fully dug out of its straw carapace that the full glory of the gift can be seen. It isn't just a desk, it is a British desk – and a royal one to boot. A brass plaque glistens in the weak Washington sun. It reads:

> *H.M.S. 'RESOLUTE' forming part of the expedition sent in search of SIR JOHN FRANKLIN IN 1852, was abandoned in latitude 74 degrees 41' N longitude 101 degrees 22' W on 15th May 1854. She was discovered and extricated in September 1855 in latitude 670 degrees N by Captain Buddington of the United States Whaler GEORGE HENRY.*
>
> *The ship was purchased, fitted out and sent to England as a gift to HER MAJESTY QUEEN VICTORIA by the PRESIDENT AND PEOPLE of the UNITED STATES as a token of goodwill & friendship.*

❧ THE STUFF OF HISTORY ☙

This table was made from her timbers when she was broken up and is presented by the QUEEN OF GREAT BRITAIN & IRELAND to the PRESIDENT OF THE UNITED STATES as a memorial of the courtesy and loving kindness which dictated the offer of the gift of the 'RESOLUTE'.

President Rutherford B. Hayes was so delighted with the Queen's gift that he had it installed into his private office as his principal desk.

You'd imagine that at this point, we might say 'and they lived happily ever after', but this isn't the end.

Not yet.

Almost every successive president used the *Resolute* Desk and made it their own. William McKinley even saw that it was topped by a daily floral bouquet from the glasshouses on the East Lawn. Woodrow Wilson used its centre drawer to hide secrets and some presidents raised its height while some lowered it. One president literally put his own seal of approval on it. But these things alone don't make a legend.

The legend is that the central front panel – which features the carved presidential seal – was added to serve a particular purpose: to conceal something from the American people and from the world. The legend is so widespread that it is taken as gospel in official White House literature. It has been heard from the lips of First Ladies themselves. It was even mentioned in the movie *National Treasure: Book of Secrets*.

❦ AN ELEPHANT IN THE OVAL OFFICE ❦

What was this carved panel hiding? The legend claims it was added to mask the fact that President Franklin D Roosevelt not only used a wheelchair but walked with leg calipers following a polio diagnosis. The new panel, by concealing his legs, hid his disability.

Like all good legends, there's some truth and some fiction to it. Yes, Roosevelt had polio and yes, he used a wheel-chair and calipers to get around, but this convenient and somewhat ableist view of history simply doesn't add up.

President Roosevelt passed away quietly and unexpectedly on 12 April 1945, yet the design for the panel is clearly dated 13 June of the same year. Two whole months later. So why was it added?

America was at war. Symbols mattered and President Truman knew this. He sat at the desk when he broadcast to the nation and adding the seal made the desk look even more presidential. It made it look more powerful. The *Resolute* Desk now had a (physical) presidential seal of approval.

Having steered the ship of state from the turbulent waters of war into those calmer ones of peace, Truman began to focus on domestic matters and that included his home. The White House was not just looking a bit shabby, it was falling apart after years of neglect. He liked to joke that every time he took a bath, he feared he might fall through the floor to greet a tea party for the Daughters of the American Revolution in nothing but his glasses.

❧ THE STUFF OF HISTORY ☙

When a piano leg crashed through the first floor of the First Family, something had to be done. The Truman rebuild was as thorough as it was brutal. The home he nicknamed 'the Great White Jail' was taken apart with military precision.

However, ever-increasing costs curtailed the Trumans' ambitions to restore the White House to a more authentic Georgian look that would have been familiar to the Founding Fathers. Many later-nineteenth-century furnishings were removed, banished to offices or placed in attics. Others languished in government buildings and some pieces were simply forgotten. The Trumans would have liked to have had genuine American federal furniture but they had to make do with reproductions. Still, under the Trumans, the White House was in a better state than it had ever been. They had set a stage worthy of America but it is not them who take the final bow in our play – that is reserved for a new star.

It's 1941 and we are in Washington. Two schoolgirls are visiting the White House with their mother. The eleven-year-old girl is fizzing with excitement; her eight-year-old sister is already bored. Though the former's excitement was short-lived, the experience affected her well beyond her childhood and into adulthood and marriage. In fact, her disappointment changed America.

Young Jacqueline Bouvier had expected to find a home, perhaps not too dissimilar to her own, but grander and

certainly more presidential. She had certainly thought she would see the proud history of her country on show. Instead, she was shuffled along, like everyone else, from one dreary room to another. The memory was burnt into her brain and that memory lingered when she returned to the White House years later.

During the ember days of the Eisenhower administration, the outgoing president and his wife invited their successors over. The inheritors were a young, bright and glamorous couple who planned to not only change America but to change the White House too.

Enter stage left a new star with the drive and glamour to make miracles happen. We've met her before but now she's all grown up. She's the former Miss Jacqueline Bouvier, now Mrs John F Kennedy, soon to be the First Lady, the Queen of Camelot, the legend who we now refer to simply as 'Jackie O'.

Jackie saw things differently. She knew that the White House was not just a home or a government building but a stage. It was a stage on which all the players should be seen and that included the furniture and the paintings. *Nothing must be in the house unless it truly deserves to be here* was her mantra. It was important to represent all the presidents and all of the American people. Before she was able to fully establish a committee of historians and designers to steer her plan, before she could establish the White House Historical Association and secure the contents for the future, she rummaged. She hunted high

and low, rediscovering what was once lost. One day she uncovered an icon.

In the Broadcast Room, under a green baize cloth and pushed into a corner, lay gold – well, golden oak. As she removed piles of file boxes and pulled back the baize, Jackie revealed a beautifully carved oak partners' desk which she immediately recognised. The brass plaque, now a little tarnished, confirmed what she thought. Mrs Kennedy had rediscovered the famous *Resolute* Desk. She placed it in the Oval Office, making it an icon of not just the Kennedy presidency but reestablishing it as an emblem of Anglo-American friendship that has been used by (almost) every president since. It reminds us that something seemingly practical can have a much more important place in history than a bust of Winston Churchill.

The little British ship once destined to take coals from Newcastle, that had once sailed the Atlantic in an attempt to find the Northwest Passage, had been lost and found. It was restored, given to a queen as a token of friendship – a favour that was later returned in desk form. This piece of furniture was a solid symbol of affection, which became a longstanding symbol of power.

When someone chose the name 'Resolute' for the former merchant vessel *Ptarmigan*, they could not have had any idea just how resolute that ship and her very timbers would be.

CHAPTER THREE
NANCY GETS HER WAY

It's 24 August 1814 and we are in Washington DC. A fine table has been set for dinner: it is laid with the best silver, and blue and gold Lowestoft china imported from England. Ale, wine and cider are chilling in the coolers on the side table. In a nearby room, an anxious wife is waiting for her husband, convinced that – despite everything that is happening – he will join her for dinner.

The servants are anxious too. Lady's maid Sukey is standing in front of one of the open windows that's allowing what little breeze there is to cool the room. Her upright demeanour hides her anxiety. She inclines her head slightly . . . she can hear something. She looks out of the open window. She spots a man she recognises on horseback. It's James Smith, who had left earlier with the President. He's waving his hat, 'Clear out! Clear out! General Armstrong has ordered a retreat!' Sukey knows

THE STUFF OF HISTORY

what this means. The guests won't be coming for dinner and all in the house must flee.

The lady of the house orders carriages. She is Dolley Madison, now widely considered to be the first 'First Lady' of America. She had successfully cemented her role within the White House, known then as the President's House.

Mrs Madison understood *the British are coming* warning all too well. Her staff had been packing up the house's contents all day. They managed to rescue the rest of her precious Lowestoft china, the silver, the red silk velvet curtains from the Oval Room and a feather bed. With the British troops just a few miles away, Dolley knew it was time to go and slotted any remaining silver into her reticule as she made her exit. On her way to the carriage, she stopped in front of Gilbert Stuart's portrait of George Washington. It struck her that America, an independent America, was personified in this iconic image. And so she could not allow it to fall into the hands of the impending British troops.

As the writers of hagiography put it, Lady Madison instructed two of her staff – butler Jean Pierre Sioussat and gardener Thomas Magraw – to take down the painting immediately. She stood, Boudica-like, with a carving knife at the ready to remove the painting from its stretcher and thus write it into history.

Except, it didn't quite happen like this.

In the melee of a soon-to-be-invaded Washington, who can say who actually took the painting down, or who

directed whom, or whom ought to be given due credit? Luckily, we have an eyewitness account.

Paul Jennings, then a fifteen-year-old footman at the White House, detailed his perception of events in his book *A Colored Man's Reminiscences of James Madison*, published in Brooklyn in 1865. He writes that any idea that Dolley had cut out the portrait herself was 'totally false'. He confirms it was the butler (and the gardener) who did it, standing on a ladder, held by Jennings himself.

Just a few hours after this grab and dash, British troops were inside the President's House, smashing windows and making bonfires out of furniture. Before the Brits set off the blaze, they paused to enjoy the wine and food that Mrs Madsion had laid on for her husband who had not returned in time. The house of the First Family then shot up in flames, only to be saved from total destruction by a heavy downpour of rain. Rain stopped flames: how very *British*.

Dolley Madison may not have saved the portrait of George Washington with her own hands, but in the early years of this new republic, her sense of history and understanding of American iconography made her a proto-Jackie Kennedy.

The post-revolutionary America of the nineteenth century had a natural affinity with France, who also got rid of kings and queens. As a result, it had an antipathy with its former coloniser Britain. One way in which early America

THE STUFF OF HISTORY

looked fondly towards France was as a tastemaker-in-chief. The clean lines, eagles and echoes of an ancient republic suited the American ethos.

Unlike the European monarchs, American presidents (and their wives) had to tread a tightrope between being 'presidential' yet not monarchical. Pomp was required, but pomp that respected the office and did not make individuals seem, or the institution seem, demi-royal. It was a tough ask that many had failed.

Two factors contributed to their failure: 1) the Americans didn't have much history, and 2) they seemed ambivalent (or downright hostile, when one considers the prevailing attitude to the traditions of its native inhabitants) towards the history they did have. Think of what Europeans have destroyed in the last one hundred years in the name of progress and then imagine if that one hundred years was the entire time that your nation had existed.

Nor was there a recognisable American aesthetic. The White House collection of china, the additions and reinventions made by different First Ladies, gives us a perfect lens to study how both American tastes evolved and how an appreciation of history began to emerge.

When the Madisons returned to the rebuilt White House in 1817 just before leaving office, they put out their French china they had originally bought back in 1806, three years before James Madison took up office. The first

'state' china came straight after. Prior to this, presidents used their own china as the state did not provide any for official 'state' occasions. It's no surprise that this earliest state china is also French. President and Mrs Monroe had turned to France for inspiration, but this time the state paid. The Monroe service was for dessert only – because at that time, dessert was the most prestigious course. Made by Dagoty et Honoré in Paris, it was the first attempt to form an American iconography in clay.

The centre of the plates shows an ascendant eagle, standing for America. The eagle is clutching olive branches and thirteen arrows, each one representing one of the original thirteen colonies, its head looking towards the olive branches. It has a shield on its chest with stars, stripes and the motto *'E pluribus unum'* – 'Out of many, one'. The phrase, accompanied by the arrows and olive branches, tell us that America is united, and ready for war but always looking for peace.

The wide border contains five cartouches symbolising the American values of 'Strength', 'Commerce', 'Arts', 'Science' and 'Agriculture'. Even the border colour was chosen for its symbolic value too. Described as 'amaranth', this purple/maroon shade was inspired by the amaranth flower, which is said to never fade. In other words, America shall never fade. This was fragile nation building in porcelain.

Whilst previous services were made in France, the china chosen by President Franklin Pierce was an attempt at

compromise. The white porcelain was French (or possibly English), but it was decorated in New York by Haughwout and Dailey, who had actively sought out presidential custom as being good for business. On their stand at New York's Exhibition of the Industry of All Nations in 1853, the firm showcased a plate which they described as 'a specimen plate of a dinner service manufactured for the president of the United States with the American eagle and blue band in Alhambra style'.

President Pierce visited the stand but did not like the 'sample' as he felt it was too fussy. He did, however, order a much simpler service in blue and gold with a thin red line also on display. The sample had a vacant cartouche to the centre. President Pierce clearly didn't care for embellishments and no presidential symbols were added. Haughwout and Dailey's efforts and their more elaborate version were not in vain, though, and their day would come.

Whilst President Pierce would take no ceramic flattery, Mary Todd Lincoln loved the rejected Haughwout and Dailey sample. She did make a significant change to the design and asked to swap the blue border for her favourite colour, 'solferino' (a purple/red which was highly fashionable at the time). The Lincoln china collection of 1861 included a 190-piece dinner service as well as a dessert service of 208 pieces, and a further breakfast and tea service of 260 pieces.

Mrs Lincoln loved the design so much she ordered another service with her initials in place of the eagle.

~ NANCY GETS HER WAY ~

This set was to be paid for using public funds. Despite 'Honest Abe' eventually paying for the set out of his own pocket, the monogrammed china caused a scandal which rather dimmed Mary Lincoln's affection towards it. In the eyes of some strident Republicans, this excess of extravagance made her almost – almost – Marie Antoinette. This was one of many incidents that dogged presidencies on the china cabinet front.

When President Lincoln was re-elected, a simpler service consisting of a buff band and gold lines was ordered, lest they once more be accused of lavishment.

Mary Todd Lincoln was the first First Lady to have close involvement with the commissioning and design of a service and this led to an incorrect mythology surrounding the set. The gold border was called 'Alhambra' by its makers, but its resemblance to a linked chain was said to represent the links between the north and south of America. Similarly, the eagle surrounded by clouds with sunlight breaking through was meant to suggest hope. The fact that this plate was actually designed in 1853 (and rejected by Pierce) shows that the myth is a case of wishful thinking.

It's 30 June 1879; we are in Washington DC, in the depths of the White House. A large quantity of wooden barrels has arrived from France. Unfortunately, they do not contain wine. Instead, they house a much more precious and fragile cargo: the porcelain designed at the behest of

THE STUFF OF HISTORY

First Lady Lucy Webb Hayes. It has been commissioned to be used at the state banquets that everyone has been muttering about. The staff don't quite know what to expect. First Lady Hayes isn't known for her sentiment. She's a much more sober sort who has declared the White House 'dry'!

Tools are brought and all look on nervously as the barrels are carefully eased open. It takes a while, but each is successfully undone whilst the contents remain undisturbed. Standing back, yet keeping his beady eye over the proceedings, is Civil War veteran and steward to now President Rutherford B Hayes, William Crump.

With one last piercing wrench, the final barrel is open. Tightly packed with wood wool, there is an envelope on the top addressed to the First Lady. The staff look to Crump, who steps forward and takes the envelope in his gloved hand.

Miranda, the Hayes's cook, who is looking on, asks, 'What d'ya think it says?' Crump looks at her witheringly. 'Whatever it says, Miranda, is none of your business.'

Now, feverishly, several hands are pulling out the wood wool, including Eliza-Jane, one of the upstairs staff who'd come down to join the porcelain party. As Eliza-Jane pulls at the packaging, she suddenly freezes. 'A crab! It's a crab!' Miranda looks at her sternly. 'Not only should you ain't be here, but where I come from, dem crabs ain't gilded.'

As more of the wood wool was teased out, the contents became clearer to all who had gathered. The 'crab'

in question was a china crab claw, one of three that formed the base of a serving plate. 'Well, I'll be darned,' declared the steward. 'Will you look at that. You sure this is what the First Lady ordered?' He suddenly remembered the envelope. It struck him that maybe he ought to take it to Mrs Hayes upstairs and alert her to the fact that her curious china had arrived. But truthfully, he was just as intrigued as the other domestics.

There were plates fashioned as a group of oysters, small plates formed as a Native American basket, plates formed as snowshoes and large, flat, rectangular plates with upturned edges. These were designs unlike anything seen before. Each plate had been richly painted by hand, decorated with American flora and fauna. Each plate had a fulsome description on the back. The verdicts amongst the staff at that first unveiling were divided. The upstairs staff saw something new and different, whilst the downstairs staff were already thinking that the complicated shapes would be a nightmare to wash.

There was, however, one verdict that united all. No one gathered in that room on that day could quite believe that the stalwart of the Temperance movement – 'Lemonade Lucy' to her detractors – had commissioned such an alternative set of dinnerware.

Much of what is new, different or innovative is a quirk of circumstances. This is exactly how the Hayes's state china was born. But to appreciate this fully, we ought to step back and consider the America in which this new

THE STUFF OF HISTORY

dinnerware was conceived, developed and arrived at 1600 Pennsylvania Avenue.

Civil War veteran Rutherford B Hayes became the nineteenth president of the USA in 1877, just one year after America celebrated its centenary as a nation. A nation which, in European terms, was a child and still finding its way in the world. The Hayes state china was an attempt, and a radical one at that, to establish a truly American aesthetic. Despite his military background and her lifelong commitment to eschewing the demon drink, Rutherford and Lucy Hayes were educated and cultured. Both loved nature and animals, and the Hayes White House was something of a menagerie. They even had the first Siamese cat in the USA.

The genesis of the Hayes china was almost unintentional. Lucy Hayes loved the short walk from the White House to the many glasshouses that once populated the East Lawn that were later swept away to form the East Wing in the following century. Hot houses were not just an acceptable way of showing status, but a much-needed facility to grow the fruits and flowers required for state dinners and lunches. In the days before rapid transit, those food miles mattered. Flowers from the White House hot houses were also sent to local hospitals in a kind of floral democracy.

On one of her walks along the East Lawn, Mrs Hayes wondered if a simple dessert service could be made and decorated with the grasses and ferns from the glasshouses.

NANCY GETS HER WAY

She mulled over this prospect, which remained unacted upon until a chance encounter. In the conservatory one morning, she saw a man painting. He was Theodore Russell Davis, a veteran Civil War artist who was currently working for the magazine *Harper's Bazaar*. Keen to seek the opinion of an artist, Mrs Hayes discussed her porcelain plan, which certainly fired the imagination of Davis. 'Why stop at dessert?' Davis asked. 'Why not showcase the beauty and bounty of American flora and fauna in a new and *American* way?'

Something clicked. Almost there and then, Lucy Hayes commissioned Davis to design a full dinner, tea and dessert service not only befitting of the president, but paradigmatic of the diverse natural bounty of America, from sea to shining sea. Lucy Hayes immediately saw that representing the richness of nature across all of the United States was an act of unity, with potential healing benefits for a recently reunified nation.

Whilst the decorative direction was fully Stateside, the manufacturing went to Haviland & Co. in France. Although they were based in Limoges, France, Haviland was founded by an American: David Haviland. It was a stroke of diplomatic genius by the seasoned Washington hostess.

Remarkably, Haviland & Co. delivered the best part of the service that same year with a final delivery in 1880. To produce so many new and inventive shapes, especially ones designed by an artist and First Lady both unfamiliar with the manufacture and limitations of porcelain, is

impressive. Haviland had spent so much on the new china that they asked for permission to sell facsimiles to a wider audience. In truth, the much-heralded commission was something of a poisoned chalice. There was a sting in the tail so bitter, it still stung over a century later. David Haviland's great-great-great-grandson recalled that his family firm had successfully fulfilled the first order, packed it and shipped it to Washington, only to receive a massive bill for import duty issued by the protectionist Rutherford regime. 'It was a slap in the face we weren't expecting.'

Unveiled at a dinner for president elect James Garfield, the Hayes service received as many praises as it did criticism. One guest – Clover Adams – later said she felt unsettled that a wolf was appearing over her soup, a feeling shared almost a century later by Amy Carter during her father's White House term. Richard Nixon used items from the Hayes service as ashtrays and it was despised so much by Franklin Roosevelt that he gave away many items to the Girl Scouts of America for rummage sales. Conversely, J Edgar Hoover and Judy Garland were fans.

Today, the Hayes White House china remains one of the greatest, most individual and innovative dinner services to have ever been created. You may question the Gilded Age taste, but you can't knock the quality or inventiveness.

Successive services sought simplicity and a return to a less complicated vision. The Harrison state service is unique in so much as the actual design was by First Lady

NANCY GETS HER WAY

Caroline Harrison, a keen china painter. In 1891, she wrote to her daughter Mary, 'I take the Lincoln china set for a guide. Instead of spots on the border, I have 44 stars. (The center is like the Lincoln set.) Corn is indigenous to the North American soil. I think they will be right pretty.'

Caroline Harrison was also the first First Lady to take an active role in collecting china owned by previous presidents. This was a change to the rather casual attitude of previous incumbents. Throughout the nineteenth century, any damaged china had traditionally been given away or donated to charities. This, along with the regular auctions of ex-presidential furnishings, began a growing secondary market and interest in both the china and furniture of the White House. Theodore Roosevelt put a stop to the giving away of damaged china as he felt it was inappropriate. He ordered anything broken to be destroyed, leading one observer to suggest that there was more White House china to be found at the bottom of the Potomac River than in the White House itself.

It's 26 February 1981 and plans are under way for a lavish banquet. The room is set with tables and chairs. Staff are busy with linens, flowers and cutlery. Many are polishing glasses. French anemones are everywhere. In the kitchen, serried ranks of chefs are chopping, peeling and prepping. Back in the dining room, the final touch is being made: a large 'service plate' is set at each place ready to receive the dish that will hold the first course later that

◖ THE STUFF OF HISTORY ◗

evening. The staff are nervous as there have been changes in the house. Their new boss is about to inspect their handiwork as an important guest is due to arrive.

The new boss is First Lady Nancy Reagan and the important guest is British Prime Minister Margaret Thatcher, who is to be honoured with the first state banquet of the new Reagan era. Nothing can go wrong. Nothing must be out of place. Nothing can be left to chance. At an apparently silent signal, the staff stop and withdraw to the walls with their hands behind their backs. The door opens and in walks First Lady Nancy Reagan and her social secretary, Muffie Cabot.

At first, it is all smiles. The First Lady surveys the room and all seems well. The green table linens, the flowers, the green and gold of the Truman china all look just how she had imagined. Mrs Reagan reaches out towards the glassware, knowing it was selected by First Lady Jackie Kennedy, but hesitates to touch it, mindful of making a mark. She is cautious not to soil the perfection she sees all around her.

But as she walks over to the table where she and the President will be sat, her smile quickly evaporates. The service plates on their table are different: horrified, she recognises them as the Roosevelt service. 'Why?' she asks. 'Why do we have different china? Can't you see what message this sends? Don't you see how this looks?' Looking around the state dining room, Nancy spies at least four different presidential services.

NANCY GETS HER WAY

Whilst Mrs Reagan's temperature rises, Muffie stays cool. As a long-time White House insider, Muffie knows the shocking truth and breaks it to her friend gently. 'The thing is, Nancy, there just isn't enough of each White House china set to go around. It does get broken, you know.' Muffie looks over at Eugene Allen, the legendary White House butler who'd already served seven presidents. Eugene nods silently, wisely keeping out of the dispute, if at all possible. Mrs Reagan wasn't happy but she was stoic. She recognised a *fait accompli* and knew that nothing could be done just then.

Despite this china crisis, the first state visit of the Reagan administration was an unqualified success, ushering in the Reagan–Thatcher era that dominated the decade politically. But back on the domestic front, Mrs R had plans.

Still horrified at the very idea that when the leader of the free world invited you to dinner, it was all done over mismatched and hand-me-down china, Nancy came up with a plan. Donors would be sought to fund a new White House service – the Reagan Service – because Nancy knew that the White House china was more than just porcelain, it was a silent ambassador for the nation. It not only reflected where the country was, but where it was going.

Just five months later, the order was placed with Lenox China Inc. of Trenton, New Jersey. Lenox had made almost all the presidential china of the twentieth century. They were reliable, discreet and *American*.

Working in tandem with designer Charles Solt, Mrs

❧ THE STUFF OF HISTORY ☙

Reagan chose a red border (her favourite colour) with gold embossing and a central presidential seal. When the Reagans welcomed Margaret Thatcher back to the White House in 1988 for their last state dinner together, Nancy Reagan was all smiles, secure in the knowledge that not only did everything match, but that she was serving her guests on what many considered to be America's most beautiful dinner service.

Perfection comes at a heavy price, however, and the Reagan china was not without controversy. First, there was the cost. At almost $1,000 a place setting, the final bill was a staggering $209,508. The fact that no public money had been spent appeared a minor consideration and much of the media failed to allow that truth to get in the way of their good story. As is often the case, the truth took a while to come out and went less noticed. When Nancy Reagan's memoir *My Turn* was published in 1989, her account of 'Plategate' ruffled a few feathers.

When Muffie Cabot declared at a White House luncheon that Mrs Reagan found the White House china cabinets to be almost empty, a few formerly discreet tongues began to lash. Bess Abell, social secretary to Lyndon and Lady Bird Johnson, could no longer hold back. The seasoned insider at the Maison Blanche felt compelled to defend the Johnsons and their china choices. She knew that there were at least 200 place settings of the Johnson china. She wondered if several shelves of china had collapsed. For why else would Mrs Reagan require a new and costly service?

❧ NANCY GETS HER WAY ☙

Queen Nancy (as some of her less close acquaintances called her) didn't like the Johnson service. As far as she was concerned, it was too 'lunch-y' and not suitable for a state banquet. Was the Johnson china too casual? Certainly it was dated but the evidence seems to suggest there was enough to fill all the place settings at the inaugural Reagan banquet. Perhaps it's a case of 'recollections differ' or maybe, just maybe, Nancy believed in the power of porcelain building a legacy.

Whilst the Reagans may have left office in 1989, the state banqueting service they commissioned remains, to this day, the most used service, while Lady Bird Johnson's epoch-defining set, that was perhaps too of its era, remains in a cupboard. Nancy Reagan, First Lady, china queen and author of *My Turn* had found her place in history.

CHAPTER FOUR
THE PEOPLE'S PRINCESS

It's 15 July 1830 and we are at Windsor Castle. It's late at night and Prince Leopold of Saxe-Coburg-Saalfeld is in bed and cannot sleep. Today, he had attended his father-in-law's funeral, but another thought is running through his mind. How different would things be if she was still here?

Everyone can remember where they were when she died. Not just that day, but the whole week when the entire nation seemed to cry. The closed shops, the queues of people waiting in line to pay their respects, that weird atmosphere, as if the whole country was under a blanket of snow. Muffled. Mournful. Haunting.

This wasn't the death of – that – People's Princess – but the OG one. As anyone who lived through the death of Diana, Princess of Wales will know, the loss of a beloved princess will grip and deeply affect the nation. The reaction

was the same when Charlotte Augusta of Wales, wife of Leopold, died in 1817. Britons knew that they had lost a daughter of hope and perhaps the greatest queen the country never had.

Imagine, for just a moment, an educated and erudite woman who outwitted politicians and princes. A woman known for her wit, individualism and for setting new fashions. A royal rebel adored by the public. A princess who married a handsome prince (for love). How different might the nineteenth century have been had she lived and her cousin Victoria remained in quiet obscurity at Kensington Palace? How might the age of Victoria and Albert have looked if it were in fact the age of Charlotte and Leopold? This is the story of an overlooked queen, the original People's Princess, whose death would change the course of the Royal Family as we know it.

Charlotte was born into chaos and drama, the one and only child of an arranged marriage which was practically over once her father had done 'his duty'. Indeed, Charlotte's father, the Prince of Wales (later known as King George IV), had done as he was told in marrying her mother, Princess Caroline of Brunswick. But young George's interest was less his bride and more that Parliament would pay off his various debts, as long as he met their conditions. And to say that George had debts is perhaps an understatement. He owed around £600,000, which may seem a paltry sum until you realise that in the 1790s, this was the equivalent to just shy of £70 million

in today's money. Seventy million and not yet thirty years old. This was profligacy on an industrial scale.

Prince George was in something of a situation, but so was the nation.

Prince George's father, King George III, was a well-liked and popular king who spoke English (unlike his grandfather George I). George III fathered fifteen legitimate children, thirteen of whom lived into adulthood. Seven were male. King George III had done his duty – not just an heir and a spare, but numerous spares. Despite the fecundity of the father, the children were less keen on marriage and producing heirs. As the eighteenth century began to draw to a close, King George III had no (legitimate) grandchildren.

It wasn't that his children were shy of sex, they were shy of doing what they were supposed to: marrying a Protestant princess and producing legitimate heirs, preferably male ones, that would take the Hanover dynasty into the next century. So the pressure was on first-born Prince George, but his father had put something of a stumbling block in the way: the Royal Marriages Act 1772.

The Act was introduced by George III ostensibly to protect the line and reputation of the family, but some suggested it was a more spiteful than that. They speculated on whether the Act was a result of the King being forced into an arranged and dynastic marriage himself, thus expecting his children to follow suit and only marry with his express permission. Any marriage that took place outside

the Act was null and void, and any resultant 'natural' children would be outside the line of succession.

Laden with debt and finding that the bank of King and Queen was closed, Parliament stepped up with a scheme to help Prince George. Minsters knew that they had him on a hook and proposed a solution that would, hopefully, satisfy all parties. If Prince George was to marry a suitable Protestant princess, then Parliament would pay off his many, many, many debts. Not only this, but they also dangled another bauble. Parliament would also increase his £60,000 a year allowance by £100,000. All he had to do was say 'I do' and – whilst it was never stipulated, it can be assumed – produce an heir or two. If Prince George did his duty, all would be well. Across Europe, Protestant princesses were learning English in anticipation.

Various emissaries were sent out seeking suitable matches to woo weary George and soon enough one candidate emerged: Princess Caroline of Brunswick-Wolfenbüttel. Caroline and George were cousins. Her mother was the favourite sister of King George III, Princess Augusta, and her father, Charles William Ferdinand, Duke of Brunswick, was favourite nephew of Frederik the Great. Caroline wasn't just a prospective wife, she was an alliance in waiting.

Whilst the King initially disapproved of a marriage between cousins, his son's determination and apparent desire to settle his debts – sorry, settle down – changed his resolve.

❧ THE PEOPLE'S PRINCESS ☙

It was said by many that Prince George had chosen Caroline rather quickly. Some said he chose her quicker than he chose a waistcoat, a pair of boots or a horse. But the decision was made and King George III wrote to veteran diplomat Lord Malmesbury, commanding him to divert his journey from Berlin to the Duchy of Brunswick and bring back the bride.

It's 1 April 1795 and we are eight leagues off the British coast on board HMS *Jupiter*. We are becalmed at sea, somewhere near Yarmouth. On board is a most precious cargo; a cargo which, when it eventually arrives in Britain, will change the course of history. What is that cargo? It's Princess Caroline of Brunswick, who by proxy is already Princess of Wales and the not-so-blushing bride of Prince George.

HMS *Jupiter* was becalmed three whole days but managed to find wind on Friday the third, which happened to be Good Friday. On Easter Sunday, the *Jupiter* arrived at Gravesend and the precious cargo and her party transferred to Royal Yacht *Princess Augusta* to make the final journey up the Thames to Greenwich.

Crowds lined the riverbank keen to see the woman who had caught the heart of the future king and somehow persuaded him to 'settle down'. Perhaps she would mend his dissolute ways?

It had been a blissful week on board *Jupiter*. So much so that her escort Lord Malmesbury described it 'like a party of pleasure'. Princess Caroline must have felt quite bridal

and yet anxious too. The *Augusta* and her party landed at Greenwich at noon after a 'pleasant and prosperous sail'. But no sooner had Princess Caroline stepped onto the soil of her new kingdom than all thoughts of 'bliss' evaporated. Whilst thousands had come out to take a look at their future queen, there was no sign of an official escort or carriage, let alone an anxious husband keen to see the woman of his dreams. An awkward hour ensued, with the poor bride-to-be hauled up at the home of the governor of the Hospital for Seamen before the Royal cavalcade arrived. Late.

An expectant princess walked out of the governor's house in a simple linen shift over a blue gown to receive her prince. The royal carriage door opened and out stepped ... not the Prince of Wales but the Prince of Wales's mistress, Lady Frances Villiers. It seems he had not only elevated her to the position of Lady of the Bedchamber, but also instructed her to accompany his bride back to his warm and waiting bosom.

Confusion ensued. Caroline tried to regain her composure, but when it became apparent that it was Lady Frances who had caused the delay, seeds of anger were planted and oh how they grew! If the lateness wasn't enough of an insult, it transpired not only had her husband sent his mistress but he had allowed her to choose a gown for his bride. Needless to say, a dress selected by her husband's mistress was not chosen to flatter her competition and the white satin concoction made the princess bride look dumpy.

THE PEOPLE'S PRINCESS

Caroline changed into the gown. The horses waited. The Dragoons hung about and all was not well. Caroline's lady-in-waiting, the Hon. Mrs Harcourt had taken great pains over the Princess's 'toilette'. Whilst Lord Malmesbury had described the Princess to the Prince as 'Pretty face – not expressive of softness – her figure not graceful – fine eyes – good hands – tolerable teeth but going – fair hair and light eyebrows, good bust . . .' he had neglected, by tact one assumes, to mention that the Princess and soap and water were not friends. In fact, Malmesbury had noted down in his diary on numerous occasions his concerns over the Princess's 'personal daintiness'.

'Argument with the Princess about toilette,' he wrote on 18 February 1795. 'She piques herself on dressing quick; I disapprove of this. She maintains her point.' He went as far as telling the princess's dresser, Madame Busche, that the Prince of Wales was fastidious in his hygiene and would expect his wife to be the same. Why, he asked, were the Princess's stockings so filthy, rarely changed and apparently never washed? It is not included in his diary how he knew the secrets of her most intimate apparel.

Freshly changed, at least, out stepped HRH the Princess of Wales in a daze of white satin, taking her place in the royal carriage ready to meet her husband. Just as the spotlight was turned on Caroline, Lady Frances attempted to grab it back. She complained to Malmesbury that she could not travel backwards in the carriage and would take ill unless she sat facing forward. In other words, she

wanted to sit next to the Princess and revel in the reflected attention. Malmesbury suspected that this was a ploy and knew it was wholly against correct form. Catching the eye of the royal mistress, he admonished her and told her that she ought not to have taken a position as a lady-in-waiting if she could not travel backwards. He concluded by suggesting that if she was truly to be sick, then she ought to travel in the second carriage with him. The seasoned diplomat had put Lady Frances back in her box. No further mention of illness was made as she took her seat opposite the Princess and away from the limelight. For now.

Finally, the much-disrupted procession took its route to St James's Palace, London, arriving late afternoon. Crowds cheered for the Princess as she stepped foot once more on English soil. She smiled and bowed in 'good grace', as noted by Malmesbury. A whole seven hours since she landed at Gravesend, at long last, she was to meet her Prince and connubial bliss awaited.

As Lord Malmesbury recorded: 'She very properly attempted to kneel to him. He raised her (gracefully enough), and embraced her, said barely one word, turned round, retired to a distant part of the apartment, and calling me to him, said, "Harris, I am not well; pray get me a glass of brandy" . . . and away he went.'

The 'party of pleasure' was over and any potential embers of passion were doused.

Caroline, who had been on her best behaviour, returned

to her usual form and exclaimed loudly in French, '*Mon Dieu! Est ce que le Prince est toujours comme cela? Je le trouve très gros, et nullement aussi beau que son portrait.*' 'My God! Is the Prince always like this? I find him very fat, and nowhere near as beautiful as his portrait.'

Perhaps Prinny felt the same way about his bride, the bride he himself had chosen. The spar-crossed lovers were reunited at an official dinner that evening, where the ever-observing Lord M recorded that he 'was far from satisfied with the Princess's behaviour', which he found 'flippant, rattling, affecting raillery and wit'.

Despite the early animus, a wedding had been contracted and a wedding took place, just eight days after Princess Caroline had arrived in England.

It's 8 April 1795 and we are in London. It's around 6pm and the streets between Buckingham Palace and St James's Palace are packed with sightseers. The lucky few who have invitations are already seated in the Chapel Royal and those with Drawing Room tickets are queuing up to take their places in the rooms that the royal party will pass through on their way to the solemnisation. It's chaotic. Despite the noble lineage of the guests, there is a lot of pushing and shoving. Regardless of their situation, everyone is here for one thing only: to get a glimpse of King George III and Queen, the Royal Family and especially Prince George with the newly appointed Princess of Wales. Maybe, they wonder, Prinny might be finally settling down? Maybe?

THE STUFF OF HISTORY

In the following days, the press paints a pretty picture of the proceedings. There were great descriptions of waves at windows and the 'costly' and 'superb' dress. 'She wore no diamond ornaments on her head; but a superb coronet of brilliants . . . and in the centre, in place of a stomacher, was the Prince of Wales's picture, richly set in brilliants.'

At least, that was how the press saw things. To those who were present, this portrayal couldn't be further from the truth. The groom was – as the newspapers used to say – 'tired and emotional', or, as Lord Malmesbury put it, 'had recourse to wine or spirits'. Another guest, Lady Maria Stewart, said, 'The Prince looked like death and full of confusion, as if he wished to hide himself from the looks of the world.'

It is said the two 'bachelor dukes', their graces Bedford and Roxburghe, had trouble keeping the groom upright. When the Archbishop of Canterbury said the immortal words, 'any person knowing of a lawful impediment', it was reported that he looked firmly at the groom, who had burst into tears. The elevated personages present knew what the archbishop was referring to: the clandestine marriage of the Prince of Wales to his then mistress, Mrs Maria Fitzherbert. It was an open secret at court. Thankfully, the Royal Marriages Act made that wedding irrelevant.

Observers noted how little Prince George said to Caroline and how often he looked towards Lady Frances, his latest mistress, instead. The Princess nodded and smiled like a 'mechanical toy', no doubt keen to get it all over

with. So, over it was and the (un)happy couple attended a reception at St James's Palace, where the prince appeared to be more sober. After a family supper back at Buckingham Palace (then Buckingham House), it was gone midnight by time the newlyweds got back home to Carlton House.

Despite Prince George's stupor and dislike of Caroline's corporeal filth, general body odour and lack of attention to her 'personal daintiness', the Prince did his duty, twice that night and once more the following night (as noted by Lord Malmesbury). After a few weeks, they may have still been married but were not living as man and wife.

Nine months later, an heir, Princess Charlotte of Wales, was born to the unhappy parents. George had done his duty: married, check. Heir, check. Debts paid off, cheque.

That the Prince of Wales paid close attention to his own 'personal daintiness' was unusual at a time when cleanliness was not associated with godliness, especially for aristocratic men. But that attitude was changing and largely down to one man, George Bryan Brummell, a.k.a. 'Beau' Brummell. Born into a comfortable middle-class family of humbler origins, the Brummells had pulled themselves up by a combination of luck and patronage, and George Brummell's father was determined to make his son a 'gentleman'.

Eton and Oxford awaited George Brummell, but he left Oriel College after just one year. In June 1794, he joined the 10th Light Dragoons, purchasing the rank of 'cornet', then the lowest officer rank. The 10th was known as the

❧ THE STUFF OF HISTORY ☙

'Prince of Wales's own' and Brummell soon caught the eye of its patron. It wasn't long before the two became acquaintances. The early death of George Brummell's father the following year left him with a small fortune and his royal patronage temporarily ensured his future. When he heard that his regiment was to move to Manchester in 1797, he retired from the army to embrace civilian life and his ever-growing fame as a wit and a dandy.

Over the following decade, Brummell ruled over high society and practically over the Prince of Wales too, who increasingly relied on Brummell for advice on all things fashionable. However, all reigns must come to an end and Brummell's fall was as swift as his rise. When the Prince of Wales became Regent in 1811, things began to change. The Prince of Wales was now the Prince Regent, a.k.a. the de facto monarch, owing to the fact that King George III was in the final stages of his mental health struggle. The Prince relished his upgraded status and the new deference from his long-suffering subjects and courtiers, all except one . . . Beau.

Perhaps due to their long friendship, Beau Brummell found it hard to adjust to his friend and mentee's elevated status and it all soon came to a head. It's safe to say that Prince George liked the spotlight to be on him and he disliked friends like Brummell hogging 'his' limelight. The Regent led the nation, but Brummell led society and the Prince didn't like it.

Brummell's inherited wealth and luck at the gambling

table, plus his royal patronage, had ensured his rise. But his spending – like that of his mentee – was rising too and it was greater than his income. Beau Brummell was in debt. Just like the Prince, none of these debts mattered with royal protection, but things were about to change. Whether it was true or court gossip, word reached the Regent that Brummell planned to 'cut' the Regent and make his father, King George III, fashionable once more. The Prince Regent felt it was time to 'cut' Beau Brummell first.

Today we would call 'cut' ignoring someone, but in regency Britain it was a serious thing. The worst type of 'cut', the 'cut direct', was when you totally ignored someone – to their face. To observe someone getting the 'cut direct' was to witness their social decline or death, if the person doing the cutting was powerful enough. They didn't come more powerful than Prinny, who planned to make a point with Brummell.

In July 1813, Brummell and fellow dandies Lord Avenley, Sir Henry Mildmay and Henry Pierrepont had all enjoyed a run of good luck at the card tables. What are dandies to do with money burning holes in their elegant pockets? Throw a grand ball, of course! The question was: should they invite the increasingly estranged former acolyte of Brummell's, the Prince Regent? In a wise move, Pierrepont, the only one who had not fallen out with the Prince, made discreet enquiries at Carlton House and word came back that, if invited, His Royal Highness would accept.

*

THE STUFF OF HISTORY

It's the night of the ball that all of the *haut ton* – London's fashionable elite – is talking about. The Dandies' Ball will close a glittering season and with news of Wellington's latest victory just in, everyone can sense a celebration. As is his habit, the Prince arrives late, but thankfully, the four dandies have been given notice and patiently awaited his arrival. As he steps down from his carriage, the Prince makes a great point of warmly greeting and shaking the hands of his hosts, but when it comes to George Brummell, this particular George was having none of it and gave Brummell the dreaded 'cut direct'.

To anyone else, this would have been a swift lesson in civility but Brummell could not keep wise counsel. Turning to his friend and fellow host Sir Henry Mildmay, Brummell said out loud, 'Henry, who is your fat friend?'

For anyone other than Beau Brummell, this would have been social suicide but the ton was divided. Many thought it was the funniest thing he'd ever said and even the Regent backtracked slightly by supposedly making it known that had Brummell taken the blow, he would have renewed their acquaintanceship. Indeed, Brummell's reign over high society continued, causing chaos to guest lists as no one dared to invite both the Prince Regent and the king of London society to the same event. Whilst society forgave Brummell, the tradesmen and women of London did not and soon debts were called in. Without his royal patron, Brummell could do little. Just three years later, his reign at the top of society ended and he fled to France.

❧ THE PEOPLE'S PRINCESS ☙

Which brings us back to the Regent's daughter, Princess Charlotte, and the real star of our story who, at the time of Brummell's departure from Britain, was coming into her womanhood.

For most of her life, Princess Charlotte had lived in enforced and quiet obscurity. The relationship between heir apparent and their heirs presumptive can be fraught, but in the case of Prince George of Wales and his one and only heir, relations hardly existed. The profligate Prince wasn't popular and the more he mistreated Charlotte's mother, Caroline, the more the public detested him and loved the young Princess. Charlotte, as the only legitimate heir, was seen as a sign of hope. As she grew up, her popularity with the public increased as that of her father shrank.

The truth is, the Prince of Wales was a bit jealous of this queen-in-waiting and was mostly absent from her life, whilst still placing restrictions on it. Even when Princess Charlotte turned eighteen, she was still kept on a short leash. Charlotte, like most women of her era, had one way out: marriage. But as the next in line to the throne, even here, her father ruled.

The Prince Regent had plans for his daughter, for whom he saw opportunities. Charlotte was to marry the hereditary Prince of Orange, which would not only reunite the British and Dutch crowns, but stabilise the Dutch as a bulwark against the French. This wasn't the opportunity eighteen-year-old Charlotte was hoping for. She had

become a pawn, caught up between the two warring houses of her father and her mother and she was having none of it.

Whether it was will, grit or naivety, somehow, Charlotte survived the War of the Waleses and obtained her father's permission to marry a man she loved. He was Leopold of Saxe-Coburg, who she wed on 16 May 1816.

It's 24 May 1816 and we are at Covent Garden. The theatre is packed for a performance of *The Jealous Wife* but the curtain opens early to reveal the entire cast on stage. The orchestra strikes up 'God Save the King', to which an extra verse has been added:

> *Long may the Noble Line,*
> *Whence she descended, shine*
> *In Charlotte the Bride!*
> *Grant it perpetuate*
> *And ever make it great;*
> *On Leopold blessings wait*
> *And Charlotte his Bride.*

Princess Charlotte and her handsome Prince, seated in the Royal Box, were the toast of society, but dark clouds were gathering. Six weeks later, a notice appeared on the railings of the same Covent Garden theatre:

❧ THE PEOPLE'S PRINCESS ☙

THEATRE ROYAL, COVENT-GARDEN,
MONDAY, JULY 8.
The Public are respectfully informed, that her
Royal Highness the Princess CHARLOTTE of
Wales, and the Prince Saxe Coburg, intended
honouring the Theatre with their presence this
evening; but the Proprietor are exceedingly sorry
to be obliged to apprize the Public that indisposition
prevents her Royal Highness from fulfilling
her gracious intention.

Although it wasn't revealed to the public, Princess Charlotte had suffered a miscarriage.

Despite Britain's great victory over the French at Waterloo, the country was in recession. Inflation, civil unrest and unemployment stalked the land. The hated Corn Laws began to put the price of bread beyond the means of the common man. The Prince Regent was as unpopular as ever. Yet, hope had not abandoned Britain and in the spring of 1817, a newspaper reported, 'The Princess Charlotte is said to be in a situation which must gratify the Nation and give an additional security to the House of Brunswick.'

Yes, the Princess was pregnant once more.

Royal baby fever gripped the nation. There was much speculation as to when the child would be born and, naturally, whether it would be a boy or girl. Betting shops opened books on the child's sex. It was said that if the baby was a girl, then the stock market would go up by 2.5 per

cent; if it was boy – a prince and an heir – then surely the stock market would go up by 6.5 per cent.

However, despite the air of optimism, something wasn't right. The royal medical team insisted the Princess diet from August onwards in an attempt to reduce the size of the baby. She was bled frequently and she wasn't even due until late October. Her due date went by and there was no baby. Contractions began on 3 November, but the 3rd became the 4th and then the 5th, with no apparent sign of a birth. Over those three days, Sir Richard Croft refused his royal patient any food. Whilst Croft was in charge of royal births, he wasn't a doctor but an '*accoucheur*', a kind of fashionable midwife, typical of high-class births at the time. Only at the last minute did someone call for an obstetrician, but it was too late and the baby – a boy – was stillborn.

To our modern eyes it seems bizarre that a mother, let alone a royal one, could enter her confinement without a doctor. It is even more bizarre that a doctor was on hand but did not participate. Baron Stockmar, personal doctor to Prince Leopold, wanted nothing to do with the birth. He feared that if the child – or mother – died, as a foreigner, he would be blamed.

Postpartum, Princess Charlotte seemed to recover and was finally allowed food. But later that night, things took a bad turn. Finally, Croft called for Stockmar to attend but it was too late. The People's Princess was dead and grief gripped the land. Henry Brougham MP and advisor to Princess Caroline summed it up:

❧ THE PEOPLE'S PRINCESS ☙

Her death produced throughout the kingdom the feelings of the deepest sorrow and most bitter disappointment. It is scarcely possible to exaggerate, and it is difficult for persons not living at the time to believe how universal and how genuine those feelings were. It really was as if every household throughout Great Britain had lost a favourite child.

Even Lord Byron, who was busy writing *Childe Harold's Pilgrimage* in Venice, was said to have run to his window and screamed out loud before adding six stanzas to his epic work to commemorate the late Princess. Byron wrote, 'The death of the Princess Charlotte has been a shock even here and must have been an earthquake at home.'

Newspapers had black borders and the whole country came to a standstill. Shops closed for weeks. The courts and the docks too. Black cloth could not be had, even for inflated prices, and it was said that even the poor tied a scrap of black material around their arms to show respect, such was the nation's grief.

Princess Charlotte's life was too short for any kind of legacy, yet in her death she found one. Leopold was plunged into deep mourning and insisted that her cape, bonnet and watch were to remain where she left them after her last airing in the grounds of their home. To the painter Sir Thomas Lawrence (who had recently stayed with them to paint Charlotte's portrait) he wrote, 'Two generations

gone. Gone in a moment! . . . My Charlotte is gone from the country – it has lost her.'

Once the nation had got over its grief, questions were asked and much attention was turned not just to Sir Richard Croft but to the way in which children were delivered: without a doctor and without forceps. Forceps had fallen out of favour in the previous century, mainly due to their misuse. Following the death of Charlotte, more and more children were delivered by doctors, and doctors specifically skilled with forceps.

Percy Bysshe Shelley drew attention not only to the circumstances of Charlotte's death, but to those of thousands of women in his 'An Address to the People on the Death of Princess Charlotte':

> How many women die in childbirth and leave their families of motherless children and their husbands to live on, blighted by the remembrance of that heavy loss? [...] Men have watched by the bedside of their expiring wives, and have gone mad when the hideous death-rattle was heard within the throat . . .

A few months later, Sir Richard Croft shot himself. He'd been reading Shakespeare's *Love's Labour's Lost* and left it open at a page where the following could be read: 'Fair Sir, God save you! Where is the Princess?'

Had Princess Charlotte lived, the world would have been very different. There would have been no Queen Victoria

and that means no Kaiser Wilhelm. So perhaps no First World War. How else might the course of history been different if Charlotte had lived to serve her reign?

It's the morning of 8 November 1817 and a couple are enjoying their breakfast. It's a normal morning, one of many that they have enjoyed over the twenty-seven years they have been together. After he's finished reading the *Morning Chronicle*, he tosses it across the table so Madame de Saint-Laurent might read it:

> I did as is my constant practice, I threw the newspaper across the table to Madame St. Laurent, and began to open and read my letters. I had not done so but a very short time, when my attention was called to an extraordinary noise and a strong convulsive movement in Madame St. Laurent's throat.
> For a short time I entertained serious apprehensions for her safety; and when, upon her recovery, I enquired into the occasion of this attack, she pointed to the article in the *Morning Chronicle*.

The article contained speculations as to whether, following the death of Princess Charlotte and her son, it might be a good time for the Duke of Kent to marry.

Madame de Saint-Laurent was no ordinary woman – she was the mistress, some might say common-law wife, of Edward Augustus, Duke of Kent and fourth son of

⊙ THE STUFF OF HISTORY ⊚

King George III. No wonder she was upset. After twenty-seven years with the Duke, was she about to be dropped like a hot potato?

Despite his long-term affection for Madame de Saint-Laurent, Prince Edward and his life had changed on the news of the death of his niece in November 1817. Suddenly, reality kicked in and by dint of a combination of both a succession crisis and his own mounting debts, a swift marriage hopefully blessed with offspring was the only route left to him. As he recalled, when his brother Prince George had married in 1792, he was given £25,000 by Parliament. Why shouldn't he get the same?

Edward wasted no time and didn't look too far. He proposed to Princess Victoria of Saxe-Coburg, the widowed sister of, yes, Princess Charlotte's husband Leopold. She had a son and a daughter from her previous marriage. Marie accepted and they married in May 1818 in Coburg, followed by an Anglican ceremony in London on 13 July.

The newlyweds moved back to the continent and settled in Leiningen, where Edward's stepson was the hereditary prince. In normal times they would have faded into quiet obscurity, but these were not normal times. When it was discovered that Princess Victoria was pregnant, the couple vowed to return to the UK in order that their child, who would be fifth in line to the throne, could be born in the country that they (might) rule over.

On 24 May 1819, Princess Victoria was safely delivered

of a child. In the following days, bulletins began to appear in the papers:

> *Kensington Palace, May 25, 1819.*
> *Her Royal Highness the Duchess of Kent has had an excellent night, and the Royal Infant continues to do well.*
> *(Signed)*
> *J. WILSON,*
> *D. D. DAVIS.*

It's 3pm on 24 June 1819 and we are at Kensington Palace, in the Cupola Room, which on this particular day is dominated by a plinth covered in crimson velvet. In the centre is the silver gilt fount commissioned by King Charles II in 1660. It is a private and strictly family affair. Following the correct form, the Kents had suggested various names for their child to the Prince Regent George IV, but he hadn't agreed to any of them, nor had he indicated that he would attend the actual christening. The child, after all, is only fifth in line to the throne. So it is to the great surprise of the Duke and Duchess of Kent when the Prince Regent arrives quite unexpectedly, throwing the event into turmoil. When the proud mother passes the babe to the arms of the archbishop, he looks towards the parents, who look to the Regent for a name.

'Alexandrina' comes the reply. Prince Edward asks, 'Might we add another name?' 'Certainly,' answers the

THE STUFF OF HISTORY

Regent. Edward suggests, 'Perhaps Georgina or Elizabeth?' There follows what seems like a long pause, then the Prince Regent replies, 'Very well, call her after her mother, but Alexandrina must come first.'

So, the Archbishop declared the child to be Alexandrina Victoria. You know her as Queen Victoria.

CHAPTER FIVE
TOO BEAUTIFUL TO PAINT

It's the morning of 7 June 1908 and we are in Paris at the home of Auguste Remy, a prosperous banker. The butler is carrying a breakfast tray up the stairs. He stops outside a bedroom, taps gently on the door and opens it. Placing the tray on a side table, he draws the curtains and opens the window. Just like every other day. Lifting the tray, he approaches the bed, but he is stopped in his tracks. He sees not his employer in repose, ready to be gently woken, but a cold and prone corpse. There is blood and a bloodied dessert knife, which he recognises, under the bed.

Several members of the family, as well as seven staff, were in the house overnight, but no one heard a thing. Money and jewellery are missing. Fingers are pointed, but it turned out that the butler did it. For Alice, Remy's sister-in-law it was another blow upon a bruise of a year.

*

❧ THE STUFF OF HISTORY ☙

The first half of the year had been miserable. The spring had been exceptionally cold and her husband Claude was always prone to a chill. Even in April, when he was expecting spring flowers, all that blossomed in Claude Monet's garden was snow. Differences of opinion between the artist and his dealer Paul Durand-Ruel did not help matters either. The difficulty was agreeing on how and when to show his 'Nymphéas' – the now iconic 'Water Lily' series of paintings that had become something of a fixation for the artist. But then hope arrived in the post. Hope that the cycle of lows that 1908 had become could be broken, hope that a change of scene and a change of air would break the never-endingness of it all.

The letter came from Mary Hunter from Venice, who became friendly with the Monets when they came to London. She was a well-known English patron of the arts. Her sister was the composer Ethel Smyth. Hunter wrote to inform the Monets that she had taken a let on the Palazzo Barbaro from Ariana Curtis and wondered if Claude and Alice might wish to stay. Alice was filled with delight. Taking the letter in her hand, she ran into the garden to find Monet. She knew that Mrs Hunter would be taking care of everything and it was the break that they both needed.

What we see today as a garden, a garden that Monet had created meticulously since 1893, wasn't just a garden to the artist. It was an impressionist laboratory. Ever since he had painted 'Impression, Sunrise' in 1872 – the painting that gave the world the name 'Impressionism' – Monet and

❦ TOO BEAUTIFUL TO PAINT ❦

his fellow artists of the same movement, Renoir, Degas, Morisot, Pissarro, Sisley and Cézanne, had pushed the boundaries between solid and liquid, sky and earth, light and dark. In his lily pond, Monet had found the perfect expression of nature to form the perfect expressions of his art.

The anticipation of each new season in his garden, the new growth, new blooms and new light, yielded promises of new art and new challenges. It's no wonder that when spring didn't seem to come in 1908, a gloom settled over both Monet and his hometown Giverny. And Monet's mood was always Alice's problem. Monet was happiest when he painted – and when the painting was going well.

Alice Raingo Hoschedé and Claude Monet married in 1892, one year after the death of her husband Ernest Hoschedé. She was his second wife and helped steer Monet's art with a gentle love of her husband that was born from a love of his art. If Monet was happy, so was Alice. If he was troubled, she shared that burden.

The unexpected murder of her brother-in-law, whom the Monets knew as 'Uncle Remy' troubled both Alice and Claude, especially as the more sensational members of the press linked the celebrity of his death to the Monets.

Now, in September, the lilies were close to blooming. Ever since the summer of 1897, Monet's paintings of the lilies had verged on obsession. At first, they were rooted in the landscape. The fringes of the pond, sky, reflection, the red Japanese bridge, the trees – all the elements

placed the lilies as just one aspect of his created landscape. This first series would usually include a horizon, but from 1899, Monet's horizons closed in on the flowers, the water and the interplay of light. It wasn't just the beauty of the flowers that fascinated him, it was their transient nature. The emerging buds, which stand proud out of the water, only unfurl late in the morning, bloom, then close once more until the following day. It was an ephemeral beauty and a challenge Monet had set himself. There was no room for ugliness in the vision. Each evening, Monet sent out a gardener in a boat to remove any dead flowers or leaves. Nothing was to blot his landscape.

After all that had occurred that year, the thought of leaving the sanctuary of Giverny before the lilies began to bloom was too much for Monet. His obsession with water and light had captured him and he had hardly ventured beyond his garden these last few years. He couldn't possibly abandon it now. As tempting a trip to Venice was, much to Alice's disappointment, Monet said no.

Perhaps something else was holding him back – was it Venice or himself? Monet, even Monet who was a master of light, knew that the light of Venice is difficult to capture. So many iconic artists whom he admired had made the pilgrimage to Venice before, artists like Turner, who was able to capture light like no other. Rather than lure him, Venice seemed to challenge him. Truth was, he had spent most of the last five years painting his garden, and more recently just the pond. Could he even paint Venice

TOO BEAUTIFUL TO PAINT

anymore? As he would later say in Venice, '[I am] too old to paint such beautiful things.'

There was something else too. He knew his sight was failing.

However, the siren cry of *La Serenissima* was too loud and Mary Hunter was insistent, so when the weather turned from the promise of sun to the return of cloudy skies, Monet changed his mind and it changed art history.

It is 2 October 1908 and we are at Venezia Santa Lucia railway station. It is late afternoon. A well-dressed lady is waiting outside. She looks anxious. By her side is a porter with a trolley. As each successive wave of passengers leaves the station, she scans each one, hoping to spy the guests she is waiting for.

'Alice! Claude! *C'est moi! Regarde ici!*' she shouts out, waving her handkerchief in her hand. ('Alice, Claude, it's me! Look here!' The Monets spoke no English.) Finally, they hear her. They smile. They have arrived in Venice.

The porter takes the luggage and departs.

Mary tells them, in her best French: 'I've come by gondola, it's the very best way to witness the city, come this way. Venice awaits!'

Whilst Mary Hunter walks ahead, leading the way, the Monets pause, mesmerised by the scene. The light, dazzling; the atmosphere, incredible; the heat, even the heat is offering a warm welcome!

'Once we pass under this horrid iron bridge,' says Mary,

referring to the original Scalzi bridge, 'and turn down Rio Marin you will see the true Venice. It's a shortcut and then we shall rejoin the Grand Canal. I thought you might like to go as far as the Bacino before we head home?' The Monets nod and smile.

Mary Hunter said little more on their voyage, nor did she get any spoken responses. She could see that Alice and Claude Monet were entranced and fully captured by all that was before them . . . the water, the light, *Venice*.

After what seemed like a day – but was just over an hour – the three friends arrived home. It was now twilight and a manservant was standing on the little dock holding a lamp. The gondolier at the front leapt off to secure the boat, with the one at the back rowing to hold the boat in place. Stepping off, Alice gazed up at the vast and vertiginous facade above her. Looking across the Grand Canal, she noticed too how different the buildings looked when viewed from land, compared to when seen from a gondola. Monet noticed too and Alice hoped he was making impressions in his mind for a subject.

Another servant held open the Gothic wrought-iron gates. He wore a black armband, which reminded her that Daniel Curtis – the owner of Palazzo Barbaro – had died that July. It was why Mary was staying. Mrs Curtis was away seeing to her late husband's affairs in Boston, getting them in order. They walked along a long corridor of brick, which then opened onto a courtyard of oleanders with a vast staircase lining two sides.

❧ TOO BEAUTIFUL TO PAINT ☙

As they ascended the final leg of the stairs, the main doors opened, revealing a room lined with green silk within stucco frames. The room had five panelled walnut doors. *Which one,* Alice wondered, *would open as if by magic, revealing their route?* It was the door on the far-right hand side that opened. Behind it was a much bigger room and a large ceramic stove, the sort you might see in Austria or Germany.

As they followed Mary Hunter into the vast *portego*, it was the light that hit them first. The hall ran from the back of the palazzo to the front, but it was impossible to distinguish the formation of the windows that looked on to the canal for the light reflected off the water was too bright. The light dappled a mirror-like pattern on the ceiling. It was the first of many encounters with *el sparlusega*, as the Venetians term it.

'We've made you a bedroom here,' said Mary, pointing to open double doors, 'so you'll have the view.'

Entering the room, Alice took no persuasion, 'May we?' she said, opening her hand towards the balcony. 'You need not ask, Alice. I want you both to treat this as a home.' Mary Hunter held open the doors to the balcony, her smile inviting them to move forward.

They stood there in the twilight bewitched. The sun may have gone down but it had left behind a warm pink light, enough to see all of Venice laid before them. The iron of the Accademia bridge framing one side, the gallery a corner, Palazzo Polignac opposite; the garden of Ca Balbi

and its palazzo with the twin terraces crested the scene. A lady with her dog was sitting on one. Alice wanted to wave but stopped herself. Then she looked down towards La Salute and the Bacino which returned the frame and cornered it. She felt she was in a dream, a fairytale.

Surely here, here of all places, Alice wondered to herself, *surely here Monet will paint?* She looked to her left and saw that her husband was also mesmerised. She recognised the look. Monet was forming impressions in his mind and soon he'd be taking up his brush, she hoped. She smiled at him and he smiled back, but any thought of art evaporated.

'It is too beautiful to be painted,' said Monet. Alice's heart sank.

Back inside, Alice looked around the room. Once more a fairytale. A frescoed ceiling, an inlaid stone floor, silk curtains framing lancet windows, each with their own little balconies. Two large silver jugs and hand wash basins had been placed next to towels on a commode. Their suitcases had been unpacked and removed for storage, she assumed – but where were the canvases, paints and brushes that had been dispatched from Giverny in time for their arrival?

The Monets settled into a daily routine of early breakfasts, of wandering the *calli* of Venice, of outings in the gondola and visits to churches. Of evening entertainments in palaces, of living in a dream. Despite the comforts of Palazzo Barbaro, despite the beauty of Venice, Alice began to wonder as each day passed if the fire and enthusiasm

for painting Venice would continue to burn inside Monet or cool.

Days continued to pass and the paints and canvases did not arrive. Alice started to think her husband would never begin painting.

Finally, on 9 October, the art supplies shipped from Giverny arrived and the pent-up impressions that Monet had formed in his mind began to flow from him like water.

He began painting from the water gate of Palazzo Barbaro and within a few days had settled into a routine, which Alice Monet described to her daughter in one of her daily letters:

> From 8 o'clock, we are at the first subject – San Giorgio, opposite Piazza S. Marco; at 10 o'clock Piazza S. Marco, opposite San Giorgio. After lunch, Monet works on the steps of Palazzo Barbaro. Then at 3 o'clock at the gondolas we take a turn to admire the sunset and return at 7 o'clock. Yesterday, as it was a Sunday, Monet cannot work in the afternoon because of the movement of the vaporetti so we went on an excursion to Chioggia in a boat, rented by Mrs. Hunter, two and a half hours from Venice and the same to return. It was magical and hundreds of fishing boats with their coloured sails and the lagoons superbly lit. Lunch on the way back, served on the boat at last, an unforgettable day . . .

❧ THE STUFF OF HISTORY ☙

Alice was delighted: 'Venice has got hold of him and won't let him go.' But just a few days later, Alice and Monet would be forced to let go of Palazzo Barbaro. For some days now, Mary Hunter had been putting off her departure from Venice; her let was coming to a close, but she was mindful that Monet had found his muse. Soon, she could delay no more and Alice and Claude Monet had to make a decision: remain in Venice or return to Giverny.

They stayed.

It is 15 October 1908 and the world's most famous artist is leaving Venice's most iconic palazzo for its most iconic hotel, swapping the wall-to-wall comfort of Palazzo Barbaro for the more commercial environs of the Grand Hotel Britannia. Considered to be the first luxury hotel in Venice, it is on the same side of Venice as Palazzo Barbaro, but further towards San Marco. It has 'electric light and steam heat in all rooms'.

The Monets' change of address changed art.

Of course, the miracle doesn't happen immediately. Cooler weather prevented Monet from painting *en plein air* and he wanted to leave the city, but then he began to rework existing sketches.

In a letter dated 22 October, Alice revealed what had inspired Monet to revisit his paintings: the electric lighting. 'We are very well at the hotel, very clean, with a large room, washroom, toilet and bathroom and above all, truly magical electric lighting. Monet sees his paintings, I

assure you, it is delicious and would make you wish you had it at home.'

The 'delicious' nature of electric light must have been revelatory for Monet. Whilst much discussion has been made of how he saw after his cataract operation in 1923, little has been said about the effect of both the electric light of the Hotel Britannia in 1908 or the effect of the light he would see when sat in a gondola.

We know from the daily correspondence of Alice Monet not only the motifs Monet painted but in many cases, the position where he painted them from too. Monet's first encounter with Venice was from the Curtis family's gondola. It is the view of Venice that he sought to capture. Like his 'Nympheas', which became more and more abstract and centred on the interplay of light and water, punctuated by flowers, the Venice pictures are at their best when he has dispensed with the (cloudless) sky and explored just the light and the water, punctuated by palaces.

It is not just what Monet saw but from where he saw it that influenced him so much. To anyone who knows Venice, it will come as no surprise that he not only delayed painting at Palazzo Barbaro but abandoned those works he began – or, at least, any from its windows. Daniel and Ariana Curtis lived on the second *piano nobile* of the palazzo. Whilst its view is magnificent, it is one of mainly roofs and brick and marble. It is no wonder that when he did begin to paint Venice, it was from the open steps at the front door on the Grand Canal.

❧ THE STUFF OF HISTORY ☙

When not painting at the water's edge, Monet painted in a gondola with Alice by his side. Sitting in a gondola is almost like sitting in the water. Even across the canal, the sky is hardly seen. It is an afterthought.

We know too that as the weather got colder, they took a gondola with a *felze*, a wooden cabin that afforded protection from the wind. The downside was that Monet only had a view from the small windows. However, these small windows frame his most intimate works, transforming his view into cinema.

Nor must we ignore the unique light of Venice and how it must have helped Monet see clearly. In the autumn and winter, the sun is low. It heightens the architecture, but it also reflects off the water. The *gibigiana* – the Venetian word for the sparkle of the water and the light it reflects – makes the buildings of Venice look like they have been lit for the theatre or the opera.

It will come as no surprise that sunglasses were originally invented in Venice to lessen the *gibigiana*. During the early part of the eighteenth century, Venetians began to wear 'gondola glasses' to protect the wearer from the glare of the canal. Where the dazzling light provided a nuisance for some, for Monet, it provided opportunity and a new way of seeing. The reflected light from the canal, just like the electric lighting in the hotel must have helped him see in a way he could not before; it must have been a revelation.

As the days turned from autumn into winter and the weather became less predictable, the Monets maintained

an uneasy routine of early breakfast followed by painting. Then lunch in the often freezing hotel, followed by more laying down of 'motifs' on canvas, before enjoying the sunset before dinner and bed.

One lunchtime, the Monets spotted a familiar face in the room. It was French-born American artist Louis Aston Knight. Monet waved and the younger man came over.

'Why, fancy running into neighbours! Oh, I apologise, I don't think you've met my wife Caroline. We got married last year, back home, this is a sort of second honeymoon,' said Louis.

'You couldn't find a better place. Will you paint too?' said the older man.

'Oh yes, I've been painting. Caroline is very patient, aren't you, my love? And you, sir, please tell me you too have been painting?'

Alice interjected. 'Oh yes, he's been painting. Fifteen canvases so far but the cold is a concern. We may have to return home soon.'

'Well, that'll be a darned shame. You know, and I mean this with all respect, sir, I have a fur coat here and if you need it, you only have to ask.' This, like all the Monet's conversations, would have been in French.

As it got colder, Monet took up Louis Knight's offer of a fur coat. Alice wore two bodices – she was cold but determined to keep Monet painting at all costs, because when Monet painted, he was happy. It wasn't that Monet needed the money.

❦ THE STUFF OF HISTORY ❧

Claude and Alice Monet began to feel Venice's chill. Monet complained about the cold at the best of times, but even with the *felze* for protection and burrowed in a borrowed fur, the chill was becoming too much. Alice, as ever, tried to make the best of it:

> A freezing wind which prevents Monet from working and this morning, we had to run to the shops to find warm knitwear for him, but apart from mosaics, pearls, glassware, lace, antiques, the shops are shabby; there is only one for toys, and very ordinary. In reality, it is so cold that they say here that it is stronger than in December. This saddens me because I fear that Monet will give up and abandon all these beautiful beginnings, but which are only beginnings.

Despite the promise of 'beginnings', the Monets left Venice and planned to return the following autumn. No sooner had they returned to Giverny, than they had electric lighting installed as they noticed on the return home and under the gas lighting at Giverny, that Monet 'could not see' and if he couldn't see, then the 'beginnings' would have no end.

Claude and Alice Monet never made it back to Venice. Alice died on the 19 May 1911. In a letter to a friend Monet wrote: 'It's over. My beloved companion died this morning at 4.00. I'm distraught, lost.'

Twenty-nine of his Venice paintings were exhibited the following May to great acclaim. Monet had lost his Alice

TOO BEAUTIFUL TO PAINT

but he had found a way of capturing the light of Venice like no one had before. Whilst Alice never lived to see the result of those 'beginnings', Monet's Venice paintings are as much her legacy as his. If not for a holiday let, a change in the weather, electric lighting, a gondola, a borrowed fur and Alice Monet's determination to make 1908 a better year, some of the world's most beloved images of its most beloved city may never have existed.

CHAPTER SIX
THE INVENTION OF CHRISTMAS

What colour is Christmas? Think hard because you can only choose one. Did you choose red? The colour of Rudolph's nose, holly berries, the stripe on a candy cane, a robin's breast and, of course, the colour of Santa Claus. Ah yes, that jolly old man, ruddy of cheek and round of shape. Fully upholstered in red and trimmed with white fur. If you did choose red as your colour for Christmas, then it was actually chosen for you in a boardroom way back in 1931. But to understand exactly how you were manipulated, we must travel back to France and 1863.

His Holiness THE POPE writes that he has fully appreciated the beneficiary effects of this Tonic Wine

THE STUFF OF HISTORY

and has forwarded to Mr. Mariani as a token of his gratitude a gold medal bearing his august effigy.

It wasn't just Pope Leo XIII who was a fan of M. Mariani and his tonic wine. Queen Victoria loved it, as did Alexandre Dumas, Emile Zola, presidents William McKinley and Ulysses S Grant. Thomas Edison was also happy to endorse 'Vin Mariani' and claimed it kept him awake longer, making him more productive. It was said to have inspired Charles Gounod, and Robert Louis Stevenson was so taken by the transformative powers of the wine that it has been credited with inspiring him to write his dark tale of Jekyll and Hyde.

Angleo Mariani arrived in Paris from his native Corsica in 1863, full of hope and ambition. He had read about the restorative effects of *Erythroxylum coca* leaves and he started to import them from Peru. His idea was simple: mix the leaves with wine to make a palatable and healthful drink. Investing in a barrel of Bordeaux wine he began to experiment, aided by his wife, Marie-Ann, and opened a shop just by the Paris Opera. His 'Vin Mariani' was an immediate hit.

Very soon, he counted a number of celebrity customers and, not missing a trick, Mariani sought endorsements from them, being one of the first to market products in this way. He soon became very rich and successful, but what was it about his tonic wine that made it so popular? Each bottle contained six milligrams of cocaine

per fluid ounce, which was quite legal at that time. The alcohol in the wine extracted the drug from the leaves naturally. Yes, the wine beloved by popes, queens and presidents was laced with an addictive stimulant – no wonder it was popular!

Vin Mariani was in production until 1930, but its successor, a cough medicine called Terpine Mariani was on sale until 1965. Terpine Mariani contained fifty-six grams of cocaine per bottle. Cough.

Success, of course, leads to imitation and many tried to copy the success of Vin Mariani. Most fell by the wayside, but one, an American dupe, did rather well.

It is 16 April 1865 and we are on the banks of the Chattahoochee River, near Columbus, Georgia. Colonel John Sith Pemberton, like many others on that day, was injured. Confederate General Lee had surrendered at Appomattox a week previously, which should have effectively ended the Civil War, but broken telegraph lines meant the news had not reached Union General James H Wilson. Pemberton had found himself in the midst of a sword fight and sustained life-changing injuries to his chest caused by a sabre. In great pain, he received morphine, administered on the battlefield. The use of morphine was so widespread that later dependency upon it became known as the 'soldier's disease'.

Peace meant a return to civilian life for Pemberton, who resumed his pharmaceutical profession, opening the

THE STUFF OF HISTORY

Eagle Drug and Chemical Co. in Columbus. Pemberton understood pain – it was a daily reality for him and many other veterans. He also knew that he, and many others, were dependent on morphine. His mission was to create an opiate-free medicine that would not only ease his pain but make him his fortune.

His first creation was Dr. Tuggle's Compound Syrup of Globe Flower, a cure-all that didn't take off, but Pemberton did not give up. In 1885, he patented his French Wine Coca, a product not a million miles from Vin Mariani. The early success might have been a one-year wonder as in the same year, a law came in that allowed counties in the state to decide to ban the sale of alcohol, which many did. Colonel Pemberton was not in the habit of giving up and so he simply substituted the wine for soda water. Pemberton's newly invented drink took off.

However, success came too late for John Pemberton and in his final years he sold his invention to one of his investors in Atlanta, Georgia. He had wanted to keep a small stake to leave to his son but his son said he'd prefer the money. Colonel Pemberton succumbed to his injuries and passed away in August 1888, just months after selling the rights to his drink for around $10,000 in modern money. You may have heard of his invention. They changed the name from French Wine Coca – it's now called Coca-Cola, which, after 1929, did not contain any cocaine.

Imagine for a moment that telegraph line had not been

broken and word of surrender had got through to Columbus. No battle, no wounds for Pemberton . . . no Coke?

It's mid-September 1919 and we are in Atlanta, Georgia. A young reporter, Archie Lee, has been sent by the *Atlanta Georgian* newspaper to interview Samuel Candler Dobbs, the newly appointed president of one of Atlanta's biggest companies. A company which has just been the subject of a multimillion-dollar takeover. Dobbs is so impressed by the young reporter that he tells him to quit his job at the newspaper and join a local advertising agency and handle his firm's account. Archie Lee follows his advice and, after approaching William D'Arcy in St Louis, lands a job with the D'Arcy agency. Within just six years, Lee is made a director. This was *Mad Men*'s Don Draper, 1920s style. Archie Lee had a lasting impact on our lives: he changed Christmas forever.

His main client, the one he left journalism for, had a problem. Their sales were high during the summer but fell off during the winter. Lee needed to shift focus from the drink's association with hot weather and reposition it as an all-year-round product. And he knew what to do. He took an existing character and rebranded him in his client's corporate colours. In one masterstroke, he reinvented the way people saw both his brand and the holidays (as our American friends call Christmas).

Archie Lee had just reinvented Santa Claus. Coca-Cola's red and white corporate colours were forever fixed in

THE STUFF OF HISTORY

the minds of all who believe in Santa. Feel cheated? You should because how you see Santa Claus is a masterclass in marketing and manipulation.

Of course, Lee didn't act alone. Whilst the concept of a friendlier, fuller and red and white Santa was his, the execution was down to artist Haddon Sundblom. Sundblom was a tried-and-tested commercial artist who had a knack of making his creations life-like and with a spark of humanity. He was the perfect artist for this exacting brief. So exacting was the brief from Coca-Cola that they insisted that Sundblom left certain parts of the canvas blank – for the all-important Coke bottle and any logos, which they had painted in later by their own artist. These paintings were not just art, they were the fine art of brand management.

In his mind, Haddon had already fixed an image of his perfect Santa – his neighbour and friend, Lou Prentice. Prentice was a retired salesman and perfectly fitted the description of Santa Claus in Clement Clarke Moore's 1823 poem *A Visit from St Nicholas*, now usually known as *The Night Before Christmas*.

> His eyes—how they twinkled! his dimples, how merry!
> His cheeks were like roses, his nose like a cherry!
> His droll little mouth was drawn up like a bow,
> And the beard on his chin was as white as the snow;

The image he created, with the tagline 'My hat's off to the pause that refreshes', appeared in the *Saturday Evening Post* during the holiday period of 1931 and permanently cemented Sundblom's vision of Santa in the minds of Americans and the world. Santa's red-dressed form was cast in iron and it was all down to a chance interview in 1919.

Of course, there are keyboard warriors and those who edit Wikipedia pages for fun who will be fuming now. 'NO!' they scream. 'This isn't true. Santa was shown as a jolly red-coated chap before 1931!' But this isn't the point. Yes, it's true that Santa Claus had appeared previously wearing red and some of these figures were jolly and rotund, but these are the exceptional players in a cast of many, many versions of Santa. The oft quoted example of a pre-Sundblom Santa in red, that by Thomas Nast from 1881, depicts Santa in red, but a red 'Union-Suit' – red all-in-one long johns! Whilst Nast was certainly first to show a rotund Santa, his image didn't burn into the collective consciousness like Sundblom's later version. For years after Nast's red Santa, we still see the character depicted in many colours and body types: blue Santa, yellow Santa, green Santa, even white Santa – most of which were creepy, thin figures who looked like they'd borrowed your dad's dressing gown and stuck on a beard. Like it or not, Coca-Cola's version of Santa fixed the image in the mind of a jolly holiday chap, and red and white became the (corporate) colours of Christmas.

❦ THE STUFF OF HISTORY ❧

There was a time when saying 'Santa Claus' was a social indicator in the UK. 'Father Christmas' was seen as a more sophisticated and more upper-class description and yet, shockingly, for the type of person who pays any attention to this type of thing, Santa and Father Christmas are two entirely separate things and from a British point of view, relatively recent creations. Therein, perhaps, lies the disapproval?

It's 21 December 1574 and we are in the city of York in England. The lord mayor has sent his sheriff to read a proclamation at each of the 'bars' of the city – the gates that both welcomed and repelled visitors: 'Oyez! Oyez! Oyez! We command that the peace of our lady the Queen be well kept by night and day but that all manner of whores, thieves, dice players and other unthrifty folk be welcome to the city, whether they come late or early, at the reverence of the High Feast of Yule till the Twelve Days be past. God save the Queen!'

This was the *Yoole-girthol*, the proclamation that translates as 'Yule sanctuary' and heralded twelve days of misrule that included the election of a 'Boy Bishop'. This period later became better known as the 'twelve days of Christmas'.

This particular year actually saw a paired-back Yuletide for York, as two years earlier, the previous Yule-riding had been banned by the Archbishop. 'Yule-riding' took place on the same day – St Thomas's – and saw two figures on

horseback riding into the city. One was 'Yule', the other 'Yule's' wife. Yule carried a shoulder of mutton and a cake, and each threw nuts to the crowd. Archbishop Edward Grindal wasn't a fan. He saw in it too much of the city's pagan Viking past. He wrote in a letter along with other citizens proclaiming:

> two disguised persons called Yule and Yules Wief
> should ryde thorow the citie verey undecentlie and
> uncomelie, drawinge great concurses of people
> after them to gaise, often times committinge other
> enormities . . .

The nature of these 'enormities' was not stated, but the letter of 13 November 1572 put paid to the tradition.

Yes, Yule is the proto-Father Christmas, a personification of the season, but his modern name was still a few years off.

It's December 1616 and we are at the Palace of Whitehall, London. King James is holding one of his court masques – this one is by his favourite playwright, Ben Jonson. For the first time, 'Christmas, His Masque' is performed.

> 'Enter Christmas, with two or three of the Guard,'
> say the stage directions:
> He is attir'd in round Hose, long Stockings, a close
> Doublet, a high crownd Hat with a Broach, a long

thin beard, a Truncheon, little Ruffes, white Shoes, his Scarffes, and Garters tyed crosse, and his Drum beaten before him.

This version of 'Christmas', or 'Old Christmas', as Jonson terms him, is still an early incarnation, but he has gained his long beard and his white shoes would have alerted the audience to his importance, as footwear of this colour was only seen on the feet of the elite. The rest of his attire is distinctly old fashioned and suggestive of age.

It took a war to transform 'Old Christmas' into 'Father Christmas'.

During the English Civil War (1642–51), Christmas became a battleground. To the Royalists, it represented one of the many strands of traditional life that they were fighting for; whilst to the Puritan Parliamentarians, Christmas was a wicked, sinful thing that they wanted banned, and yet it is during this period that we see a reference to 'Father Christmas'.

'The Arraignment, Conviction and Imprisonment of Christmas' was published as a 'broadside' – a pamphlet which was the traditional method of spreading information. It was said to have been: 'Printed by *Simon Minc'd Pye*, for *Cissely Plum-Porridge*; And are to be sold by *Ralph Fidler*, Chandler, at the signe of the *Pack of Cards* in *Mustard-Alley*, in *Brawn Street*. 1645.' This sentence is laced with Christmas imagery that its reader would recognise: the 'Minc'd Pye' and 'Plum-Porridge' (a precursor to our

❦ THE INVENTION OF CHRISTMAS ❧

Christmas pudding). Likewise, 'Fiddler', as the playing of fiddles was a big part of Christmas entertainment, just like card playing. Brawn served with mustard was a popular dish of the many of those times.

According to the pamphlet, 'Old father Christmas' is in trouble:

> The poor old man . . . was arraigned, condemned, and after conviction cast into prison amongst the King's Souldiers; fearing to be hanged . . . he broke out of Prison in the Holidayes and got away, onely left his hoary hair, and gray beard, sticking between two Iron Bars of a Window.

Father Christmas is missing and the not-so-subtle message is that only a restoration of a monarchy can bring him back.

Now that we've settled that 'Father Christmas' is a specific character representing the festive period, let's turn our attention to 'Santa Claus'. Santa Claus is a distinctly American creation, specifically New York, but, once more, he was born out of politics.

*

It's 16 December 1773 and we are in Boston. A number of men who call themselves the 'Sons of Liberty' have boarded some ships in the harbour and are throwing chests of tea into the water. News of this reaches the *New York Gazette* and on 20 December, the paper reports the events of a

few days prior in Boston. Right next to this report is news of a recent dinner:

'Last Monday [i.e., 13 December] the Anniversary of St. Nicholas, otherwise called St. A Claus, was celebrated at Protestant-Hall, at Mr. Waldron's, where a great Number of the Sons of that ancient Saint celebrated the Day with great Joy and Festivity.'

Whilst the Sons of St Nicholas were less radical, their formation was a discrete riposte to British rule and a clear statement of the Dutch roots of New York, once New Amsterdam. It's also the first mention of S(ain)t A. Our 'Santa Claus' comes from the Dutch 'Sinterklaas', which itself is a foreshortening of Sint Nikolaas (Dutch for Saint Nicholas). This is the reason for the oft stated but erroneous claim that it was the Dutch who brought Santa to America – but there appears to be no evidence for it.

St Nicholas was an incredibly popular figure, a non-biblical saint with a huge following and dedicated churches around the globe. St Nicholas is also the reason we used to give oranges as a gift at Christmas. One of the legends associated with the saint was that he gave a gift of three gold balls to three women who had no dowry, saving them from poverty. The orange represents the gold ball. So if you got an orange in your stocking, it wasn't some kind of struggle present, but a hope for wealth.

It should come as no surprise that much of the myth-making around Santa emerges just before and especially after American independence. America was growing up,

moving away from 'Britishness' and towards an American dream – and Santa was America's first superhero.

America's myth-maker-in-chief was Washington Irving (1783–1859), though his role in the invention of our modern Christmas is often overshadowed by one Charles Dickens. Irving first came out for Christmas in 1809 with his *History of New York*, which was penned under the comic pseudonym of Diedrich Knickerbocker and published on St Nicholas's Day, 6 December. Here, Irving begins to construct the myth of Santa, painting a picture of a rotund and pipe-smoking elf. Santa is noticeably softer than Father Christmas and he's more family friendly. Once Irving had let Santa out of the sack, New York, then America, ran with it.

Within another decade, Santa was fully formed but not yet fully upholstered. His beard, his sleigh, even his reindeer and the concept of 'naughty or nice', because this early Santa arrived with both presents and birch twigs to scold the naughty!

It's 3 February 1879 and we are in Newcastle in the north east of England. A lecture is to be given that evening and it will include a demonstration of a new invention. People arriving at the Literary and Philosophical Society for the lecture could not help but notice the large stationary engine outside. A few recognise John Fairless, the engine's maker, and word spreads that something special is about to happen.

THE STUFF OF HISTORY

The hall is packed, with standing room only, as George Stephenson introduces the lecturer: Joseph Swan. Swan is well known to the audience – an obsessive who has been working on the same project since 1850. Electric lighting. Is tonight the night?

Joseph Swan did not disappoint the assembled crowd. At the end of his lecture, he instructed that the seventy gas jets lighting the hall be extinguished. 'Then – with a suddenness which in those days seemed quite magical, he transformed the darkness into light by switching on 20 of his own lamps, producing an illumination which, as compared with gas light, had a very brilliant effect.'

It wasn't long before news of Swan's success spread and everyone wanted electric lights, including one Richard D'Oyly Carte, who was busy building a new theatre in London. His Savoy Theatre opened to great acclaim in October 1881 and by the end of December, it was the first theatre to be fully lit by electric lamps. The Savoy was home to the operettas of Gilbert and Sullivan:

> An interesting experiment was made at a performance of *Patience* yesterday afternoon, when the stage was for the first time lit by electric light, which has been used in the auditorium ever since the opening of the theatre. The success of this new mode of illumination was complete and its importance for the development of scenic art can't be overrated. The light was perfectly steady throughout the performance,

and the effect was pictorially superior to gas, the colours of the dresses – an important element in an aesthetic opera – appearing true and distinct as daylight. The Swan incandescent lamps were used, the aid of gaslight being entirely dispensed with.

But it is not *Patience* that concerns us, but another operetta, *Iolanthe*, which opened on 25 November. What took place in the second act stunned the audience and changed Christmas. During the second act, as the Fairy Queen entered, electric stars lit up in her hair and that of her attendants. In later performances, thirty fairies had illuminated stars, as *The Times* reported on 17 February 1883:

> A novel feature of the performance was the appearance of about 30 of the fairies with electric stars in their hair. Hitherto only a few have been so adorned. The experiment was made in the moonlight scene, in which the fairies dance with the peers in Palace Yard, and was entirely successful, the flowing drapery of the ladies effectually concealing the small accumulators which they carry on their backs charged with the electricity required to maintain the incandescence of the tiny lamps on their foreheads.

You may be asking what this has to do with Christmas. These 'fairy-lights' took London by storm and it wasn't long before they were seen on the best Christmas trees.

❦ THE STUFF OF HISTORY ❧

*

It's December 1848 and the *London Illustrated News* has just hit the newsstands. It contains a special supplement, one that will change the Christmases of millions. Within an oval framed with fruits, fish and fowl, a family is gathered around a Christmas tree, lit with candles, hung with toys and crowned by a star. There is no headline; the readers know this family – it's the Royal Family and this illustration of Victorian perfection takes Britain by storm, especially as the short description, 'Christmas Tree at Windsor Castle – Drawn By J L Williams', lets readers know that this is the actual tree of their Queen.

Christmas trees were not unknown to Britons – Prince Albert did not introduce them – but this image made them the must-have seasonal accessory for those homes who could afford them and an aspiration for those homes that could not.

It's Christmas Day 1800 and we are at the Queen's Lodge, which was the home of the King and Queen when at Windsor. During the day, Her Majesty Queen Charlotte had sent a Christmas dinner to 'sixty poor families' but it is what happens that evening that concerns us. As her early biographer, Dr John Watkins, who was one of the adults present, wrote:

> Sixty poor families had a substantial dinner given them and in the evening the children of the principal families in the neighbourhood were invited to

THE INVENTION OF CHRISTMAS

an entertainment at the Lodge. Here, among other amusing objects for the gratification of the juvenile visitors, in the middle of the room stood an immense tub with a yew tree placed in it, from the branches of which hung bunches of sweetmeats, almonds and raisins in papers, fruits and toys most tastefully arranged and the whole illuminated by small wax candles. After the company had walked round and admired the tree, each child obtained a portion of the sweets which it bore together with a toy, and then all returned home quite delighted.

This was the first record of a Christmas tree in Britain, a habit that remained within the Royal Family until the *London Illustrated News* shared that festive image and kickstarted a trend.

These early royal trees were tabletop affairs, whose candles were only lit for the actual gift-giving on Christmas Day, but as the tree became more and more popular, they became bigger and ended up on the floor, sometimes with unintended consequences.

It's Christmas Day 1855 and we are at Kilve Court in Somerset. Caroline Luttrell has decided to throw a family party. She wants it to be an extra special day, especially as her father, Colonel Luttrell, a veteran of Waterloo, is away with his regiment in Cork. Caroline has arranged a surprise for her guests and has gone to great lengths to keep it a

THE STUFF OF HISTORY

secret. She has set up – in a locked room – a Christmas tree and plans to make it the centrepiece of the family gathering, as each guest will receive a present from the tree. She can't wait to see everyone's faces, but things do not go as planned.

Caroline manages to slip away from the family and unlocks the room containing the tree, carefully ensuring she relocks it, lest anyone discovers the secret too soon. She wants everything to be just right, especially as this will likely be the first Christmas tree her guests have seen. As the *Huddersfield Chronicle* reported it on 2 February 1856:

> During the evening the . . . young lady left the circle for the purpose of lighting the tapers on the tree, and desired none of the party to visit the room until she rang the bell. To ensure that no intruders would enter Miss Lutrell turned the key of the door, and commenced lighting up the tree.
>
> Unfortunately, she commenced lighting the lower tapers first, and then, reaching up to light those on the higher branches, her thin evening dress caught fire and she was immediately enveloped in flames. It appears that the deceased ran to the bell and pulled it violently, and afterwards unlocked the door and proceeded towards the room where the company were assembled. On meeting her surrounded with flame and smoke their horror, it may be conceived, was extreme.

ᘡ THE INVENTION OF CHRISTMAS ᘠ

Her brother, assisted by others, with great difficulty extinguished the flame, but not until after receiving a severe burn on her hand. Medical assistance once was immediately sent for. Miss Lutterell's eyelids, face, and neck were found to have suffered the most from the flames: but it was at first hoped that no fatal result would follow. The exhaustion, however, and shock caused to the system were too great and on Monday she died. The deceased was in her 25th year.

It should come as no surprise that some of the earliest adverts for electric 'fairy-lights' showed a richly lit 'electric' tree alongside a tree with candles on fire.

It's Christmas Day 1948 and we are in the East German Soviet occupation zone. Children across the area are opening what presents their parents were able to find. But some are in for a surprise. Those lucky children receiving a doll on that Christmas morning will soon find their excitement cooled – or perhaps chilled? As thousands of excited children unwrap their dolls, they discover – to their no doubt horror – that their dolls have no eyes.

Glass eyes, for humans and dolls, were once one of the specialities of Lauscha, a Thuringian town near the then border with the West. The state-controlled glassworks were not doing well and the skilled makers of glass eyes had been tempted to flee to the West and the rival

glassmaking centre of Neustadt, causing the great glass eye drought of 1948.

The following Christmas saw dolls with glass eyes restored, to the delight of many in the newly formed GDR – but to the no doubt shock of the comrades, these glass eyes were made in West Germany, in Neustadt, by ex-Lauscha workers.

It's 10 January 1597. Hans Greiner and Christoph Müller have just received some good news: an official concession from Duke Johann Casimir of Saxe-Coburg to operate a glassworks in Lauscha. The glassmaking settlement was built in the forests between 1590 and 1594, but a concession was a big deal. Hans Greiner had developed a rectangular furnace with twelve ports, and he and Müller and their sons began to produce drinking glasses and window panes. With royal support, an efficient furnace and raw materials on its doorstep, Lauscha thrived into the next century, but success had a price.

Whilst successive generations of Greiners and Müllers moved away to found their own glass houses, by the mid-eighteenth century, Lauscha had another problem: deforestation. The once plentiful forests that surrounded the town were almost exhausted. Wood was vital for glassmaking – not just to fuel the furnaces, but potash, from burnt wood, was an essential part of the mix. The combination of lack of space and environmental damage forced the glassblowers of Lauscha to look to new products.

THE INVENTION OF CHRISTMAS

Glass eyes were an early product and with Europe at war so much in the eighteenth century, a booming addition to the town's catalogue of products.

The glass furnaces were too small so that many of the skilled glass-makers began to work on objects that could be worked by a lamp at home. These primitive lamps – powered by alcohol or turnip oil – limited production to small objects and one in particular was well suited to both the limitations of home working and the low heat of the flames: hollow glass beads. These beads were crudely mirrored inside with a mix of molten lead and tin and proved a great hit, particularly beloved of milliners. People soon began to string these silvery beads together on lengths of cord and sell them for the newly fashionable Christmas trees.

The introduction of a bellows to the glassmakers' lamps in the 1820s meant a much hotter flame, which gave the skilled workers of Lauscha a freer rein to make larger hollow items. The small beads soon became the first Christmas tree baubles, the production of which was and remained a literal cottage industry until the twentieth century.

The inhabitants of the many homes scattered around the town of Lauscha lived mainly in poverty, eking out a living. The glassblower would make the baubles and his wife decorated them. The children – their labour an essential part of these family micro-businesses – wrapped the fragile works to await the arrival of the 'messenger woman'. These were often elderly widows whose job it was to collect the

THE STUFF OF HISTORY

glass baubles from the homeworkers and walk the twelve miles to Sonneberg. This long walk was known as the 'Glassworkers' path and remained in use until 1886, when a railway was built. Sonneberg was where the agents and wholesalers were. It was these wholesalers who were key to introducing the world to Lauscha's baubles.

It's 21 June 1879 and a new store is about to open on North Queen Street, Lancaster, Pennsylvania, the heart of Amish country. Despite its diminutive size of just fourteen feet wide, the red and gold fascia makes it stand out, and the fact that everything in the store is either just five or ten cents. The three sales staff, including thirteen-year-old Susan Kane, are paid $1.50 a week. The counters are made from packing cases and the goods wrapped in newspaper. The thrifty locals approve of the simple aesthetic and the store takes off. (Today, it would be a trendy 'zero waste' store and cold-brewed coffee shop.)

It's autumn in the following year, 1880, and twenty-year-old Bernard Wilmsem is exhausted. He runs a fledgling import and manufacturing business in Philadelphia, but at every shop he's called at, no one will buy his products. He's disheartened. He came to America from his native Germany to seek his fortune; right now, he's seeking a sit down and a rest. He's one shop left to visit; it really is his last chance.

The new shop is small. It's been open for just a year and, to be honest, he's not hopeful, but he puts his best

foot forward and goes into the store. He's looking for the owner and is directed to a man sitting at the back, watching all and taking the money and giving change. Bernard shows his wares but the store's owner is not impressed. 'Why will my customers buy these things? They don't "do" anything.'

Bernard is disheartened once more but he also knows this is his last spin of the wheel, so he says to the man: 'Look, mister [sounding more like 'meester', with his heavy German accent], I will level with you. You are my last chance. I've hawked these all over the county so I'm gonna make you an offer, a one-time-only price, and if they don't sell, well, I will take them back. You can't lose.'

The store owner looks at him. He smiles a little, thinking, well, what does he have to lose? They shake hands. Bernard smiles too.

Before the day was out, all 144 items had sold out and more were ordered the following year. It wasn't long before this product was one of the store's top sellers. Remarkably, from that one box of 144 items sold in 1880, by 1939, the one store and the others subsequently opened had sold 500 million of these things that didn't 'do' anything. To think that if Frank Winfield Woolworth hadn't bought that one box of Lauscha baubles on sale or return terms, an entire industry, nestled on a German mountain, might have withered away. No wonder they built a train line to Lauscha just six years after that first purchase.

This one deal, in an Amish town in Lancaster county,

opened F W Woolworth's eyes to new opportunities because it made him realise that his customers didn't just want a neat and clean home, they desired pretty things too. Over the next few years, the businesses of both F W Woolworth and Bernard Wilsem expanded exponentially and made both men rich. Much of that wealth came from useless items that didn't 'do anything' like Christmas baubles and tinsel. Perhaps if young Bernard Wilsem had called at Woolworths' first and not last, the vast chain of stores, beloved of generations, may never have existed. That's the wonder of Woolies.

CHAPTER SEVEN
THE ROBIN HOOD OF HOLLYWOOD

It's 11 June 2015 and we are at Tioga Mine Pit Lake, near Grand Rapids, Minnesota. Divers from the Itasca County sheriff's office are gathered by the turquoise waters, putting on scuba gear. They are preparing to search the lake. Their quarry? A sealed Tupperware box whose contents are insured for $1 million. After two whole days, the search is fruitless.

Let's go back. It's 17 May 1970 and we are in Culver City, Los Angeles, on stage 27 of the MGM backlot, to be precise. It's 8pm and an auction sale, which had begun at 1pm, is paused. The auctioneers welcome to the stage the local mayor, Martin Lotz. Lotz is about to make an extraordinary speech. At first, he asks auctioneer David Weisz to donate the next lot to the city, but Weisz responds by suggesting that maybe the mayor can persuade people

not to bid against him? Lotz's speech is met by polite, if lukewarm, applause from the 2,500 people waiting to see the hammer fall. It's one lot that's captured visitors' hearts. The one lot with no description. Some people simply stare at it, mesmerised.

As Lotz returns to his seat, someone else comes on stage. He is dressed simply and has naturally curly blond hair. He's carrying a pink silk cushion on which are displayed a pair of red shoes. His name is Kent Warner and he's showing the ruby slippers from *The Wizard of Oz*.

Unbeknownst to the audience and even to the auctioneer (who chose the venue because of its size), stage 27 is where Judy Garland began her journey down the Yellow Brick Road, wearing the very same ruby slippers.

Showing off the ruby slippers to the world seemed a far cry from the day Kent found them. They were wrapped in an old towel on the third floor of a forgotten costume store on lot 2 of the backlot: 'Ladies' Character Wardrobe'. In a costume bin, beneath decades of dust, and despite the almost pitch-black darkness, Kent Warner knew what he'd found – an icon of Hollywood and the world's most famous shoes. Shoes which even dust could not dim because they'd captured the imagination of billions.

Kent Warner was well known and well liked in Hollywood. Working as a costumer gave him access all over town, and his charm and winning smile found most doors open to him. He had a reputation of being able to 'pull' any costume. No request, no matter how weird or specific, was

beyond Kent; he knew exactly where he could lay his hands on whatever it was that a client wanted.

Alongside his charm and good looks, Kent knew the studios and how they worked like the back of his hand. The 1960s and 70s were the twilight of the studio system; whilst few of the great names ran Hollywood, much of the 'back lot' work, the craft of the industry, was still in the hands of people from the Golden Age, a time that fascinated Kent.

As an insider and a costumer, Kent Warner knew that at the close – or 'wrap' – of a production, the wardrobe was 'broken'. Costumes were split on gender lines, then separated further into individual categories. Then into style. This meant that if a studio, or independent costumer like Western Costume, had to supply twenty Edwardian day dresses, it was just a case of going to the right rail in the women's wardrobe section.

The other practice that Kent knew well was 'counting hangers'. This was common in the industry and meant that if a studio loaned out, say, ten cowboy costumes, so long as ten were returned, no one minded if they weren't the exact ones. This was as old as the movies themselves; it streamlined and sped up the swift exchange of wardrobe, and kept costs down.

An unintended consequence of wardrobe breaking and hanger counting was the loss of 'star wardrobe' – clothing worn by the principal players in a movie. An outfit that was once worn by John Wayne might simply end up in a row of mixed cowboy wardrobe. Only knowledge of the production

and the sewn-in label would identify who wore what. The studios were not interested. Kent was.

His first day in Hollywood was one of delight and delusion. The boy from Long Island arrived in Hollywood aged twenty-one and landed a job with Bermans Costume House. Kent's first task was to go over to the old RKO Pictures lot and remove any viable pieces for Bermans, who had bought the entire wardrobe from Desilu Productions, the new owners, who, in a few years' time, would film *Star Trek* on the same lot.

When Kent arrived at RKO on his first day in Hollywood – the legendary studios that had made *King Kong*, *Little Women* and *Flying Down to Rio* – he must have felt like the kid in the candy store, but when he discovered that the commissary was using old items of wardrobe as kitchen rags, the reality of Hollywood in the late 1960s sunk in. It wasn't long before Kent was 'rescuing' iconic costumes, such as those worn by Fred Astaire and Ginger Rogers. No wonder his friends began to call him 'Lana Lift'. Kent's trained eye did not just spot famous items worn by the great stars of the Golden Age – when he saw an 'opportunity' he 'lifted', stuffing Golden Age costumes into his ever-present duffle bag. After all, better he took them home than someone took them out with the trash, he reasoned, waltzing out of the lot with a winning smile that no one suspected.

No one cared. No one noticed.

Kent Warner also knew that star wardrobe was always

made in at least doubles, or triples. On-set damage could stall a production and cost thousands, so there was always at least one spare, identical costume for every piece of star wardrobe. For complicated scenes like dance numbers or battles, more than one example would be made. Kent knew this and was happy to 'lift' the occasional costume for himself, safe in the knowledge it would not be missed and no one – including the studios themselves – actually cared about Hollywood's heritage. Kent Warner cared, deeply.

He was young, good-looking and living his Hollywood dream. He had an apartment in the fashionable, if run-down, 'El Cabrillo' apartment block built in 1928 by Cecil B DeMille and known during Kent's tenure as 'Patio Gardens'. His apartment was part museum, part shrine, but certainly a home. He especially enjoyed letting guests take a guess about the origin of something before telling them, 'Well, you know what it is? It's *the* curtain dress from *Gone with the Wind*.' He loved to see their expressions change. He loved the drama of it. His neighbour was Harris Glenn Milstead, better known as 'Divine'.

Kent held weekly screenings of movies from the Golden Age. His party piece was to show the movie and, at the right moment, reappear wearing the same costume seen on screen. One week, he might be Fred, one week Ginger. This was his church and these were his icons.

He saw his home very much as a halfway house: the next stop before items found forever homes with collectors who were prepared to pay. Kent wasn't cheap, but what he

found was the best. There was, however, one thing Kent would not sell: the ruby slippers. On a four-foot-high pedestal, within a plexiglass case, displayed at an angle and spotlighted, one corner of Kent Warner's sitting room was a shrine – to the ruby slippers.

It's the end of February 1970 and we are on the third floor of a former soundstage on lot 2 of MGM Studios. Twenty-seven-year-old Hollywood costumer Kent Warner is on a mission. He's been employed by Dick Caroll, a fellow costumer, to seek out star wardrobe for the forthcoming sale of 'Countless treasures acquired from Metro Goldwyn Mayer', a mammoth sale of Hollywood memorabilia organised by Auctioneer David Weisz, Caroll's father-in-law. The sale is to be essentially an eighteen-day wake for old Hollywood. Kent has brought his knowledge and winning smile; he's also brought his duffle bag.

Dick Caroll and David had a problem. Weisz had purchased lock, stock and barrel hundreds of thousands of pieces of wardrobe that he didn't really want or understand. What Weisz had actually wanted, and paid $1.5 million for, was room after room of actual rooms removed from French chateaux and European castles. Vast quantities of antiques used for set dressing. Chandeliers. Countless vehicles, carriages, chariots, a full-sized sailing boat and a paddle steamer. Even the bougainvillea used to grace many a Hollywood balcony were for sale. MGM had gone from a dream factory to a breaker's yard.

ೂ THE ROBIN HOOD OF HOLLYWOOD ೨

The plan was simple: David Weisz's daughter Judy and Dick Caroll would help to find 30,000 of the best pieces of costume, the star wardrobe, and the rest would be sold off a few months later at a glorified 'yard sale', at everything-must-go prices. Except, David Weisz didn't know where anything was and neither did the Carolls or the studio. One person did: Kent Warner. They knew of his reputation; they knew he was clever and talented. As Caroll said, 'Probably too clever.'

Kent was taken on board and transformed the sale, arranging full-room sets and tableaux, using his deep knowledge (and love) of old Hollywood to rescue from oblivion the treasured wardrobe no one wanted. Yet.

The iconic costumes from *The Wizard of Oz* were high on the list of wants but no one knew where they were. Not even Kent Warner. With most costumes, it was a case of looking in the right rack or bin. From a row of 'female ball attire', Kent Warner could spot Ginger Rogers' wardrobe several paces away. A quick look at the label confirmed the hunch. But the Oz costumes remained elusive.

Part of the issue was that they were deemed unlikely to be reused when Oz wrapped and would have gone into deep storage. After all, flying monkeys and munchkins don't appear that frequently on a film call sheet.

When Kent found the ruby slippers in a costume bin on the back lot his excitement was tempered by a dilemma. The trouble was, he didn't just find one pair – he found four or maybe even five pairs. There was another problem:

the condition. The slippers were ruby in name only. Most of the delicate hand-sewn sequins were falling off. Of the four pairs Kent found, one pair stood out, and not just because of their condition but because they didn't have any orange felt glued to the soles. In the half light of the sound stage, Kent noticed something and a shiver went up his spine. On the soles were noticeable wear patterns, curved patterns, the sort you'd make if you clicked your heels together and said out loud, 'There's no place like home.' Kent was frozen. He held in his hands the very pair that were the focus of the movie – the close-up pair. The ones we first see on the feet of the Wicked Witch of the East, then on the feet of Dorothy Gale. The ones that zapped the witch and set Dorothy off to follow the Yellow Brick Road. The same pair that got Dorothy Gale back to Kansas. Kent slipped them into his duffle bag.

Dick Caroll wasn't impressed when Kent showed him two pairs of ruby slippers, filthy and very worn. Kent had hedged his bets by not only taking the best pair for himself but holding back the second best set too. Very quickly, he knew he'd done the right thing. David Weisz was said to be furious when he heard about the discovery of two sets. 'There can only be one pair of ruby slippers,' he is said to have told Dick Caroll. 'Get rid of the other pair.'

That night, when he jumped into his car, Kent didn't throw his duffle bag onto the back seat – he placed it reverentially in the seat well.

Now Dick Caroll had a dilemma. Staring at the two pairs

of ruby slippers that Kent Warner had brought to him, the two pairs that his boss and father-in-law said ought to be just one, he wasn't sure what to do. Could he destroy a legendary piece of movie history? An American dream captured in red sequins and memories?

We do know what he did next – partially. He sent some ruby slippers to Malone Studio Service to be cleaned, but did he send both, so the pair in the worst condition could be used to provide replacement sequins for the best, or did he take his father-in-law's advice? Whatever happened, only one pair made the auction, as David Weisz had wanted.

Not only was there more than one pair of ruby slippers but the slippers themselves had evolved. In L Frank Baum's book *The Wonderful Wizard of Oz*, the slippers are not ruby but silver and always referred to as shoes. Studio head Louis B Mayer wasn't having 'black and white shoes' in his costly Technicolor movie, so at the suggestion of scriptwriter Noel Langley they were changed in the shooting script from 'silver shoes' to 'ruby shoes' – the 'ruby slippers' must have come later.

Noel Langley also introduced the concept of actors who played the Lion, Tinman and Scarecrow, would also be cast as farmhands in Kansas. He also created the character of Miss Gultch, prefiguring Margaret Hamilton's later role as the witch.

Whilst Langley picked the colour, it was Gilbert Adrian who designed the slippers. Born Adrian Adolph Greenburg, but always credited as 'Gowns by Adrian' – he was MGM's

top designer. Adrian came up with two 'test shoes', the so-called 'Arabian pair', and a more familiar pump-style shoe. Whilst the Arabian pair looked great on the dead witch, it was felt they did not work on farmgirl Dorothy Gale, so they were rejected. Both shoes had another problem: too many 'rubies'. Adrian had lavished each pair with heavy glass beading, all of which was hand sewn. Whilst the weight difference might have seemed minimal to the casual observer, to sixteen-year-old Judy Garland, who might be wearing shoes for hours a day, lightweight was the right weight.

Adrian went back to the drawing board and simplified the slippers. He retained the simple pump shape but replaced the heavy beading with hand-painted fish scale sequins, adding a simple and neat bow bedecked with bugle beads. They passed muster. The ruby slippers were born.

Mayor Lotz sat back down in his seat. He looked over towards his potential nemesis, Hollywood legend Debbie Reynolds, who smiled politely. Knowing he'd only received pledges up to $7,500, he feared bigger fish might outbid him.

To the public, she was the girl from *Singin' in the Rain*, but to the covert collectors of old Hollywood, Debbie Reynolds was the kingpin. She was horrified at the casual attitude of studios and many of her fellow stars to their own history and had been quietly amassing a collection, much of it via Kent Warner. The MGM sale appalled her –

❧ THE ROBIN HOOD OF HOLLYWOOD ☙

she'd tried to have the auction stopped, she'd tried to buy the lot before it was sold, she tried to save Hollywood.

Sat next to fellow star Ann Miller, Debbie was determined to buy as much as she could. As Kent came on stage with the slippers, all eyes were on Miss Reynolds.

It just took forty-six seconds to sell the ruby slippers. Weisz took to the rostrum himself: 'Now, what is your pleasure? How much do I hear for the shoes? Start it out, someone.' A slide projector clicked and an image of the shoes appeared on screen. 'There they are,' said Weisz.

Mayor Lotz looked over to Debbie Reynolds; she didn't smile back. The bidding began at $1,000 and rose quickly. Debbie Reynolds had set a limit of just $5,000 and didn't even get a chance to bid. Martin Lotz saw this, but his one and only bid of $7,000 was soon passed. Next it was $10,000 then $15,000. David Weisz tried for $20,000 but no hands went up. Bidder P-890 triumphed. Mayor Lotz and Debbie Reynolds looked dejected. They didn't get the shoes, but after the auction, Debbie did get her hands on the Arabian test pair via one 'Miss Lana Lift'.

It is 19 May 1970, two days after the MGM auction in Culver City. We are in Memphis, Tennessee. A woman is sitting at her kitchen table reading the local paper. Her name is Roberta Bauman. She's shocked and calls out loud, 'Why, looky here!' She's reading an article about how the iconic ruby slippers had just sold for $15,000. But how? She goes upstairs and looks in the wardrobe.

THE STUFF OF HISTORY

She sees a shoebox. Lifting the lid, a sense of relief comes over her. *They're still there*, she thinks to herself. Roberta Bauman still has the ruby slippers in her wardrobe. So what is this other pair? The pair that's just made so much money?

In truth, Roberta hadn't thought much about the shoes since 1939 when she won them in a competition organised by MGM. She came second. The ruby slippers were a consolation prize and she'd spent the last few decades sharing her ruby slippers with children. No fancy museum shows, just homespun show-and-tells at local schools. The sale in Culver City changed that. She didn't want something so valuable in her home. She called the bank and she wrote to MGM. Ten days later, her letter was returned, unopened, so she contacted the press, determined to discover if her shoes were real or if she'd been palmed off as a schoolgirl.

To say that David Weisz was furious when he found out about the Bauman pair was an understatement. The secretive buyer must have been furious too, but in 1979 they donated his pair to the Smithsonian, where they remain today. At least the public could see them there, which is why collectors call them 'The People's Pair'. Debbie Reynolds must have been pleased.

Kent Warner also sold his shoes, his prized possession, for just $12,000 on 1 October 1981. He was seriously ill and he had bills to pay. Selling them must have broken him. Just seven years later and four years after Warner's death, his pair exchanged hands once more for $165,000.

∾ THE ROBIN HOOD OF HOLLYWOOD ∾

They were last seen in December 2011 when they failed to sell at auction but were purchased by Leonardo di Caprio and Steven Spielberg for $2 million after the sale and donated to a yet-to-be-opened Hollywood museum. Kent would have liked that.

Roberta Bauman kept her pair in a bank vault until 1988, when she was sixty-five. She called Christie's auction house, who sold them for $150,000, roughly quarter of a million in today's money.

But there is one pair that we have yet to account for, of the two pairs Kent kept back, because we've saved the best story for last. This pair, in almost as good condition as the ones Kent kept for himself, was bought in 1970 by collector Michael Shaw. Some say Shaw was acting as intermediary and the shoes were intended for Debbie Reynolds, but Shaw has always denied that. Shaw was well known in the then tiny and often clandestine circle of movie memorabilia collectors. His was one of the best collections. He owned the witch's hat and gingham dress from Oz; he owned Scarlett O'Hara's 'curtain' dress and he even owned the Ten Commandments brought down from a cardboard Mount Sinai by a bewigged and bearded Charlton Heston. In 1970, he now owned the ruby slippers, or rather one of the four/five pairs.

Over the years, Shaw had been generous in showing off his collection and the slippers travelled around America, which gave them the affectionate title of 'The Travelling Pair'. In the 1980s, they were shown in shopping malls. In

❧ THE STUFF OF HISTORY ☙

1989, the fiftieth anniversary of the release of *The Wizard of Oz*, he loaned them to the Judy Garland birthplace museum in Grand Rapids, Minnesota. This loan was such a success that Michael Shaw continued to loan them the slippers from time to time.

It's 28 August 2005, around 2.30 in the morning. We are at the Judy Garland Museum in Grand Rapids. Glass is smashed and a door opened. A man skirts the walls of the back room and enters another. He walks by a carriage owned by Abraham Lincoln that featured in *The Wizard of Oz* and steps in front of the case holding the ruby slippers. With two blows of a sledgehammer, the man smashes the glass, grabs the slippers and runs. A single sequin falls to the floor; for years, it will be the only proof the slippers existed.

Michael Shaw couldn't stop crying when he was given the news. It was like a death to him, the death of a member of his family. It didn't help that many suspected Shaw of the theft. After a protracted legal battle with the museum's insurer, Micheal Shaw accepted a payout of $800,000. But it wasn't about the money for Michael Shaw, it was about the magic. For a time, he'd held in his hands the collective memories of billions of movie goers; for now, those memories were lost.

Rumours and claims began as to the whereabouts of the ruby slippers. Wild rumours. Which is what led to the fruitless search of the Tioga Mine Pit Lake.

THE ROBIN HOOD OF HOLLYWOOD

*

It's July 2018 and we are on board a Delta flight heading to Washington DC. Two men in dark suits are sitting either side of a shoe box. The steward asks if she can place the shoe box in the overhead locker. The two men inform her that the shoe box has its own ticket. 'In which case it will have to buckle up,' she tells them, smiling. The two men are agents with the FBI. The shoe box contains the ruby slippers which had been recovered in a sting operation in a Minneapolis coffee shop earlier that month, on 5 July. The agents are flying to Washington to compare their shoes to those at the Smithsonian Museum.

It's 28 August 2005 and we are at a house on Wisconsin Avenue, Minneapolis. We are at the home of career criminal Jerry Saliterman. Fellow mobster Terry Martin has just arrived. He was expected. He's carrying a parcel which Jerry opens excitedly. Both men are in their seventies. They've just pulled off the theft of their careers – they've stolen the ruby slippers. They plan to remove the rubies and retire. Jerry is shocked when he opens the package. No rubies, just sequins. The two men can't understand it. How can this be? How can a pair of what look to the men like stripper shoes be worth a million dollars? Neither man had seen *The Wizard of Oz*. Jerry digs a hole in his backyard. He places the slippers in a plastic box and fills back the soil.

*

❧ THE STUFF OF HISTORY ☙

The agents land in Washington. They head straight for the Smithsonian's National Museum of American History. Their timing is perfect because the museum's own pair of ruby slippers are off display as they are coming to the end of a two-year restoration, sequin by sequin. The agents head for the lab and conservator Dawn Wallace begins her work. After careful examination, Dawn can confirm that not only are the pair in the possession of the FBI genuine, but they are the mismatched twins to the Smithsonian pair, presumably mixed up soon after the plain silk pumps were bought from the Innes Shoe Company of Pasadena and Hollywood, way back in 1938.

Whilst the FBI's ruby slippers technically belonged to insurers Markel, for now they remained as evidence in an unsolved case.

Terry Martin knew he was dying. He also knew that because he had pleaded guilty to stealing the ruby slippers, his wife, Manuela, his principal carer, was about to be deported. He felt something rare for a career criminal: guilt. Martin had confessed to the crime but he did not name his pal Jerry. Turns out, he didn't need to, as the FBI was on the case. Manuela, on fear of deportation, had 'sung like a canary' to both the FBI and the police. The case – as far as the FBI was concerned – was closed.

It's 18 May 2024 and we are back in Grand Rapids. The Judy Garland Museum has a special guest – Michael Shaw, who is visibly older and frailer than on his previous visit.

❧ THE ROBIN HOOD OF HOLLYWOOD ☙

When he accepted the $800,000 from the insurers, he knew he took it on the basis that he had the right to buy back the slippers when (if) they were recovered. He maintained that right. The slippers were his once more but he was yet to see them. As he's led into the front room of Garland's childhood home, he stops; he can see the slippers. He goes towards the plinth, stops once more and bursts into tears. 'They're in very good shape,' he blurts out. No sooner as he is formally handed the shoes, he announces that they are to be sold at Heritage Auctions in Dallas. The estimate is $3 million.

A Confusion of Slippers?

Let's recap. When Kent Warner found the iconic ruby slippers, he didn't just find one pair, but four or maybe five pairs, plus the so-called 'Arabian Test Pair'. Over the years, unofficial names have become established amongst the collecting fraternity:

- The pair sold in 1970 and now in the Smithsonian are known as the 'People's Pair'. They were bought by an anonymous 'Southern California millionaire' who later donated them to the Smithsonian Museum. It is often suggested, but unproven, that these were restored using sequins from a badly damaged pair which were later destroyed.
- The Roberta Bauman pair. Sold by Bauman in the 1980s they now belong to the American Academy

of Motion Pictures. These are known as the 'Bauman Pair'.

- Kent Warner kept two pairs. One was sold to Michael Shaw and the pair in best condition he kept. This pair likely made for close-ups which is why they are known as the 'Witch's Shoes'. These shoes are unique as they do not have the orange felt on the soles.
- The pair sold by Kent to Michael Shaw are known as the 'Travelling Pair' as they travelled to a number of exhibitions and were later stolen.
- The 'Arabian Test' slippers. Also found by Kent, sold to Debbie Reynolds after she didn't manage to buy the ones sold at the MGM sale.

It's 7 December 2024 and we are at Heritage Auctions, Dallas. About to go under the hammer is lot 182: Michael Shaw's ruby slippers. Online bidding has already reached $1.5 million. Within moments it's over the $3 million mark. The bids are rapid. The war chest gathered by the Judy Garland Museum didn't come close. The bidding reaches $7 million. At $22 million there are still six bidders on the telephone. '$24 million is the highest bid.' But the bids keep coming. The hammer drops at $28 million to bidder 7508.

It's a world record for an item of movie memorabilia. The previous record seems paltry at just $5.5 million for Marilyn's Monroe's iconic 'subway dress'.

THE ROBIN HOOD OF HOLLYWOOD

Both items came from Kent Warner.

Would he have liked the money?

Possibly.

He certainly would have enjoyed the drama.

CHAPTER EIGHT
THE WOMEN WHO WORKED ON THE MOON

It is January 1876 and we are on the Tapajós River in Brazil, a major tributary of the Amazon River. We are deep in the rain forest of Amazonia. An English couple is seeking out groves of a particular tree and collecting seeds. Seed pods, each containing three seeds, naturally dry on the tree before 'exploding', casting the seeds far and wide. The seeds are mottled and about the size of a quail's egg.

By May, they had collected and dried 70,000 of them. Each seed was worth almost £1 in today's money. Henry and Violet Whickham headed back down river towards Santarém, at the confluence of the Tapajós and the Amazon rivers, with their valuable cargo. With the help of the British Consul, the seeds were whisked through the strict Brazilian

THE STUFF OF HISTORY

customs as 'botanical specimens for Queen Victoria's personal garden'.

Setting sail aboard the SS *Amazona*, Henry and Violet Whickham were heading to London – not to Buckingham Palace, but to Her Majesty's Royal Botanic Gardens at Kew. The arrived on 14 June to an atmosphere of incredible excitement. Many others had tried to bring back seeds of this kind, but they had always arrived rancid and useless. However, the Whickhams' seeds appeared viable and were planted immediately.

By 7 July, 2,700 seeds had germinated, confirming that Henry and Violet Whickham had committed perhaps the greatest act of industrial espionage by successfully bringing viable rubber seeds out of Brazil and breaking the country's monopoly on this important material. No wonder Brazil considers them 'bio-pirates'.

The precious seedlings were planted up in miniature greenhouses, called Wardian cases, and placed on ships destined for the British colonies of Ceylon, Burma and Singapore. By the time the now Sir Henry Whickham died in 1928, over 80 million rubber trees were flourishing across the Empire, each one a direct descendant of those 2,700 seeds that germinated.

It is 22 October 1905 and we are in Odessa, Ukraine. A family is sheltering in their home. They can hear gunshots and bombs going off. People are being attacked and killed in broad daylight. They are terrified. Death stalks the

streets of Odessa once more. Hyman Spanel looks to his wife Hannah and to his son, Abram, four, and daughter, Fannie, aged five. Once things have settled, Hyman thinks to himself, they will – G-d willing – leave Odessa and settle elsewhere. Days later, the Spanels flee their home, where they no longer feel welcome or safe. They are one of the lucky families. Over 400 of their fellow Jews had already died in the violence that had taken over the city.

For the next six years they are settled in Paris. Hyman resumes his work as a tailor and Hannah takes in washing to make ends meet. By 1911, they have saved enough money and got permission to travel to America.

Odessa was a home, Paris was a haven, America was a dream.

The family established themselves in Rochester, New York. Abram was a bright and intelligent boy with natural curiosity and a brain that was too quick for school; by 1922, he had dropped out of Rochester University. Abram left to pursue a dream and his first invention: the Vacuumizer bag.

He had noticed that many households had a vacuum cleaner, often sold directly to housewives by door-to-door salesmen. The Vacuumizer bag utilised this appliance in the form of a moth-proof clothes bag that could be sealed by the use of a vacuum cleaner. Rather than sell to stores, Abram approached the vacuum manufacturer Electrolux, who added a free bag as an incentive to purchase their products. By 1927, Abram had made his first million.

◈ THE STUFF OF HISTORY ◈

His Vacuumizer Manufacturing Corporation sounded impressive, but was just three men who produced, marketed and sold the product.

Spanel had noticed that the price of rubber had come down during the 1920s, mainly due to lower demand after the war and the Brazilian monopoly being broken by the British. He became interested in the possibilities of latex, the liquid extracted from the rubber trees.

In 1932, Spanel established the International Latex Company. He began to manufacture shower caps, waterproof nappy wraps and a make-up cape, broadening the company's horizons. However, the range of products was limited as they had to be small. Latex may have had many positive properties – it was waterproof and flexible, for a start – but its structure also meant it was vulnerable to tearing. Small-scale products made sense; a torn nappy cover hardly embarrassed its wearer. Spanel knew if he could reformulate the way latex was made, the sky would be the limit.

Business was booming and in 1936, Abram moved his business to Dover, Delaware, where milder winters were better for the storage of latex. The following year he opened 'Playtex Park', his new facility which had air conditioning, showers for staff and even a hospital. The next few years saw new products and profits roll in, but dark clouds were gathering. With new and advanced facilities, work on improving latex led to the introduction of the first Playtex 'living' girdle in 1937.

❧ THE WOMEN WHO WORKED ON THE MOON ☙

When Japan invaded the Dutch East Indies and Malaysia, 90 per cent of America's rubber was cut off. Spanel began to build underground storage tanks and buy as much latex as he could store. When America entered the war in 1941, Spanel switched from making commercial products to military ones. His lightweight boats and floating stretchers saved thousands of lives.

The post-war period saw ILC diversify more than ever before and reach new heights. Its brand became a household name, not for rubber nappy covers, but what we know as 'shapewear' today. Spanel's latex girdles may have held a body in to make it look more svelte, but slimming came at a sweaty price.

As the twentieth century dawned, most women, and all respectable women, were still trussed up in corsetry, though nineteenth-century whalebones had given way to metal. Whilst some women had begun to ditch the corset and turn to what was termed 'rational dress' in the late 1900s, looser garments were still seen as just another fashion and a fringe one at that. The thing that finally freed females from being hemmed in by a corset was war.

Corsets needed metal and so did war. And when resources are tight, the national interest takes priority. War needed men, so as the men went to war, the women stepped in. But physical work could not be done in a tight corset, so they stopped wearing them. Women may have been free of the corset, but were now often tied to factories, where they also found flowing locks impractical.

❧ THE STUFF OF HISTORY ☙

Hello crop, goodbye corset.

When peace finally put war back in its cage, it must have taken the corsets too, as the 1920s said goodbye to the bosom and the hip and hello to the shift dress and freedom. The twenties was an era when women enjoyed less constrained bodies, but only if their body shape already followed fashion. For the more voluptuous, there was always a corset that would constrict in line with the times.

What is considered to be beautiful evolves continuously. Beauty is about control; nature isn't controlled so it has often not been seen as beautiful. For women – and, for that matter, men – to be considered beautiful, their bodies had to be controlled. To our forebears, beauty was nothing without man's intervention. Just as the most precious jewel is nothing when it is found in a mine. Beauty can be polished, beauty can be mounted in finery.

Modern corsets emerged in the sixteenth century in France under the influence of Catherine de Medici. In the seventeenth century, men and women wore corsets, but by the 1800s they were becoming a much more female and more restrictive garment. The tiny 'wasp waists' popularised in the late nineteenth century pushed women's bodies into new and dangerous shapes, restricted by steel and tight lacing. It's no wonder they frequently fainted and someone who was seen as too prim and too proper was called 'tight-laced'. Abram Spanel's latex corsets might seem to us a sweaty mess, but after being trussed in

steel and hemmed in by tight lacing, many women of the period saw them as liberating.

It is 12 February 1947 and we are in Paris at number 30 Avenue Montaigne. It's 10.30 in the morning. In the grand salon, full of flowers and grey silk hangings, ladies sit on golden chairs. There is an air of expectation in the room. Unbeknownst to the people present, even those behind the scenes, fashion history is about to be made.

Six models – known as mannequins at the time – will show ninety outfits from two collections, which were officially called 'Corolle' after the rings of petals that form a flower and 'En Huit' after the shape of the number eight. A number the designer considered lucky.

Each look that is shown receives rapturous applause. Afterwards, the editor-in-chief of *Harper's Bazaar*, Carmel Snow, is the first to congratulate the designer: 'It's quite a revolution, dear Christian! Your dresses have such a new look.'

Christian Dior has created the 'New Look' and fashion never looks back. Full skirts are back in, as are tiny waists. Not even the most restrictive latex corset will be enough to help women now.

Always one for innovation, Abram Spanel's International Latex Corporation knew their latex corsets needed a reboot and Dior's New Look gave them the impetus. 'Fabricon' was the answer, an innovative mix of cotton and latex that could restrict in the right places but

also allowed the skin to breathe. Shape was back, sweat was out.

It wasn't just the products that got a reboot, from 1947, ILC also had a 'new look' and rebranded itself as Playtex from 'play' and 'latex'. The work of ILC military division did not stop in the post-war period. During the Jet Age, they moved into flight suits for testing supersonic aircraft. It was this work that would take the once tiny producer of clothing bags and shower caps to new heights, that even its founder could not have dreamt of.

It's 4 October 1957 and across the globe amateur radio enthusiasts are tuning in to 20.005 or 40.002 megacycles on their sets. They know when they have the right setting as they can hear the message. All over the world, dials are turning to listen to a series of beeps. But these are no ordinary beeps as they are being transmitted from space.

Russia has just launched the world's first artificial satellite into orbit around the Earth, Sputnik One, a ball of aluminium that spread both fascination and panic across the world.

Some weeks later, on 27 November, two women noticed something in the sky above Aberdeen through a break in the clouds. It was flashing and streaking across the sky. Mrs S. Pyper, who was accompanied by her friend Miss Milne, told the local paper: 'Ann drew attention to it. What appeared to be a star came out of the north-west at a terrific

speed and flashed across to the sky, fast. It was too fast to be an aeroplane.'

Was it the Sputnik, the two women wondered?

Whilst the public considered the new marvel in the sky, older and perhaps wiser minds worried. If the Russians could launch that into space, what else could they launch? A radio and three batteries today – a bomb tomorrow?

Sputnik stopped the Jet Age and started the Space Age, but the Space Race was still some way off.

Whilst the world watched in wonder or in fear, the Russians saw the mass panic that Sputnik's launch had caused, particularly in America, and Russian premier Nikita Khrushchev seized the opportunity to show the supposed strength of the Soviet space programme and directed the attentions of the Russian space agency to prioritise the achievement of as many 'firsts' as possible. Russia was punching above its weight, but they knew they were ahead in the PR battle.

This proxy 'Space Race' really began in 1961 when the Soviets sent Yuri Gagarin into space and brought him back home. America could no longer observe, it had to act. The Space Race was on.

The following September, President Kennedy gave a speech at Rice University, Houston, Texas, that made history. To a packed stadium, he said:

We choose to go to the moon. We choose to go to the moon in this decade and do the other things not

THE STUFF OF HISTORY

because they are easy, but because they are hard, because that goal will serve to organize and measure the best of our energies and skills, because that challenge is one that we are willing to accept, one we are unwilling to postpone, and one which we intend to win, and the others, too.

It's 1949 and we are in Dutchess County, New York State. A man is driving to Princetown to visit a customer. As he turns off Route 206 and into the long drive leading to the property, he realises that this isn't just a house, it's a mansion. He wonders to himself, who is this Mr Spanel who needs his TV repaired?

Len rings the doorbell. He's surprised when it's not a maid who answers but an old man who is at least twice his age. When you are in your twenties, anyone more than twice your age is old.

'Would you be Mr Spanel, sir? I'm Leonard but call me Len, I'm here for the TV.'

The older man shows him through the house and to the room with the TV. Len gets straight to work whilst Mr Spanel watches. They chat and it's clear Mr Spanel is interested in both Len and his approach. Turns out, Len is a dropout from MIT. Spanel knows a fellow outsider when he sees one. Abram Spanel is in the process of setting up an industrial division. He offers Len a job.

Just over a decade later, Len Shepard is the lead scientist developing a spacesuit for NASA.

❧ THE WOMEN WHO WORKED ON THE MOON ☙

The oft-quoted but apocryphal story of how America spent millions developing a pen that would work in space whilst the Russians used a pencil neatly sums up the almost invisible problems of designing something on Earth to work in space. A graphite pencil would be a bad choice in space. We've all broken the point of a pencil, but in the zero gravity of space – the same reason a typical pen won't work – a tiny shard of graphite could be disastrous. A natural conductor, a tiny piece could cause a fire if it made a connection with a solid-state circuit. When President Kennedy challenged America to put a man on the moon, he challenged America not to just reinvent the wheel, but to reinvent a wheel that would work in space – a place of which we knew very little.

The challenge was a vast one. It wasn't just a case of designing the spaceship to get the astronauts there and back but everything else. To land a man on the moon was one thing but to be able to get that man out of the ship and enable him to walk on the moon itself was quite another. The moon's lack of atmosphere and vast range in temperature, plus the potential damage done by micrometeorites, was an almost impossible challenge.

To exit the landing module, each astronaut would need a safe, pressurised suit, which was practically a wearable spacecraft. Playtex, via their ILC division, felt they were uniquely placed to pitch to NASA to make the spacesuit.

It is 18 March 1965 and we are orbiting planet Earth. Russian cosmonaut Alexei Leonov is about to make history.

ॐ THE STUFF OF HISTORY ॐ

He is getting ready to leave the relative safety of his space capsule for the vacuum of space. He is about to make the first spacewalk.

Emerging from the chrysalis-like inflatable airlock, Alexei pauses. He is surrounded by stars and it is so silent that he can hear his own heartbeat. Looking down, he is momentarily overwhelmed at the immensity of Earth below him. He feels like he is a grain of sand.

But he notices something else too, something more concerning. In the vacuum of space his pressurised suit has ballooned up and become rigid. He can't move his legs or his body. The spacesuit had grown so much that his hands slip out of his gloves and his feet from his boots. He knows he is now unable to pull himself back to the craft using the tether and that in just five more minutes he'll be in the darkness of the Earth's shadow. In the back of his mind is the terrifying prospect that his suit is now too big to allow him to get back inside the airlock and into the capsule.

Without telling anyone or asking for advice, Alexei Leonov makes a decision. If he can somehow hold the valve on his suit and open it, he may be able to release some of the pressure. It's a high-risk strategy – too much and he'll not only lose vital oxygen but induce decompression sickness, known as 'the bends'. But he knows that if he does nothing he will die. Russia is racking up space firsts; he does not want to be the first death in space.

Remarkably, Alexei Leonov's plan worked. Little by little, he opened the valve and was able to coil the tether

❦ THE WOMEN WHO WORKED ON THE MOON ❧

around his arm, bringing him back to the space capsule. As he got closer, he could feel a pain he recognised in his legs: he was getting the bends. His temperature was rising so quickly that his helmet started to steam up. Leonov was blind and could only feel his way back via the tether. Somehow he managed to get back inside the tiny craft.

He had sweated 6kg of water which filled his suit right up to his knees.

Playtex, we have a problem.

It's spring 1969 and somewhere in Delaware a young woman is in bed. Her name is Jeanne Wilson and she is crying. She just turned 19, but this is not the reason for her tears. She's just started a new job, an important one, thanks to her older sister. Jeanne is the tenth of thirteen children and learned to sew at her mother's knee aged seven. Why is she crying? She's worried that she's messed up on her first day. She's worried that she's left a pin in the work she's completed. If she has, a man could die.

It's the next morning and Jeanne and her sister are having breakfast. Jeanne confesses to her sister that she's worried. Terrified of returning to work. 'Why?' exclaims her sister. She tells her she's worried about pins. 'Oh relax, girl. Why, didn't they tell you? Every night the work is taken to an X-ray machine to be tested, they ain't gonna take any chances.'

Jeanne's new job was with the International Latex Corporation, better known as Playtex, but she wasn't sewing bras, she was sewing spacesuits.

❧ THE STUFF OF HISTORY ☙

Problems were what ILC understood best and they knew that problems were not always solved the obvious way. The men from Playtex designed a suit that could not have been made without the skills of the women who sewed the bras and the girdles. By working closely with these women who understood how fabric moved, acted and reacted, they came up with a groundbreaking suit that was more an extension of its wearer. The two other firms in the offing – both tried and tested NASA suppliers – offered hard shell suits that offered little movement.

Perhaps it was their unorthodox approach that made NASA nervous, but ILC were runners up, forced to work with Hamilton Standard – originally manufacturers of aeroplane propellers – on any issues with fabrics. Forced marriages rarely work out and by 1965, Hamilton Standard, after a number of difficult years, filed for a divorce. They argued that Playtex was a consumer manufacturer ill-suited to working within the confines of the cutting-edge engineering the spacesuits required. How could a team led by a former TV repairman be trusted?

Playtex was out of the Space Race. For now.

But NASA wasn't happy. They terminated Hamilton Standard's contract as their suit wasn't good enough. NASA was going to have to hit the reset button.

Len Shepard was not a quitter. He and his team called themselves the 'Hard Knockers' because they'd graduated from the school of hard knocks rather than university. But at this point, he'd imagined his version of a spacesuit for

over ten years and he wasn't taking a no as any kind of answer. In one final throw of the dice, he practically begged NASA to reconsider and allow ILC to submit its own design. If NASA said yes, Shepard told them, the expenses would be borne by ICL.

In the best tradition of the Hollywood plotlines, NASA said yes – but only if they could deliver a working suit to be tested in six weeks. Shepard accepted the terms; Playtex was going for bust.

A team of twelve, armed with skill and dedication and two giant sewing machines called 'Big Moe' and 'Sweet Sue' worked around the clock. Even so, the suit developed by ILC was delivered two weeks late, but NASA still agreed to test it. It passed twelve of the twenty-two tests. Only then did the ILC team discover that the other two suits, manufactured by David Clark – who made suits for military pilots – and Hamilton Standard had failed.

Unlikely as it may seem, the suit designed under Len Shepard by the International Latex Corporation – makers of 'Cross Your Heart' bras and '18-hour' girdles – founded by Abram Spanel, a Jewish refugee from then Russian Odessa, was the suit that got a man to be able to walk on the moon. It was made from twenty-one layers of material, meticulously sewn together by women who had previously sewn bras, girdles and dresses. Women who knew that if their stitches deviated only slightly it would mean not only certain death for the astronaut wearing it but the death of the American Dream.

❦ THE STUFF OF HISTORY ❧

*

It's 20 July 1969. Five minutes past eight in the evening in the UK. Across the world, people are glued to the radio or television. Men are about to land on the moon. It's tense. Those who were around then remembered when President Kennedy – who has now been dead for nearly six years – announced to a shocked world that America would go to the moon and back. Many can't quite believe what they are about to witness. The minutes pass like hours, but at 20.17 the capsule lands safely.

'Houston, Tranquility Base here. The Eagle has landed.'

It is now 02.51 UK time. Those still up watching television can see a shadow on their screens. Astronaut Neil Armstrong is emerging from the lunar lander.

'One small step for man, one giant leap for mankind.'

A man is walking on the moon.

It's no wonder that, nineteen-year-old Jeanne Wilson, head seamstress at ILC, watching the moon landing on TV, leaps out of her seat screaming, 'I made that scene. I made that scene. I can't believe I made that scene.'

CHAPTER NINE
THE VASE IN THE CORNER

It is 10 October 1925. We are in Peking, the capital of China. It's still only 7am but the city is at a standstill. Traffic is jammed. Everyone is heading in one direction. It's hard to tell if they are fleeing from or heading towards something. There is a feeling of chaos.

Since the coup led by General Feng Yuxiang the previous year, an air of uncertainty hung about the former Imperial capital. Despite the day being declared 'Republic Day', people were anxious. And yet the movement of people in Peking wasn't due to a revolution or another coup: the vast, seething crowd was heading to the opening of a museum.

This may surprise some people but the residents of Venice rarely go to the Rialto Bridge or the Piazza San Marco,

THE STUFF OF HISTORY

especially during the day. They are simply too crowded. The only queue you'll find a Venetian in is that for the butcher or the fishmonger.

Piazza San Marco is the square of queues. The smallest queue is for Florians, which annoyingly can obstruct your passage through the arcade of the Procuratie Nuove, whose shade is most welcome in summer. That said, the queue is of little concern for the locals who go straight in and head to the bar at the back. Then there is the queue for the Campanile and the biggest and most frustrating queue for the Basilica. It can stretch right down the Piazzetta to the Molo on busy days. Those in the queue know that even when they do, finally, get inside the Basilica, that they will be joining just another queue that shuffles about and sees little. If they happen to get lost they may find themselves in the Treasury. Here, for a handful of euros, the shufflers can see things that will stop them in their tracks – for here, laid before them, are the riches of Byzantium. Gold, enamel, rock crystal and agate. Priceless and unique objects, each a pearl beyond price.

Yet, one of the 283 objects in the room would catch the eye of only the very learned or very curious. In one corner is a small white vase. Stained and a little misshapen, it stands a modest twelve centimetres high. Very few would be able to tell why this apparently modest item sits amongst such rare and valued peers because the vase has no label. And yet it is of incredible significance. For this vase is the very first piece of porcelain to ever be seen in the West. The vase

❧ THE VASE IN THE CORNER ❧

in the corner was brought back to Venice by none other than Marco Polo.

To us, porcelain is so familiar that we rarely think about it. To our modern eyes, porcelain is just a mug or a cereal bowl. Something that cost us pounds. But to our ancestors in the time of Marco Polo, porcelain was a magical material that no one quite understood but everyone wanted.

Polo spoke little of porcelain, despite coining the name we all use today. The white and glossy glaze, the thinness and purity must have reminded him of the cowrie shells he would have known from the beaches around Venice; they were known colloquially as *porcelini* – 'little pigs' – because the rounded shape reminded locals of a pig's back. It is from his *porcellana* that we take our word 'porcelain'.

> The river that flows by the port of Zaitun is large and rapid . . . At the place where it separates from the principal channel stands the city of Tin-gui. Of this place there is nothing further to be observed, than that cups or bowls and dishes of porcelain-ware are there manufactured.

Polo's 'port of Zaitun' is generally considered today to be Quanzhou, whilst 'Tin-gui' is Dehua City, famed for its white porcelain even to this day.

Of Tin-gui (Dehua), he wrote: 'Great quantities of the manufacture [of porcelain] are sold in the city, and for a Venetian groat you may purchase eight porcelain cups.'

❧ THE STUFF OF HISTORY ☙

This is all he wrote about this miraculous substance; perhaps he was influenced by the casual attitude of the Chinese who at this time saw it as nothing in particular?

Porcelain emerged in China sometime in the sixth century. Various types of porcelain were made: dense and smooth in the north, and glassy and sugary in the south. By the ninth century, cobalt was used to decorate the white porcelain, giving birth to blue and white porcelain, but this nascent substance was still very much domestic and quotidian in nature.

Several centuries after Marco Polo's visit, the Chinese developed kilns under Imperial control at the fabled city of Jingdezhen. It was these kilns that made blue and white ware for the newly established Ming Dynasty, pottery that was to beguile the world for centuries and make the word 'Ming' inseparable from porcelain.

Marco Polo missed out one vital detail about porcelain. It's not just the thinness, it's not just the purity, it's the translucence that makes porcelain magical. What went unnoticed (or unrecorded) by Polo had been observed and written down by a previous traveller to fabled Cathay, Sulaymān al-Tājir. Other than his account of his visit to the Far East, little is known about al-Tājir, but he saw what Marco Polo did not, and centuries before. Al-Tājir wrote: 'The Chinese have a fine clay of which they make drinking vessels as fine as glass; one can see the liquid contained in them.' This was in 851 AD.

One can see the liquid contained in them was the

❧ THE VASE IN THE CORNER ☙

game changer. It made porcelain different, unlike glass, porcelain veiled its secret; translucence is the final word in the spell.

It's New Year's Day 1587 and we are in Kent, at the Palace of Greenwich. It's a Sunday. Queen Elizabeth I is holding court, seated upon her throne under a cloth of honour. Behind her is a tapestry. The room is full as the traditional presentation of gifts to the sovereign is about to take place. It is the day when those jockeying for position attempt to impress the monarch with lavish gifts of money, gold or jewellery, but clothing and objects are just as likely to catch the eye. It's a minefield of potential mishaps deluxe.

Like all things courtly, there's a strict order to the ceremony. Ministers first, followed by each rank of nobility down to gentlewomen and gentlemen. Whilst gifts were not obligatory at this date, they were expected. There were no rules on what ought to be gifted but the higher the rank, the higher the expectation of the gift. It could be a golden goblet strewn with diamonds or it could be perfumed gloves or even a pie.

It wasn't a one-way street because in return for these gifts the monarch might bestow a favour or give a gift themselves. Of the forty-five gift-giving ceremonies attended by Queen Elizabeth I, around twenty-four 'gift rolls' remain. These long sheets of parchment record on one side gifts received and on the other gifts given out.

THE STUFF OF HISTORY

1587 seems to have been the year of rock crystal: 'Item, one cup with a cover of cristall, fashioned like a dragon, slytely garnished, with golde, and sett with several small rubyes. Geven by Sir Chrystopher Hatton, Lord Chancellor, 38 oz.'

Clearly word had got around that Her Majesty liked rock crystal and the next few gifts presented to the Queen were also 'cristall'. Lord Burghley, Lord High Treasurer and trusted confidant of the Queen, came forward. He bowed and knelt before the Queen, his staff aiding him, and presented his Sovereign Lady with not rock crystal, but, as the gift roll records: 'Item, one porrynger of white porselyn, garnished with golde, the cover of golde, with a lyon on the toppe therof.'

This wasn't the first time the Queen had seen porcelain; she already had seven pieces in her jewel house. Her father had only had three such treasures. Just like gifts of gold, the weight of porcelain items was recorded in the register of gifts. Lord Burghley's gift weighed 38oz. During this era, porcelain was not only rarer than gold, but worth its weight in gold. Literally.

The crowds had become a seething wall of humanity. Old, young, all curious, all heading in one direction, towards a museum. It wasn't just that on its opening day entry to the museum was free, it's because previously, visiting would have meant certain death. Today it became a museum, but it had been the home of the Imperial Family

of China, the Forbidden City, by name and by nature, as for over 500 years it had been forbidden to enter on pain of death unless you were a eunuch, member of the Imperial household or family. To the tens of thousands who packed the formerly forbidden courtyards and pavilions on that day, it wasn't about appreciation of the art contained within the palace, it was about being able to be there.

A small, but dedicated team of scholars and curators had spent the previous year on the mammoth task of cataloguing the riches that had formerly belonged to the Chinese ruling dynasties. The Qing Dynasty ended on 5 November 1924; His Imperial Highness, the Xuantong Emperor became Aisin-Giro Puyi, a private citizen of the Republic of China. He was given three hours to leave. It is remarkable that in under a year, Chinese officials of the new government were able to catalogue and record 1.7 million objects. It's also remarkable that, unlike Russia, following the 1917 revolution, no treasures were sold.

Whilst just a small portion of those treasures were on show when the Forbidden City reopened as the Palace Museum, the message was clear and twofold: Chinese culture belongs to the people and not the Imperial Family – who aren't coming back. Whilst China had an ancient and celebrated culture, the fruits of which – its finest jades, paintings, bronzes and porcelains – had never been seen outside the Imperial Family. On 10 October 1925, it went public. China's art now belonged to China.

And yet, just eight years later, the people's art would

leave the people's palace, which would be stripped of its treasures, some never to return. Rebels were gathering, Japan was on the warpath. The future of the imperial treasures was uncertain.

It's 31 January 1933 and we are once more in Peking. Again, people are moving en masse towards the former Forbidden City. This time, they are porters and their task is to transport hundreds of cases of treasures of Chinese culture to the railway station to the (hoped for) safety of Shanghai, but the plan does not go well.

It's freezing cold outside and the 600 porters strike, demanding an additional five yuan a day. Whilst the 3,000 crates are successfully moved into the courtyard, they will sit there for weeks as no one will supply trucks or carts for transportation. The rumour is the government is stripping the palace to auction its treasures overseas; others feel it is defeatist and giving in to the Japanese invaders.

It has taken the curators since 1931 to choose and pack the key objects, assisted in their mission by local antiques dealers, many of whom were former household officials; much of whose stock was stolen from the last Emperor. No wonder they knew how to pack and move fragile china.

In 1912, when the Emperor effectively lost his powers, he was allowed to remain emperor, but only within the Forbidden City. It was, in essence, a prison deluxe. A yearly sum of the equivalent to £5 million was granted to run the Qing court and keep the Emperor in the style he

◈ THE VASE IN THE CORNER ◈

was accustomed to. But this apparently huge sum wasn't enough and to make up the shortfall, objects were sold from time to time. Some were mortgaged against loans. This, along with the many thefts of objects that no one knew existed and that no one missed, led to a burgeoning antiques trade in Peking, mainly on Tian an men Street, right opposite the Forbidden City.

It's clear from his autobiography that even the last Emperor was unaware of the riches of his own family, and their value. On one occasion, the household department wanted to sell a gold pagoda 'as tall as a man' but only planned to sell it as scrap gold, with no consideration of its history or provenance. It was only sold for its true value after the Emperor's English tutor, Reginald Johnston, stepped in, causing a rift with the household staff. Were they planning to cream off profits or did they simply gauge items on weight alone, just like Elizabeth I's gift rolls?

The emperor also recalled how one day, out of curiosity, he asked the eunuchs to open a sealed warehouse. It was packed with chests of treasures from the personal collection of the Jiaqing Emperor and had been closed up since his death in 1820. The sixteen-year-old Emperor was the first person to see them in 102 years. Shocked by the treasure he found that day – treasures that even he, the Emperor, was unaware of, Pui Yi demanded that an inventory was made of everything he owned. To say the eunuchs and household staff pushed back is an understatement.

The first inventory of Imperial possessions was begun on

❦ THE STUFF OF HISTORY ❧

27 June 1923. That very day, a storeroom behind the Palace of Established Happiness erupted in flames. The entire contents, along with the beginnings of an inventory, were destroyed, reducing the buildings to ashes. The store had held the treasures of the Qing Dynasty. Officially, 2,665 gold Buddhas, 1,157 scrolls, 435 curios and thousands of books were lost, but this was an estimate. No one knows what was lost, because no one knew what was inside. It was probably the greatest loss of Chinese art in history.

Had the eunuchs and members of the household set fire to the storeroom? It was highly likely. In his autobiography, the Emperor recorded that when he asked the household department to clear the destroyed storeroom, they found no evidence of porcelain or scrolls or art objects in the ashes, suggesting they had been secretly removed before the fire. What they did find was a lot of melted gold, silver and pewter, so much so that a local bullion dealer bought it for $500,000. The emperor later learnt that the household department divided the ashes amongst themselves – ashes rich with precious metals. No wonder the five million a year grant was insufficient.

In response, the Emperor banished the eunuchs from the Forbidden City. It was a decisive act, but too late to change the course of history.

Whilst the new curators of the Forbidden City took the advice on packing from local antiques dealers – many of whom were eunuchs or former members of the Imperial Household – they also discovered something quite remark-

able: unopened boxes of porcelain fresh from the Imperial Kilns at Jingdezhen, untouched for centuries.

The Imperial Kilns were nowhere near Peking, but over eight hundred miles south. A perilous route for man or beast, let alone fragile china. They were sited at Jingdezhen for a reason; its proximity to Mount Gaoling (or Kaolin) the source of China's secret ingredient for the manufacture of porcelain; Kaolin or china clay. Whilst the route, by mountain, lake and river was known, the exact way in which the precious Imperial porcelain had been packed, was lost, until now.

When the treasures of the Forbidden City were threatened and needed to be evacuated for safety, the curators recalled the warehouse they had discovered with the unpacked cases of porcelain. They realised that if they copied the method of packing and treasures left the palace in the same way that they had arrived, then surely they'd be safe? Could this once lost knowledge from China's past, protect its treasures for China's future?

It's 5 February 1933 and a train is finally leaving Peking railway station. It contains 2,118 of the 3,000 cases packed by the curators and their colleagues. The train will snake its way all over China for another sixteen years as it protects the flowers of Chinese culture, some of the world's most important objects, from danger. Treasures that had been on public display for just a few years are once more hidden from view. Some will never be seen again.

THE STUFF OF HISTORY

Outside the Forbidden City, outside the new Republic, the world was waking up to China and its art. From within and without, opportunities were presented.

London's Royal Academy saw such an opportunity. In 1930, they had held one of the first 'blockbuster' exhibitions: *The Exhibition of Italian Art, 1200–1900*. Crowds had queued around the block. In 1935, *The International Exhibition of Chinese Art* was intended to be a repeat performance. The situation in China remained politically dire, with the Communists and Nationalists at tense loggerheads and the Japanese putting pressure on the north. This meant, for the curators of the Royal Academy, that there had never been a better opportunity to borrow items that would never normally be considered for loan.

Chiang Kai-shek's Nationalist government seized on this opportunity, which it saw as a massive flag-waving exercise for the new regime. To show the arts of China at Britain's Royal Academy would be to show the world that they were not 'minor' but as fine as any Western Old Master. The days of the emperor may be over, but the culture and art of China had been preserved. And might this show of warmth also help in their battle against the encroaching Japanese? Some international sympathy for the otherwise diplomatically isolated country would do no harm. And so the West got a display of never-before-seen Chinese art, and the East recognition of Chinese culture.

❧ THE VASE IN THE CORNER ☙

Curators from the Palace Museum, now relocated to a storage facility in Shanghai, were instructed to help a British committee choose the creme-de-la-creme of Chinese art to leave China for the very first time. This was fragile diplomacy with porcelain as ambassadors.

As with the objects' previous departure from the Forbidden City, the choosing of what was to be loaned was not simple. Word got about that, once more, items were being selected to be sold overseas. The British committee, led by Sir Percival David, the noted collector of Chinese art, knew what they wanted: the rarest and best pieces. But the Chinese curators often said no. They felt – strongly – that no unique pieces should depart for the West. Slowly, surely, 1,022 pieces were chosen and agreed upon. And before they left China, they'd be shown in Shanghai so that the Chinese people could see what was to be loaned abroad.

Thus, on 7 June 1935, HMS *Suffolk* cast off from Shanghai's docks with ninety-three steel cases marked 'Handle with Care' on board, containing bronzes, jades, porcelains and scroll paintings. These very best examples of Chinese art were leaving China for the first time. As the *Scotsman* reported when HMS *Suffolk* docked on 25 July:

> The British cruiser, Suffolk, doing duty as a treasure ship, docked at Portsmouth yesterday with a cargo worth millions of pounds consisting of Chinese art treasures lent by the Chinese Government for exhibition at Burlington House, London. They

THE STUFF OF HISTORY

consist mainly of priceless articles from the Chinese Imperial collection formerly in the Palace of Peking, including jades porcelains, textiles, paintings, books, fans, bronzes, and ancient thrones and epitomise thousands of years of Chinese history.

It's 26 July and we are in London, it's 1935 and we are in the great courtyard of Burlington House. Several vans marked 'Bishop and Sons' are parked up. They do not contain the usual house contents but the contents of palaces. One by one, the ninety-three specially constructed steel cases are removed. It will take until 19 September to unpack each item, carefully assessing it for any damage and taking photographs.

The political success of the exhibition can be gauged very simply: as soon as it was over, the Japanese government began to make discreet enquiries about holding a similar display of Japanese art in London. They found no support from the UK government but, tellingly, found a welcome elsewhere – in Berlin in 1939.

It's 1948 and post Imperial China is once more in chaos. The Japanese have been defeated but the Nationalist government of the Chinese Republic is in retreat. As the Communist People's Liberation Army sweeps its way across China, Chiang Kai-shek and his Republicans pack up what's left of their regime, the country's gold reserves and the art treasures of Imperial China and take them to

❧ THE VASE IN THE CORNER ❧

Taiwan. Thousands and thousands of cases of irreplaceable art were picked over. Only the best of the best was chosen.

Today there are two Palace Museums. One in Beijing and one in Taipei. Beijing may have a much bigger collection but it is in Taipei that you will find the most valued treasures. In elevating the silent witnesses to China's Imperial past, the new regimes made vases into building blocks of nationhood. To remove one is to remove part of the nation's very identity. This is why the newly minted billionaires of today's China are so fervent about returning art treasures back home. It is both a duty and a birthright because they (as they see it) belong to no one but China. The dizzying prices seen in the first decade of the twenty-first century were one consequence of this fervour.

It's late September 2010 and we are at the Trinity Hospice in Clapham, south London. An elderly man smiles as he recognises his visitor, who is carrying a carrier bag from Waitrose.

'Something for me, I hope,' the man says.

'Well, kind of,' replies his visitor who sits down.

The visitor knows his friend will want to see what is in the bag so he begins to open it. Pulling out something wrapped in bubble wrap, he unveils a large Chinese vase of rare beauty.

'I thought you might enjoy seeing this, my old friend,' he says as he hands over the vase.

Despite his frailty and the sixteen-inch-high vase's

THE STUFF OF HISTORY

weight, the old man in the bed sits bolt upright, balancing the vase on his leg. He caresses it, running his finger around the foot rim, examining every detail.

'Turn that light on,' he says to his friend, who switches on the bedside light. He pays particular attention to the square seal mark painted in blue on the base, reserved on a turquoise ground.

After a time, the man in the bed turns to his visitor and fixes him in his eye. 'I may be old and I may be at death's door, but, you know, this looks right to me.'

His visitor smiles, a mix of relief and happiness. 'It's going in our next sale, now that you think it's right too,' he says.

'Oh, when will that be, Luan?'

'November,' he replies.

'Well, hopefully I will be around then,' the man in the bed jokes.

But Gordon Lang, one of the UK's leading ceramics experts, did not live to see the vase sold. He died a few weeks later.

Peter Bainbridge went down the narrow stairs leading to his office above a sandwich shop, wondering if anyone had turned up for the pre-auction preview, especially after the expense of that full-page advert in the *Antiques Trades Gazette*. When he opened the door, he was greeted by a long queue. Faces he recognised, important faces. Eminent experts in Chinese art. People he'd seen on TV. Peter

THE VASE IN THE CORNER

gulped. Was the vase 'right' or 'wrong'? He was nervous but forced a smile. Those in the queue would be the judge of that. It was a make-or-break moment.

One by one, they shuffled up the two flights of narrow stairs. Most smiled when they saw it, agreeing that the vase was 'right'.

Peter Bainbridge had first encountered the vase in an industrial unit next to a tyre warehouse in Ruislip, north-west London. He was there with his friend Luan Grocholski, a freelance valuer, to look at the items from a general sale – Doulton ladies, plaster rabbits, tea sets and boxes of teaspoons, unopened and unused since they were once a wedding gift. The unwanted flotsam and jetsam of deceased estates around the locality. Nothing rare, no art, just the bric-a-brac of forgotten lives and evaporated memories.

A porter pulled out a large vase, placing it on a shelf marked 'Ceramics'. It caught Luan's eye. He went over to have a look. 'Imagine if this was real; we'd be looking at over a million pounds,' he said lightheartedly. The others in the room laughed.

Soon, Peter – the boss – said it was time for a break and they all headed off to the pub. But Luan couldn't stop thinking about that vase. Later, he went back to the warehouse/saleroom. Alone in the office, the vase on a desk, he began to wonder, *Could it be real?*

The vase was sixteen inches high and very unusual; the top half down the shoulder was yellow, Imperial yellow.

THE STUFF OF HISTORY

It was beautifully enamelled with lotus blossoms and scrolls. The centre section was pierced, which is very unusual. There were panels of fish in relief. The lower portion was the same yellow as the top. The base had a perfectly central seal of Qianlong in blue, reserved on a turquoise ground. The footrim was as smooth as silk.

The more he looked, the more his heart said it was 'right', but his head still said no. He called Peter Bainbridge to tell him that he was taking it home for further study and packed it into a Waitrose bag. All the way home his mind was racing. *Is it? Could it be?* If the vase was real then it was the discovery of a lifetime.

Luan had never felt more alone in his life. The life of a freelance valuer is a peripatetic roller-coaster. Without the safety net of an auction house behind you, you are being paid for your knowledge – knowledge that can make a vendor very rich if correct. Each opinion is a make-or-break moment – making a career (and fortune) or breaking your reputation. As he sat looking at the vase, he knew he was mesmerised. He had to focus. The more he looked and the more he delved, he kept asking himself, *Why can't it be real? Why if you were going to make a fake vase, would you choose to fake something so complex and so difficult to make?*

Often in these cases provenance helps, but here there was nothing. The vendors, a mother and son, knew nothing of the vase other than it had been in the family since at least 1960. They had no connection to China. They'd only

❧ THE VASE IN THE CORNER ☙

contacted Bainbridge's because they found a flyer in the house from the auctioneer.

A breakthrough of sorts came when Luan found not a pair, but a vase of similar form in the collection of the Palace Museum in Taipei, one of the pieces that never returned to Peking, now Beijing. In every respect it was the same vase, the same 'Yancai' colours, the same pattern of lotus and auspicious symbols, but on a red ground, not yellow. Also, the panels on this vase were landscapes, not fish. As Luan looked the Taipei vase over, zooming into the high-definition images on the other side of the world, he felt something – a kind of warmth. He didn't feel so alone in his opinion.

After showing the vase to his old mentor Gordon Lang in the hospital he told Peter Bainbridge the vase was 'right'.

The vase was pulled from the weekly sale and put into a general sale that would take place during Asian Art Week. It was lot 800, an auspicious number in Chinese culture.

Many of those attending the auction, which took place on Thursday 11 November 2010, three days after the preview, had flown in for the occasion and were puzzled by the location. This wasn't Mayfair or St James's. It certainly wasn't Christie's hallowed halls. This – Bainbridge's Auctions – was a tin shed near a nail bar. None of this mattered to the queue. They knew why they were there: to return a lost Chinese masterwork to China,

THE STUFF OF HISTORY

a masterwork they called 'The Fish Vase', estimated at £800,000 – £1,200,000.

The sale began at 11am; lot 800 didn't come up for sale until 6pm.

By then, the auction room and the mezzanine floor was packed. The rows of odd chairs – all lots in the sale – were full, many more were standing. Many attendees had been there all day. Peter Bainbridge was at the rostrum.

'Lot 800 now, the vase, let's welcome it. I think it's a very, very fine item,' he said, clapping. Some of the audience joined. A man in a grey suit stepped forward with the vase, placing it on an opened card table just to one side of the rostrum. Luan Grocholski was about to find out if his conviction that the vase is 'right' is to be borne out. Would it exceed his cautious estimate? Yes, he thinks, but by how much?

As Luan placed the vase on the table, much of the audience was dialling China on their mobiles. Peter's wife Janet was manning phones too, newly bought 'burner' phones, purchased to meet the demand.

'Where shall we start? £800,000?'

Janet nods: one of her phone buyers has said yes.

Quickly, the phone bidding shoots over £1 million. Luan felt happy and relieved.

Within minutes, it was over £14,000,000. Peter suggested the next bid of £15,000,000. Next we were at £20,000,000.

❧ THE VASE IN THE CORNER ☙

'Do I hear thirty?' asked Peter.

Yes, replied someone in the crowd.

£40,000,000 and applause went around the room. But the auction was not finished. £43,000,000 was bid.

Peter paused: 'We are at £43,000,000. I will invite further bids; is anyone now saving their bidding?' He looked around the room, like a bird of prey, but no word came back. 'Then I'm counting down, for the first time at £43,000,000 . . . for the final time . . . sold! SOLD!'

Peter Bainbridge smashed down his gavel with such force that a small piece broke off. The two main bidders were both sitting in the front row on a settee, right next to each other.

As soon as the hammer came down, Luan Grocholski took the vase to the office. It was a fairytale ending. A vindication of a hunch. But not all fairytales have happy endings.

The news of the sale shot around the world like wildfire. Every TV station on every channel and every nation. The newspapers too, all lapping up the tale of a vase from an ordinary home in an ordinary suburb making an extraordinary price. Not just a large price but a world record. The commission alone ran into millions. Peter Bainbridge took every opportunity to wallow in the success and notoriety the sale had brought him. But within a month, dark clouds were beginning to gather. Gossip was swirling.

There was talk the vase wasn't 'right' – and that the buyer hadn't paid.

❧ THE STUFF OF HISTORY ☙

The buyer – an anonymous Chinese billionaire – had not paid. He baulked, it was claimed, at paying the buyer's premium (20 per cent of the hammer price) and had expected a sliding scale, like at the major houses. Did he have buyer's remorse? Had he allowed his passion to take over? We will likely never know but the fact remained that two years later, the world record 'sale' was void and the story went cold.

Then, out of the blue, Bonham's quietly announced that they had sold 'that vase' privately and for an undisclosed amount. Whilst those news outlets who reported it mentioned £20–£25 million, that was based on pure speculation. Trade insiders claim it was more like £10 million. We will likely never know who bought it and for how much.

It's 3 October 2018 and we are at Sotheby's in Hong Kong. A Chinese vase of rare quality is about to be sold by auction. It stands sixteen inches high and has panels of fish in relief. It's the 'pair' to the vase that never sold. There are high expectations but as the sale begins, the internet goes down. They have one bid on the books and no one in the room is bidding. The vase is sold for a 'maiden bid'.

It went for £15 million including costs, which makes it seem like a bargain.

CHAPTER TEN
THE BARONESS AND THE BABIES

It is around 16 May 1894 and we are in Harrogate. A lady in her early thirties is sipping a cup of tea. She has an air of resignation about her. She looks tired and she is. She has travelled from London to try to find lodgings on behalf of someone, so they can take the famous waters of 'the Queen of Spas' on her doctor's suggestion. So far, everything she's seen will not suit and she's seen everything that her friend had approved.

Perhaps there is nothing left, she wonders, but to accept failure and return south and face the music. After finishing her tea, she ponders a moment, running through her mind the options. She decides to put off the decision and take a short walk to enjoy the late spring air. Turning the corner she sees a shop sign: 'Batley: agents for letting.' Maybe she

will find something after all and her visit will not have been in vain?

'Good afternoon,' she said in perfect, if German-accented, English. 'I am seeking rooms to let for three weeks for three ladies, and I must add I have been disappointed by everything I've seen so far.'

'Then you've come to the right place, miss – forgive me, or is it madam?'

'It's baroness actually, as you ask. Now, what rooms can you show me?' Gretchen realised how tired she was and hoped that she hadn't come over as rude.

'There's three that come to mind, one a new listing. I can get my boy to show you them now if that suits, Baroness?'

'Indeed it does, I hope to return to Windsor later.' She immediately regretted saying 'Windsor' as Mr Batley raised an eyebrow. Soon enough, Batley's office boy appeared and the unlikely duo set off on a lodging house hunt.

'This is the last of 'em, m'lady. Cathcart House, Mr and Mrs Allen.'

It was a plain but neat-looking house, stone built and bay windowed, on a corner next to a church and with an open view onto parkland. It looked promising but she did not want to build up any hope just yet.

The boy knocked on the door. 'Would you be Mr Allen, sir? I'm from Batley's about a let for this lady. Might we look at the rooms?'

'Good afternoon, Mr Allen. I am Baroness von Fabrice, I trust that we are not incommoding you?'

❧ THE BARONESS AND THE BABIES ☙

'Not at all, ma'am, but please forgive my wife not being here, she's a bed.'

'Nothing contagious?' enquired the Baroness.

'No, no, nothing catching.'

Batley's office boy had never run so fast in his life. Such was his pace that he had to stop outside Mr Batley's office to gather himself before going inside.

'Whatever is wrong, boy?' asked Mrs Kelly, the secretary.

'Thars nowt wrong, missus, but it's the empress!'

'Empress?' said Mrs Kelly. 'What empress?'

'You-Genie, I'm certain of it, coming to Cathcart House. That baroness works for her I reckon. Told me I was to tell you to advise Mr Allen of a three-week stay beginning the twenty-third. She'll be writing to confirm it.'

'Who? The empress at Cathcart House, Empress Eugine?'

'No, that baroness Mr Batley had me show round town. She'll be writing, but it's the empress staying I reckon. They had an empress at Cromer a while back, why not Harrogate?'

As she closed the door of her train carriage, Gretchen Fabrice allowed herself a sigh of relief. She had completed her task to find suitable lodgings in Harrogate and she was on her way back home to Windsor. She just needed to write a letter confirming the arrangements and all would be settled.

It's 20 May 1894, a Saturday, and the post has just arrived at the home of Mr and Mrs Christopher Allen of Cathcart

❧ THE STUFF OF HISTORY ☙

House in Harrogate, Yorkshire. The Allens are a well-known and respected family in the town. Mr Allen is a plumber, sanitary engineer and electrician. Mrs Allen is a housewife but also a landlady, who lets rooms at their home during the season. In the next few days she's expecting a three-week let. She is also heavily pregnant with twins.

Leafing through the mail, Mrs Allen spots one with a Windsor postmark. She sits, opens the letter and reads. It is about the let:

> Baroness Fabrice hopes that Mrs Allen has received her answer by Mrs Kelly that she wishes to take the rooms as agreed upon from next Tuesday the 22nd May: she begs Mrs Allen to buy the food for the first evening and for Wednesday and to have tea . . . would Mrs Allen be kind enough to order two cabs to meet the ladies at the station on their arrival from London, on Tuesday p.m. 6/30 as well as a porter to bring the luggage (about six boxes) to the house. Please put the best linen onto the bed on the first floor.

'Well, I never, Mr Allen, what sauce!'

Mr Allen looks up from his paper. 'What is it, Emma?'

'The guests. All is well, coming next Tuesday, but, listen to this last part from this Baroness Fabrice. "Please put the best linen onto the bed on the first floor." I've a mind to write back to this "Baroness Fabrice" and tell her that

❧ THE BARONESS AND THE BABIES ☙

Cathcart House only has "best linen" fit for a queen. Well! I best be off to see your friend the butcher; they want food ordering too!'

'She seemed quite nice when I met her. Let one of the children go.'

'No, if a thing's worth doing . . . Besides, if it's a Baroness making the arrangements, it's likely the guests are the quality too. Who knows, she wrote from Windsor, might even be the Queen herself!' she says, giggling.

Mr Allen returns to his paper.

Three elegant ladies descended from a first-class carriage into the hustle and bustle of the Harrogate railway station. The youngest lady in the party was strikingly beautiful and dressed in a way that marked her out not just for her youth and beauty, but her nobility. She was already attracting the looks of fellow passengers and instinctively pulled down the veil from her hat to cover her face.

'Now, ladies, before we get to the cab, just to remind you, I am just Baroness Starkenburg for the length of this stay. It is crucial that we are not discovered, not only for myself and for my intended, but for the sake of my dear grandmama too. It is imperative that you only address me thus.'

One of the ladies replied, 'It won't be easy, your Gr— I mean, Baroness. I've been in your service since I was sixteen; it's second nature.'

'I know, Gretchen, but we must persevere. I am here

under Dr Reid's orders and I hope to remain as incognito as we may for as long as we are able.'

As the ladies exited the station, they saw two hansom cabs waiting. The driver of one asked, 'Begging your pardon, missus, but are you the ladies for Cathcart House?'

They nodded and the youngest lady indicated to the older two that they ought to take the first cab. 'When we arrive, you knock on the door, whilst I wait,' she said quietly, turning back to them and unconsciously touching her veil.

The two cabs set off on the short ride to Cathcart House, the two older ladies gossiping, the younger smiling to herself, enjoying a brief moment of being alone and wondering what the next three weeks, and indeed, months would bring.

As they turned the corner from Station Parade onto Raglan Street, a sense of nervousness gripped the young lady in the second carriage. It would be the first time in her life she had been away without the company of a relative. Just loyal Gretchen Fabrice and her new tutor.

Just as she had planned, the other cab arrived first and her two companions were already at the front door, which was opening as her cab drew up. The driver leaped down and opened the doors. 'Cathcart House, m'lady,' he said, touching his forelock.

At this point, young 'Baroness Starkenberg' realised she had no money in her reticule. 'Gretchen!' she said, calling to the lady on the steps. 'Will you pay the driver?'

With both drivers paid, the horses clattered along the

❧ THE BARONESS AND THE BABIES ☙

cobbles and the young Baroness climbed the seven stone steps to the front door of her new, if temporary home.

'Good evening, ladies, I am Mrs Allen, your host. Baroness Fabrice told me to expect you and everything is in order.'

'I am Fabrice, this is Baroness Starkenburg and this is Fraulein Scheider.'

'This is your sitting room, and the dining room off, although some of my ladies prefer to take meals at the table in the window?'

'No! That is not our way, we are very private people. The dining room is preferred, thank you, Mrs Allen,' said Gretchen.

'Very well, I've a chicken just gone in and a nice cherry pudding to follow, the last of my own bottling. If you'll allow me, I shall show you the bedrooms; the luggage is already here with your man and lady's maid.'

The four women climbed the stairs and Mrs Allen opened the door to the bedroom above the sitting room. It too had a bay window.

'This is the first-floor bedroom, Baroness, the one you wrote about.' At this point, Mrs Allen had to stop herself mentioning the 'best linen' as she spoke to Fabrice. 'I take it to be your room?'

'Oh no, this is for Baroness Starkenburg.'

Mrs Allen was a little surprised as the best room was going to the youngest lady, something she thought strange but dismissed. 'Then you two ladies will be back here. I shall send up hot water.'

❧ THE STUFF OF HISTORY ☙

Closing the door to her bedroom behind her, Baroness Starkenberg smiled. It was just as Gretchen had described it. The room was neat and clean, and she felt it was going to be fine there, especially once she'd unpacked a few photographs and bought some flowers. She loved flowers.

By the time the ladies had washed and changed they could smell chicken roasting and made their way downstairs to the sitting room. The dining room table had been set and presently Mrs Allen arrived with a roast chicken on a platter which she placed at one end of the table.

'Shall I carve?'

'No, I shall carve myself,' declared Baroness Starkenberg. Gretchen and Trina Scheider smiled.

'Then,' said Mrs Allen, 'I shall leave you to it and return with the cherry pudding when it's ready.'

'And when, if I may be so bold as to ask the Baroness, did she learn to carve a chicken?' declared Trina, affecting a formal tone.

'It shall be my first time and I feel we shall all be doing many things for the first time during our stay in Harrogate.'

It's 22 May 1894, almost 11pm. We are at Cathcart House in the bedroom at the front and a young woman is writing to her betrothed.

My own darling Nicky,
 Here we are at Harrogate, it is getting on for eleven, but yet I must begin my letter to you. I left

✧ THE BARONESS AND THE BABIES ✧

C. Lodge at 10 . . . Got here at 6 1/2, had supper, I tried to carve the chicken but was not very successful and made the Ladies laugh. Our pudding stuck in our throats but all devoured cherries with delight. Then I arranged my photos and books in the nice, large sitting room we have. The Ladies are playing halma (I did too before) the game you so much like. I have got a nice bedroom. No, I think it will all be quite nice, it is neat, clean and large enough for us . . .

She can feel her eyes closing and she lays down her pen. She can complete the letter tomorrow.

The next morning, our ladies found the sideboard all laid with the breakfast things in covered dishes. Soon, Mrs Allen arrived with the tea. She looked tired.

'I trust everything is in order? I've booked the tricycle chair for 10am, Baroness, as you requested, and if that's all then I shall leave you to your breakfast.'

The ladies continued their breakfast, each keeping their own thoughts to themselves. Privately, Baroness Starkenburg's mind raced. How much her life was about to change, how much she needed to do and, yes, how long before the truth about her was exposed?

As the three ladies enjoyed their breakfast and their freedom, there was a knock at the front door, but they didn't hear it. Mrs Allen did and, presently, she knocked on the door of the dining room. The tired Mrs Allen had become

the ashen-faced Mrs Allen. There was a sense of nervousness about her too. A hesitancy and unusual timidity.

Baroness Starkenburg looked up and smiled.

'Might I have a quiet word, ma'am?'

'Of course, Mrs Allen. Perhaps in the drawing room?' The Baroness extended her hand towards the room.

'Won't you sit down, Mrs Allen? You look, if you'll forgive me, a little wan.'

'Thank you. I'm just a bit tired. Thing is – and begging your pardon me bringing this to your attention and all – but the most peculiar thing has just happened. A man came to the door from the papers and asked me who had arrived with the princess. I told him, "I've no princess here!" I hope I did the right thing, Baroness?'

At this point, Gretchen and Trina, who had been hovering by the double doors to the dining room, came in and looked towards, Baroness Starkenburg, who looked pale. She sighed. 'Of course you did the right thing and I thank you for it. Indeed, we all do. We came here for quiet and for my health – but, oh! Mrs Allen, can I put my trust in you?'

Mrs Allen looked a bit startled and blurted out, 'Why yes, of course. I am a soul of discretion.'

'Very well, then I – we – shall take you into our confidence. I am indeed Baroness Starkenberg but that is a minor title. In full, I am Her Grand Ducal Highness Princess Alix of Hesse and the Rhine. Baroness Fabrice is my lady-in-waiting and Fraulein Scheider is my tutor.

❧ THE BARONESS AND THE BABIES ☙

For, you see, I am engaged to the Tsarevich of Russia and one day – God willing – I shall be the Empress of Russia.'

Emma Allen almost fell faint but, gripping the chair arms, she began to raise herself.

'Please, Mrs Allen, please do not stand. We must try to maintain a sense of anonymity – if not for us, then for the sake of my grandmama.'

'Grandmama?' asked Mrs Allen.

'Yes,' said Gretchen Fabrice. 'Her Grand Ducal Highness's grandmama is Her Majesty the Queen.'

'Oh, you mean . . .' Mrs Allen looked towards the chimney breast and the framed prints of the Queen and the late Prince Albert. 'Then what are we to do? Oh, mercy!'

'We shall persevere, Mrs Allen, and I do hope you can help us.'

Later that morning, Princess Alix took up her pen once more to complete her letter, hoping to catch the noon post:

> I had my first sulphur bath this morning, it did not smell lovely, and made my silver bracelet which I never take off quite black, but that one can clean with the powder one uses for cleaning up one's silver things. Then I rested and began a book.
>
> In half an hour I am going to drive with Schneiderlein. An impudent reporter turned up here this morning to ask when and with whom I had arrived, so they have already found out who I am and it is stupid.

THE STUFF OF HISTORY

Fancy, the first thing I noticed when I came into the room was an old print of Granny's and one of Grandpapa. I think it's too nice. We bought some flowers and a pot of marguerites this morning and they make the room more cheery. There is a nice bow window which I am so fond of.

The royal party enjoyed a full twelve hours of seclusion and simplicity before the news broke in the papers. It's probable that the six trunks that were sent from Windsor Castle, likely with her name on, gave the game away. Gifts began to arrive at the house, all of which were refused. Letters came by the score and all over Harrogate, signs began to appear in the windows of shops: 'Patronised by Royalty'. Almost no one – in this pre-digital age – knew what Princess Alix looked like, so any shop or café that had been visited by three well-dressed women made the claim of royal favour.

The next day, crowds appeared outside Cathcart House, much to the frustration of the soon-to-be Tsarina, who had to leave by the back door to take her tricycle chair to the baths.

The daily letters that Alix of Hesse wrote to the heir to the Russian throne speak much more of their clear love for one another. Each letter is numbered so they may be read in order as they often arrived out of sequence. Sweetly, Alix referred to herself often as 'your old owl', whilst Nicky called himself 'your old cow'. In one letter, he enclosed

❦ THE BARONESS AND THE BABIES ❧

pressed cowslip flowers so that she 'may kiss the cow's lips'.

In Alix's letter dated 29 May, a full week after they had arrived, she reported the news to her fiancé of the birth of Mrs Allen's twins, which – according to the princess – had remarkably been born just before the party had arrived. Yet she had somehow been able to wait on her guests.

> You know, the day before we arrived here, twins arrived and so I asked them to be brought up to-day. They are 8 days old now, sweet tiny little things. The boy is a little bigger than the little girl, but she has thick dark hair. They are most sweet but very tiny. Writing on 8 June 1894, Princess Alix told the Tsaravich:
>
> The man of the house has got sweet little puppies born on the 6th. I intend being Godmother to his twins, as he is always most obliging. Victoria said I ought to propose their being called after you and me – the idea! Well, we shall see!

The stay was clearly going very well, despite the pressures no doubt put on their hosts by their new arrivals. Alix's letter reveals that it was in fact her sister Victoria who had the idea to call the Allen twins Nicky and Alix. It has always been assumed that it was Alix's idea, even though it was against her unassuming nature.

Princess Victoria had recently joined Alix at Cathcart House, accompanied by her four-year-old daughter

THE STUFF OF HISTORY

Princess Louise, who grew up to be the Queen of Sweden. Victoria clearly not only suggested the idea but got her way, because on 11 June 1894, Princess Alix wrote:

> I will remain here until the 20th . . . My writing today is again vile as I am writing in a great hurry to be ready for supper and then immediately Seibert [the princess's manservant] must take this to the post. Well, I am going to be Godmother of the twins and they are going to be called after us both. On Wednesday morning the Christening is to be, on purpose earlier than they had intended as then I can go to it in Church at 11 and nobody except the other relations and Godparents will be present and no one is to know it is, otherwise crowds w[ould] come. As it is, to-day there was an immense mass of people staring into the carriage when I came out from my bath (out of the house I hope you understand) as they have found out that I go there in the morning. Then this afternoon there were more than ever and they followed a good long time making Schneiderlein and me furious and Louise would ask me loudly why so many people were there and I tried to stop her in German.

To the deeply religious Alix of Hesse, the birth of the twins – a boy and a girl, the ideal dynastic birth – was seen as a good omen for her future marriage. Despite living at

❧ THE BARONESS AND THE BABIES ☙

Cathcart House for just under one month, she never forgot her time there, nor the twins who became her God children.

It's 21 May 1895 and we are in Harrogate. A large parcel has arrived at Cathcart House. It's from Russia and bears the stamp 'Correspondence Imperiale' beneath a double-headed eagle. It is the first birthday of Nicholas and Alix Allen, and inside the package are birthday gifts from their godmother, Her Imperial Highness Empress Alexandra Fedorovna, Tsarina of Russia. There is a letter too, not from the Tsarina, but her lady-in-waiting, Baroness Fabrice. She explains that the knitted petticoats, one pink and one blue, are the handiwork of the Tsarina and were the colours she first saw the twins wearing. There are also two flannel sleeping jackets and two polished oak boxes, each adorned with a silver plaque:

PRESENTED TO
Alix Beatrice Emma Allen
BY HER GODMOTHER
HER IMPERIAL MAJESTY THE CZARINA OF RUSSIA
21ST MAY 1895

An identical box is labelled:

PRESENTED TO
Nicholas Charles Bernard Hesse Allen
BY HIS GODMOTHER
HER IMPERIAL MAJESTY THE CZARINA OF RUSSIA
21ST MAY 1895

THE STUFF OF HISTORY

Each contained a set of silver gilt and cloisonne cutlery by Grachev Brothers, jewellers by appointment to the Imperial Household. The following year, whilst staying at Balmoral with her husband, the Tsarina sent matching silver gilt tumblers for the twins. For their confirmation in July 1910, she sent a diamond brooch of the Imperial eagles for Alix Allen and similar cufflinks for Nicholas. The last gift she sent was a gold orthodox cross made by Ivan Britzin for Nicholas Allen, who was then serving in France. The simple cross was sent to Mrs Allen with a personal letter from the Tsarina, who asked that she might have a photograph of Nicholas. Somehow, in the chaos of war, one mother – who happened to be an empress – was writing to another mother – who happened to be a plumber's wife.

Harrogate and the twins had clearly left an impression on the twenty-two-year-old Alix of Hesse and the Rhine. She wrote to her governess Miss Jackson during her stay at Balmoral in 1896, 'I hope my Harrogate and the beautiful Yorkshire air did you good!'

It is October 1895 and we are back at Cathcart House in Harrogate. The post has just arrived and there has been a letter from Russia. They're used to letters from the crowned heads of Europe, ever since the now Empress of Russia stayed with them the previous year and stood as godmother to their twins. But this letter is different. The envelope is pale blue; it is not stamped 'Correspondence Imperiale', but it does bear the crest of the Imperial Family.

❧ THE BARONESS AND THE BABIES ☙

Curious as to its contents, Emma and Charles Allen sit down to read it together. The letter is from 'C Fabergé Joaillier de la cour' and written in English.

Dear Sir,
His Majesty the Emperor has charged me to make a rich album containing views of all the places where Her Majesty lived in her youth.

Would you be kind enough to send me a photo of your house in which Princess Alice lived in 1894. And if you have none, would you kindly order a photograph to make a good view of the garden, house etc, it need not be large (4" or even smaller). I will pay with pleasure the expenses.

I hope, dear Sir, you will favour me with an answer and beg to believe me,

Yours very thankfully
C Fabergé

'Well, then, what d'you reckon of that then, Mrs Allen? Our house in a "rich album" for the Empress? This will have them queuing up to stay, I reckon?'

'What a thing to say, Mr Allen! We keep a quiet house here. Discreet. That's why they come.'

Soon enough the photograph, as requested, was winging its way to St Petersburg. A reply was received dated 20 November:

❧ THE STUFF OF HISTORY ☙

Dear Sir,
I am very thankful for your kindness and am very pleased with the photo, but excuse me I must have an other view too. Will you kindly order the Photographer to make a view from far and from the side – so that the church and more of the garden will be seen. As this view shall be painted, it must be more picturesque and not only architectural. What is the colour of the house and roof? Please let me know what I owe the Photographer and excuse me that I give you much trouble.
 Always ready to your service, believe me, dear Sir,
 Yours very truly
 C Fabergé

The 'rich album' referred to by Carl Fabergé was in fact a series of miniatures on ivory by Danish miniaturist Johannes Zehngraf that formed the central part of the so-called 'Rock Crystal egg', now in the Virginia Museum of Fine arts, being the gift of Lillian Thomas Pratt.

Each miniature was mounted in a gold frame and attached to a central column, entrapped inside a rock crystal egg on a gold and enamel stand. A Rolodex *de luxe* of the places the Tsarina lived when Princess Alix. Castles, palaces and a house in Harrogate that looks like the start of a terrace that was never completed. A modest house where she spent just under a month, but a month she clearly cherished.

❧ THE BARONESS AND THE BABIES ☙

A house good enough to feature on a Fabergé egg.

Perhaps what she discovered there in those few weeks is captured in this quote from the Grand Duchess Xenia, the sister of Alix's then soon-to-be husband, Tsar Nicholas II: 'The Russian Revolution took almost everything from me but the Bolsheviks left me with one privilege – to be a private person.'

Being a 'private person' for almost a month clearly left a deep impression on Princess Alix of Hesse and the Rhine, an impression worthy of memorial by Carl Fabergé.

It's 19 August 1911 and Cathcart House is once more graced by royalty. This time it's Princess Victoria, daughter of the late King Edward VII. On that particular afternoon, an extraordinary gathering occurred.

HER MAJESTY QUEEN ALEXANDRA.
His Majesty, King Manoel of Portugal.
Her Majesty Queen Amelia of Portugal
HM The Dowager Empress of Russia.
The Grand Duchess George of Russia.
HRH Princess Nina of Russia.
HRH Princess Xenia of Russia.
HRH Prince Christopher of Greece.
HRH Prince Obolensky of Russia.
Count de Souorel of Portugal.
The Marchioness of Ripon.
Colonel Streuthfield.

THE STUFF OF HISTORY

Baron Stoeckl
Baroness Stoeckl
Miss Stoeckl.
The Hon Charlotte Knollys.
Sir Reginald Lister.
The Hon Blanche Lascelles.
Countess Heiden.
Major Phillips.
Count Pavlos.
Lord Derby

If this unprecedented gathering of royalty wasn't surreal enough, in the midst of the tea and cake, that same afternoon, a basket was left on the steps of Cathcart House. It contained homegrown tomatoes and a bunch of garden flowers. Attached was a label:

> To Her Royal Highness Princess Victoria.
> Kindly accept these homegrown flowers and tomatoes. From one who admired your Father.
> 'The peace maker'

The Allen family sold Cathcart House in 1919. For almost one hundred years it slipped back into quiet obscurity. Until 2017, when someone walked into an auction with a Tesco carrier bag . . .

CHAPTER ELEVEN
THE EGG IN THE CARRIER BAG

It's 28 June 1952 and we are in Long Beach, California. The municipal auditorium is packed. A large catwalk has been erected; the audience is seated alongside it. Ten women in matching white and gold bathing costumes walk onto the stage, each with a sash bearing the name of a country.

It is the first 'Miss Universe' pageant and the 'most beautiful girl in the world' is about to be selected. Five are eliminated; one is chosen – eighteen-year-old Armi Kusela from Finland. Hollywood actress Piper Laurie enters the stage and a cape is placed over Armi's shoulders. Piper Laurie presents her with a sceptre before placing a glittering, if ungainly, crown on the young Armi's head.

The small crown has a ribbon on each side and Piper Laurie proceeds to tie these loose ribbons under Armi's

❦ THE STUFF OF HISTORY ❦

chin. No wonder the newsreels cut away to the audience whilst the awkward procedure takes place.

Declared and crowned, Armi walks cautiously along the catwalk, her crown glittering in the stage lights. It's clear that young Armi is terrified it might fall off.

The audience begins to mutter. 'They've broken the bank with all those rhinestones,' says someone. 'Are they diamonds? Just look at them glitter,' wonders another. 'Diamonds? No way! It's Miss Universe, not Miss Park Avenue!' her companion rejoins.

The awkward scale, the ribbon attachments and the apparent weight of the crown made it look more than improbable, almost tacky, but the truth is stranger than the fiction. Miss Universe is not wearing rhinestones; she's wearing over a thousand diamonds. A real crown, of not a queen, but an empress. Armi is wearing the Romanov nuptial crown loaned for the occasion by Cartier.

Armi's was the first head to bear that crown since the young Princess Alix of Hesse and the Rhine married her Tsar. A crown worn by every Romanov bride since 1848, a dazzling diamond treasure, now gracing the head of a beauty queen in California. No wonder it was tied on tightly with ribbons!

Prince Christopher of Greece and of Denmark, first cousin of Tsar Nicholas II, recalled a visit with Pierre Cartier, the famous Parisian jeweller, to his New York showrooms in his 1938 autobiography, *Memoirs of HRH Prince Christopher of Greece*.

❦ THE EGG IN THE CARRIER BAG ❧

Suddenly he (Pierre Cartier) said: 'I would like to show you something.' He took out a velvet case from his private safe, laid it upon the table and opened it. Within lay a diamond crown with six arches rising from the circlet and surmounted by a cross. 'Do you recognize it?' he asked me. I nodded wordlessly, seized by a sense of melancholy that rose from the depths of my memory. It was the crown of the Romanovs. My mother had worn it and her mother before her; it had adorned all the princesses of the imperial house on their wedding days. All at once, it seemed to me the room was filled with shades of long-dead brides.

Perhaps it was these 'shades of long-dead brides' that tainted the crown and perturbed buyers, perhaps Pierre Cartier thought someone might see it on Miss Universe's head and buy it? It had previously been seen in an advert for fur coats. Perhaps this strategy worked? In 1966 the crown appeared at auction once more, whilst she wasn't successful at the auction, the crown was bought by Marjorie Merriweather-Post, the noted jewellery collector and cereal heiress. It remains today as part of the collection at her Hillwood Estate.

From the head of an empress to that of a beauty queen is some journey. It involves great tragedy, death and a man named Norman Weiss.

❧ THE STUFF OF HISTORY ☙

It's Wednesday, 16 March 1927 when we are at the auction rooms of Messers Christie, Manson and Woods. We know them today as simply 'Christie's'. They are about to sell an unparalleled collection of jewellery, the jewels of old Russia.

> Catalogue of an important assemblage of magnificent jewellery mostly dating from the eighteenth century, which formed part of the Russian state jewels and which have been purchased by a syndicate in this country ... which will be sold by auction by Messrs. Christie, Manson & Woods ... at their great rooms ... on Wednesday, March 16, 1927

One of the highlights of this sale was lot 62, listed at 'THE NUPTIAL CROWN'. It was composed of double rows of fine brilliant-cut diamonds in borders of smaller stones and surmounted by a cross of six large brilliants, the whole on a setting of red velvet.

Prior to the 1917 Revolution, Imperial Russia was unlike any other country. For centuries, there was no middle class. Russian society consisted of the Imperial Family, the nobility and the serfs who served them, worked for them and did everything for them – for free. With its indentured workforce, natural resources, vast size and huge population, Russia was wealthy and its royal family was one of the wealthiest in the world. In today's terms, they were practically trillionaires.

It's 23 June 1918 and we are in Yekatarinberg, Russia.

❧ THE EGG IN THE CARRIER BAG ☙

There is great, if stifled excitement at Ipatiev House, where a family has been staying since April. When they moved in they found all the windows were sealed shut, but today, one will be opened. Fresh air will once more enter the house. Prior to this one small window, known as a fortochka – in the next door room, shared by the four daughters, was the only window in the house to open. It is a day of great joy for the family who have very little to celebrate. In just a few weeks time they'd all be dead. Murdered. Shot, bayoneted. Their bodies stripped naked, burnt with acid and broken by grenades. For this is no ordinary family, they are 'Former People', they are the Imperial Family of Russia.

It is just before midnight on 16 July 1918. The former Tsar of Russia and his wife, now simply Nicholas and Alexandra Romanov, are awakened by their doctor. He wakes the children next. They are told to dress and come downstairs and to wait in a semi-basement room. They are told they are about to be evacuated. This is a lie. The family were not to be evacuated, but executed.

Seven members of the Imperial Family, four servants, three dogs. The slaughter took over twenty minutes. When the smoke from the initial gunfire subsided, it was clear that some of the poor condemned souls still lived. Bayonets ended their lives. They even butchered the dogs. Once the red mist had faded, cooler heads checked the bodies and declared each one dead. Each body was stripped, the clothing of the Imperial Family was found to be lined with jewels, carefully sewn into linings, each one representing

both Russia's past and the family's hope for future. As the double doors were opened and the bodies carried out on stretchers, the Tsaravich's dog, Joy, an English Spaniel, was found to have somehow survived. Joy leapt up and ran off into the streets of Yekaterinberg.

Remarkably, Joy survived and was rescued by an English officer. Joy ended his days in Windsor, the very place his former master had hoped that he and his family were being evacuated to.

The full horror of what happened on that cruel night remained largely within Russia. Authorities soon admitted that the Tsar had been 'shot' and the family evacuated for safety, but it took until 1926 for the news that the entire family had been executed to be revealed. The lack of information on the family's whereabouts fuelled speculation, so when news began to emerge that the Romanovs' vast collections of art and jewels was for sale, it caused a sensation that begat a myth.

The Soviets had blood on their hands, a lot of blood, but they had another problem: the legacy. What to do with the vast wealth of the Romanovs?

The Bolsheviks nationalised their possessions and considered those of any noble family that had fled Russia to be theirs too. This was incalculable wealth in every sense. A fortune in art, antiques and especially jewels. A balance had to be struck between its monetary worth and its heritage, or perhaps its value as propaganda. The Bolsheviks knew, especially in the case of the Russian

❧ THE EGG IN THE CARRIER BAG ❧

crown jewels, that they were powerful symbols of old Russia, a Russia some sought to restore.

There was another issue facing the fledgling Soviet government: debt. Whilst they had claimed the wealth of Old Russia, they had also – as other nations saw it – inherited its debt too.

Writing in a US newspaper in 1917, gossip columnist the 'Marquise de Fontenoy' (French-born Marguerite Cunliffe-Owen) speculated:

> If the socialist and ultra radical element of the provisional government at Petrograd has its way some of the very finest jewels in the world will shortly be placed on the market, for its leaders are anxious to convert into cash and, above all, get rid of the magnificent crown jewels, so as to be able to convince people at home and abroad that there will be no restoration of the monarchy in Russia.

The 'Marquise de Fontenoy' wasn't the only journalist who'd got the scent of something going down in Russia. Speculation about the whereabouts of both the wider Romanov family and especially the hugely valuable jewels was rife. Had the family managed to hide the jewellery in the hope of rescue? Had they in fact survived? No one outside Russia quite knew and rumors spread. On 27 September 1917, the *Sheffield Daily Telegraph* ran the following story:

❧ THE STUFF OF HISTORY ☙

RUSSIAN CROWN JEWELS.

The *Daily Mail* reproduces from the Paris *Journal* a remarkable story concerning the disappearance of the Russian crown jewels, believed to be the most magnificent in Europe. The Provisional Government sent a commission to the Hermitage Museum, where the crown jewels were guarded in a special safe. The Imperial crown and other priceless objects were found in the place, but the precious stones had been replaced by coloured imitations. The ex-monarchs were questioned separately without result, but the inquiry showed that the missing gems had been packed in two ordinary trunks and sent under cover of a diplomatic courier to Darmstadt, the Grand Ducal residence of the ex-Czarina's brother.

Some papers reported that not only had the Tsarina sent jewels to her ancestral home in Germany before they were placed under house arrest, but she had replaced real stone with paste and even replaced famous paintings with copies. They gushed that when the revolutionaries had opened the vaults, all seemed to be well with everything in place, but only when they began to examine pieces individually did they realise that whilst the settings were real, the gems were fake. One paper even claimed that the crown jewels had been stolen from the London flat of Prince Yusopov, who married the Tsar's niece and had managed to escape Russia, by the Bolsheviks.

*

❧ THE EGG IN THE CARRIER BAG ☙

It's 1847 and we are at 15 Marino Crescent, Dublin. A woman is giving birth in a room upstairs. She is safely delivered of a baby, a boy, and he is christened Abraham Stoker. You may know him as Bram Stoker, the creator of *Dracula*. It is 75 years later and 15 Marino Crescent is now the home of Harry Boland, member of the fledgling Irish government. His sister Kathleen is in the kitchen. She is on her knees in front of an old and unused range and is hiding something in the ash pit. She is hiding part of the missing Russian Crown Jewels.

Three years earlier, the radical Irish Republican party Sinn Fein won 73 out of 105 seats in the general election. The newly elected MPs refused to take up their seats in Westminster, instead – as per their manifesto – establishing a separate Irish parliament, the Dail Eireann. Russia was the first country to recognise this fledgling – and currently illegal – government.

Whether recognised or not, as the Russians themselves knew only too well, a new nation needs cash and quickly, so a national loan scheme was opened, bringing in around £13 million in today's terms. But the most financial support came from America. Éamon de Valera and Harry Boland travelled there in May 1919 in an attempt to gain recognition for the Irish State. Whilst this part of the mission failed, money flowed into the coffers of the new and self-styled 'republic'. Also in America at that time, and on a similar mission, was Ludwig Karlovich Martens, the de facto Russian Ambassador.

❧ THE STUFF OF HISTORY ☙

The newly declared and unrecognised Irish republic was now awash with money and Martens knew this. He approached the Irish delegation in New York, seeking a loan of $20,000 (around $250,000 today) and he offered them a box of jewels as collateral. The box contained a diamond pendant with a sixteen carat central stone and three sapphire and ruby brooches. They were said to have been from the collection of the Imperial Family. The loan was agreed and Boland returned by ship to Cork on 27 December 1921.

Harry Boland attempted to hand the jewels to Finance Minister Michael Collins but he was having none of it. In fact, he is said to have thrown them back across the table: 'Take them! I don't want to touch them, there's blood on them!'

Boland is said to have stormed out of the room and entrusted the box of Imperial jewels to his mother. Just a few months later, Harry Boland was shot and died of his wounds. On his deathbed, he told his family not to give up the jewels until Éamon de Valera was in power. The family hid the priceless artifacts in a pair of Harry's old riding boots, finally handing them over in 1938, the year after de Valera became taoiseach. On 13 September 1949, the four pieces of Imperial jewellery were returned to the Soviets, who were prepared to repay the original $20,000 loan. De Valera was glad to be rid of them.

*

❧ THE EGG IN THE CARRIER BAG ☙

It's Valentine's Day 1923. It's just before dawn and we are in the National Cemetery, Brooklyn, New York. Armed guards of the Eighteenth Infantry surround a grave, whilst two grave diggers are removing the soil. It's bitterly cold and wet. The men suddenly stop. They have hit the coffin of US Seaman James Jones, a naval mess man, which is removed from its grave. The coffin is opened and men search frantically for the lost Romanov crown jewels. But to no avail. The coffin is empty, save for the corpse of a humble seaman. Such was the press interest in the 'missing' jewels that the rumour swirling that Jones was smuggling diamonds for Russia, that he'd died mysteriously and was interred in a metal coffin, led to his body being disinterred. None of this was true.

In truth, the crown jewels were not 'missing' nor had they been stolen. During the First World War the Imperial Family sent them from the Hermitage in St Petersburg to the Armoury in Moscow and thus further away from the advancing Germans.

The crown jewels were not 'missing' they were just misplaced and it took the Soviets a while to work it out.

So why all the speculation? The press loves a good mystery, but it's likely it was darker than that and most of the stories were likely to have been cleverly planted by Soviet agents to keep the press talking about where the Romanov jewellery was, to distract from the fact that the Soviets had quietly dispatched, some say martyred, the Romanov dynasty. Something they still hadn't admitted.

❧ THE STUFF OF HISTORY ☙

It suited the Soviet narrative.

While the West was falling for a diamond-encrusted bait and switch, in the East, the Russian overlords were quietly cataloguing the Romanov treasure and wondering exactly what to do with their riches. One might imagine that when billions worth of diamonds and other precious things fall into one's lap that the answer is simple – sell – but the Soviets woke up after a post-Revolution fervour to find a more complicated world.

For one, the members of the Romanov dynasty who had managed to escape Russia, along with other aristocrats, had fled with diamonds, pearls, gold boxes and other portable valuables, which they exchanged for cash. The world was already flush with Russian diamonds; selling off more might cause a crash in the value.

The other problem was that their booty was tainted. These jewels were the first 'blood diamonds', their ownership still in question by many nations. In typical Soviet style, they raised a false flag: a lavish and much illustrated 'catalogue' to tempt foreign buyers. It quietly advertised what was – potentially – available, but also could gauge the political and commercial reaction.

It would have been the sale not of the century but of centuries. Had it gone ahead. Referred to by scholars as 'the Fersman Catalogue' after the gemologist behind it, the catalogue conveniently came in Russian, French, English and German. It claimed it was created to:

THE EGG IN THE CARRIER BAG

A. To repudiate the rumours abroad that the crown jewels have been sold or broken up,
B. To make a contribution to the Science and History of Mineralogy,
C. To leave for future generations of Russians an accurate and authentic description of the gems which the government expects soon to convert into cash, and
D. To acquaint intending foreign purchasers with the details of the collection, which is described as the greatest aggregation of regal jewels in all history.

It is 18 December 1925, a month before the publication of the Fersman Catalogue, and we are in Moscow. There is a large queue, but it is not a queue for bread. Ordinary Russians are queuing to see – for the first time – the Russian crown jewels. Prior to the potential dispersal, the Bolsheviks are showing the Russian people (and the world) that the jewels are not 'missing' as many have speculated, but intact, catalogued, photographed. And for a fee of two roubles or just fifty kopeks for trade union members, Russians may view them. Russian workers queue to gawp; reporters and cameramen for the newsreels arrive.

The Fersman Catalogue was dispatched to potential buyers to gauge a response. The vultures, sensing – hoping for – a fire sale, began to circle. They were disappointed. Potential buyers met with commissars still reluctant to

part with the jewels and looking for high prices. One American syndicate was told that the prices began at one million dollars.

One man was more successful. His name was Norman Weiss. He was the face of a syndicate of Anglo-American buyers who somehow, against the competition of other interested parties, managed to purchase a parcel of jewels, most of which were unconnected to the recent members of the Imperial Family, save for one item: the Romanov Nuptial Crown.

Weiss returned to London with his booty and to Messrs Christie et al who sold the lot as: 'Magnificent Jewellery Which Formed Part of The Russian State Jewels'. On Wednesday 16 March 1927, lot 62, the Nuptial Crown, was sold for £6,100.

It is 25 January 1933 and we are in New York City, at Lord & Taylor department store. A lady is shopping; she's a regular and well known to many of the sales clerks. Not looking for anything in particular, she wanders over to the Georgian Room and sees a new department, what we'd call a 'pop-up' today: 'The Hammer Collection of Russian Imperial Art Treasures from the Winter Palace, Tsarskoye Selo, and Other Royal Palaces'. She has no idea what this is but she's intrigued. For a moment she thinks she's stumbled into some kind of rummage sale. Perhaps it's for a charity? As she surveys the room, she sees porcelain, clothing and jewellery. There's a pile of coin purses made

❧ THE EGG IN THE CARRIER BAG ☙

from silk brocade. She picks one up. Inside the flap there's a label: 'Made of Imperial Russian Brocade/from the Hammer Collection.'

A sales clerk comes over, hoping for a sale. 'Isn't it pretty?' she says. 'Plus it comes certificated.'

'Certificated?'

'Yes, everything Dr Hammer sells has a certificate,' she confirms, handing over a piece of paper. The paper is a buff colour, dappled; it looks like parchment but it isn't:

> Coin purse made of yellow silk damask woven in conventional design outlined in red. Russian Circa 1870. From a collection of brocades which were formerly used in the Imperial Chapels of the Romanoffs. They were brought from the various palaces about St. Petersburg to the Winter Palace. Here soldiers of the present government sorted them for burning so that the precious gold and silver used in weaving many of them could be reclaimed. Fortunately, Dr. Armand Hammer heard of the plan and succeeded in saving a large number of the vestments by purchasing them. These glorious fabrics, brilliant with metals that will never tarnish, combine the skills and artistry of the West with the originality and color of the Far East.

'Goodness,' replies the woman, looking once more at the little coin purse, which she quickly puts back down.

❧ THE STUFF OF HISTORY ❦

She looks again around the room, which, despite its elegance, still looks like a very grand estate sale. There are plates, monogrammed towels and handkerchiefs. She picked up a china egg. The handwritten label, replete with eagle crest reads: 'No.4122C Small porcelain Easter egg decorated in gold with crown and monogram of Czarevitch Alexis, Drawn through with red ribbon. Made in the Russian Imperial Porcelain Factory. PRICE $12.50.'

Then her eye catches something. It's a small mother-of-pearl and vermeil fork, which for some reason, unknown to her, she decides to buy.

That evening, back at home, she was toying with her fork and beginning to realise not just what she'd just bought but what she'd witnessed that day. She was holding in her hand a fork that would have been held by one of the Russian emperors. It was such a romantic notion, she thought. She would return to Lord & Taylor. She knew she would be buying more.

The very next day, she went back to the department store. She had decided to form a collection, a kind of tribute and yes, perhaps a memorial too. She saw this as her chance to form a sort of connection with them.

The sales clerk from the previous day recognised her. 'Good morning! I see you've come back,' she said brightly, smelling a commission. 'We've lots more cutlery if that's what you're looking for?'

The clerk registered the lack of interest on the woman's face. 'If I may, might I show you something rather special?'

❦ THE EGG IN THE CARRIER BAG ❧

she asked. She led the lady over to another display and an empty table. She put a small gold stand on the table, on which she placed a blue and gold egg. The lady couldn't help but notice a huge diamond on the bottom of the egg.

'Take a seat, you'll want a good look.'

Intrigued, the woman sat down. 'That's the most remarkable thing I've seen. What is it?' she asked.

'Can you believe it's an Easter egg? A gift to the Tsarina on Easter day.' She opened up the egg, reached inside and pulled out a kind of elaborate picture frame made of diamonds and formed as a double-headed eagle. 'Look at this – 2,000 diamonds and a portrait of the Russian heir, and not a photograph either.' She turned it around, revealing the portrait of Tsarevich Alexi, doubled-sided and set between rock crystal cabochons, giving a three-dimensional quality.

'Take it,' said the clerk, 'it won't break.'

The lady began to instinctively remove her gloves, then stopped, thinking that maybe touching such a thing was better with gloves? Looking at it she felt a shiver, remembering the day she read about how the Bolsheviks had murdered the Russian Royal Family and realising that she was – at that moment – touching something that the last Tsarina had touched too. She felt a connection. What she held in her hand wasn't just 2,000 diamonds. It wasn't just a portrait of the heir to the throne of Russia – an heir who never lived to sit on the throne, an heir murdered at just 13. It wasn't just a token of deep love and affection, it was practically a relic. She was mesmerised.

THE STUFF OF HISTORY

The clerk sensed a sale and sent for the big guns: the man who had organised the event, Dr Armand Hammer.

'Good morning, I am Dr Armand Hammer.'

'Good morning,' said the lady. 'I am Mrs John Lee Pratt.'

'I'm told you're interested in the Fabergé egg?'

'Well, I wouldn't go so far as to say that. It's just wonderful. Dare I ask the price?'

'It's on the back of the card. I shan't say it out loud, for the sake of discretion.'

Mrs Pratt smiled at this consideration and picked up the card, pausing to read the description before she turned it over. As she did, her smile evaporated – the egg was $55,000. She couldn't help but gulp. No wonder – that's practically one million pounds in today's money.

Dr Hammer sensed the situation. It was awkward. He didn't want to suggest that the egg was beyond Mrs Pratt's reach, nor did he want to lose a potentially huge sale. He knew who she was – or, at least, who she was married to: a director at General Motors. He was a consummate salesman and he sensed that this customer wasn't just rich but that she was drawn to the collection too. He was right.

'You see, Mrs Pratt, if you'll allow me to explain, the Fabergé Imperial eggs aren't just gold and jewels, it's much deeper than that.'

'Go on,' says Mrs Pratt.

'The last Tsar's father began the tradition, Easter gifts for his wife. His son continued it, one for his wife and one for his mother. Each year Carl Faberge the court jeweller

would come up with a new and novel idea. So they not only represented the most holy day in Russia, but they also represented something else.'

Before he could complete the sentence, Lillian Pratt said, 'Love.'

'Yes, love, Mrs Pratt, love, family, Russia, history all in 18 carat gold and diamonds. Hard to put a value on that really?'

'Yet you've managed, Dr Hammer? Fifty-five thousand dollars. Some price!'

'Well, these things are not exactly easy to come by, Mrs Pratt. I've a business in Moscow and I'm what you might call well connected.'

Lillian Pratt was enthralled, some might say beguiled. That day, Lillian Pratt bought over thirty items, including the egg. It was the beginning of a magnificent obsession.

It's 22 November 1937 and we are at the Hammer Galleries in New York. No longer an in-store pop-up, but a standalone gallery on Park Avenue. One of their most important customers, Lillian Thomas Pratt, has just arrived to preview the exhibition: 'Fabergé – His Works'. Mrs Pratt has loaned a number of important pieces, including some of the eleven eggs on display. Alongside the items on loan, Armand Hammer has a number of items for sale, including four Imperial Easter eggs.

Armand Hammer greets Lillian Pratt warmly but there is also a sense of anticipation, if not the rubbing together of hands. Not yet at least. He invites Mrs Pratt to sit. He

THE STUFF OF HISTORY

leaves her momentarily and then returns with a large ivory velvet egg. It must be a good twelve inches high.

'Now, I know you're not buying eggs at the moment—'

Mrs Pratt interrupts: 'I'm busy paying for one right now, Dr Hammer!'

It's true; since the previous year, she'd been buying Fabergé's Imperial Pelican Egg by paying off small amounts that she'd continue to pay until 1938. Even millionaires' wives have been affected by the Great Depression.

The egg Hammer is about to show her is special and Lillian Pratt is probably the only person able to buy it. He places the egg down in front of her and unhinges the catches – one either side and one at the top. 'Just look at this, Mrs Pratt. Just look at it,' he says, opening the twin halves of the velvet egg with an artistic flourish and the genuine glee of a child.

Inside this velvet-and-satin-lined-egg is a smaller one, on a gold and enamel stand. It's not like any of the Fabergé eggs she's seen before. The egg itself looks like glass, or perhaps rock crystal, and inside its 'shell' is a carousel of small miniatures of palaces and castles. The top of the egg has a large green stone finial.

Dr Hammer is silent. He's waiting for a reaction. He can see his potential client is fascinated. Rather than say anything, Hammer proceeds to demonstrate the 'surprise' of the egg. Turning the green stone – a massive emerald – he moves a gold hook that, in turn, moves each small painting. Mrs Pratt remains silent, beguiled.

THE EGG IN THE CARRIER BAG

Suddenly, she says, 'Wait! Stop!'

Hammer wonders what it is, but he stops.

'This one, this one here; look. This isn't a palace, it's not a castle. It's just a little house and church.'

'Well spotted, Mrs Pratt. That is the Palace Church at Coburg. It was Queen Mary in England who identified each one, that's how we know. Each of the buildings, large and small, played a role in the late Tsarina's life before she married the Tsar.'

'So it was the royal church and the house next door was for the priest?'

'Well, I guess so. Queen Mary didn't say.'

'Oh, come now, Dr Hammer. Next you'll be telling me you'll ask her.' In the four years since she'd first met Dr Armand Hammer, Lilian Pratt had got the mark of him.

'Well, you know I want it, but how much do I want it *and* how much is it? And remember, I'm still paying you for the last one.'

Hammer doesn't say anything, taking the gentle jibe. 'I'm afraid it's $55,000, Mrs Pratt.'

Lillian Pratt didn't buy this egg, known as the 'Egg with revolving miniatures'. At least, she didn't buy it on that day. She did buy another Imperial Fabergé egg, the 'Red Cross egg with portraits'. But the rock crystal egg she saw that day stayed in her memory. In 1945, it became the last egg she bought, likely at a discount. Lillian Thomas Pratt died on 21 July 1947 and left her collection of Russian Imperial objects, including five Fabergé eggs, to

the Virginia Museum of Fine Art. It's a testament to the changing opinion of Fabergé's work, that – whilst the objects have their own gallery today – for many years they were only brought out occasionally, especially at Easter.

What transformed these eggs from private objects of love and devotion, to objects you could buy in a depart-ment store, to the mythic objects they are today? How did the very name 'Fabergé' become such a legend when by the 1970s 'Fabergé' was a brand of supermarket cologne? Appearing in a James Bond movie helped, but it was one man – Malcolm Forbes – who made Fabergé and his eggs famous.

Forbes, born in 1919, was a publisher and a politician. He was also a millionaire when that meant something. From the mid 1960s onwards he became fascinated with the work of Carl Fabergé, especially pieces made for Russia's Imperial Family. He was collecting in a great period, as many of the original Fabergé collectors were dying – or divorcing – and Forbes cashed in. Big time. By the 1980s he owned ten Fabergé eggs, as many as the Kremlin. Here is one of the things that drove him. It wasn't just that they were beautiful, it wasn't just that they were historic and rare, what Malcom Forbes really loved about these eggs is that each time he bought one it was a triumph of Capitalism over Communism. The 'race' initiated by Forbes to own more eggs than Russia captured the imagination of the decade of excess – the 1980s – and made the name Fabergé into a byword for luxury and rarity.

*

❧ THE EGG IN THE CARRIER BAG ☙

It's 11 June 1985 and we are at Sotheby's in New York. Lot 478 is about to be sold. It's an Imperial Fabergé egg. If Forbes can buy this lot, he will have one more egg than the Russians. It's a battle he's determined not to lose. The hammer falls at $1,760,000 (plus 8 per cent tax). Forbes is successful. Finally he was ahead of the Kremlin. People sitting close to Forbes say he muttered under his breath, 'Forbes 11, Kremlin 10.'

When he died in 1990 his collection of Fabergé works of art, including – by now – twelve eggs, was sold privately – to a Russian.

It's January 2017 and we are at Bulstrodes auction house in Christchurch, Dorset. It's the day of the week when members of the public can bring in items to have them valued for free. So far, auctioneer Kate Howe hasn't seen anything to set the world on fire. It's the nature of these events, of course – one hopes for plums, but it's more often prunes that come over the threshold.

Kate is cold so she goes off to make herself a cup of tea. Returning to the valuations table she finds a woman waiting for her holding a Tesco carrier bag. By the shape of the contents, she's imagining a postcard album. The woman reaches inside the bag and does indeed produce an album, but there are no postcards inside. She pushes it over to Kate, who opens it. She is first puzzled but then quickly mesmerised by its contents. The woman says nothing. Kate's tea goes cold.

❧ THE STUFF OF HISTORY ❧

Newspaper cuttings, letters and photographs have been glued into the old album, telling the tale of a bed and breakfast in Harrogate run by a family called Allen. Turning the pages, Kate suddenly stops at pale blue letter. It is from Carl Fabergé.

The letter asks for a photograph of Mr Allen's house, but it is who is asking Fabergé to ask Mr Allen that intrigues Kate. 'His Majesty the Emperor has charged me to make a rich album containing views of all the places Her Majesty lived in her youth . . .'

'There's another one in there too and then there's this,' says the woman, breaking her silence. She reaches into the Tesco bag once more and brings out an oak box with a silver plaque. 'This is Fabergé too,' she says.

Opening the box, Kate is delighted to see a cutlery set comprising a knife, fork and spoon, a napkin ring and a salt cellar and salt spoon, all enamel on silver gilt. 'This is Fabergé?' she says to the woman.

'Yes, look at the plaque.'

Closing the box again, Kate sees a silver plaque which is engraved:

PRESENTED TO
Alix Beatrice Emma Allen
BY HER GODMOTHER
HER IMPERIAL MAJESTY THE CZARINA OF
RUSSIA
21ST MAY 1895

❧ THE EGG IN THE CARRIER BAG ☙

The woman asks what Kate thinks it is worth.

'Well,' replies Kate, 'that rather depends. It's certainly a unique piece. Did you have something in mind?'

'If it's Fabergé it must be thousands?' says the woman.

'It's certainly something we'd love to sell. I can get back to you on the estimate, but yes, it will be thousands. May I ask, what is the provenance? Where did it come from?'

'Straight from the family. My husband's – well, ex-husband's family, he's a descendant of Miss Allen.'

Kate Howe didn't realise it at the time, but the two letters from Carl Fabergé were about to change history. Fabergé scholars around the world knew what these letters meant and a race was on, but who would win?

As soon as the sale went live, Bulstrodes were inundated with calls and emails requesting more info on both the cutlery and the album. One even asked where they could land their helicopter, but the excitement quickly turned to disappointment.

The more that people looked at the cutlery set, the more it became clear that though he had written to the Allen family personally, Fabergé was not the maker. Instead, it was by a contemporary court jeweller, whose name is less illustrious – the Grachev brothers. That helicopter never landed and the £8,000–£10,000 estimate of lot 650 was now looking optimistic.

Word soon got around the closely knit field of Fabergé scholars who saw the importance of the two pale blue letters from Carl Fabergé. Not because each was signed by

the jeweller, but because they of what they revealed. For the first time, they identified one of the miniatures of the Rock Crystal egg of 1896 not, as Queen Mary is alleged to have thought, as the 'Palace Church at Coburg' but rightfully as Cathcart House, Harrogate, where the Tsarina spent almost a month in 1894. They restored its place in history. Whilst this was significant enough, there's something much more important, because these letters identify the role that the Tsar must have played in their creation.

Whilst many see the Fabergé Imperial eggs as masterworks of the jeweller's art, others see them as the vulgar baubles of a dying dynasty. In reality it's simpler than that: they are personal objects of devotion, both religious devotion and the private devotion of the Tsar to both his wife and his mother.

The letters in the Allen family album clearly suggest that the Tsar's role in the creation of the eggs was greater than previously thought. Who else could have known the places where the young Tsarina lived prior to her marriage? Not Fabergé. Not even Queen Mary, a collector and a relative. Only the Tsar or his immediate circle would have such knowledge. This begs the question of how much the Tsar was involved in the design of the other eggs created for the Imperial Family.

In his June 2015 article for *Antique Collecting*, Fabergé expert Geoffrey Munn puts forward an interesting theory. In 'Unscrambling Fabergé Imperial Easter Eggs', Munn highlights how a number of eggs and widely available

❧ THE EGG IN THE CARRIER BAG ☙

Easter Cards share common elements. Is it too much of a leap (a leap of faith perhaps?) to suggest that the Tsar may have given Fabergé Easter cards to act as inspiration for these Imperial commissions?

It's 2 March 2017 and we are in the saleroom of Bulstrodes auction house, Dorset. Whilst there are hundreds of lots in the auction, all eyes are on just one: lot 650, the cutlery set given to Alix Allen by her godmother, Tsarina Alexandra Fedorovna, formerly Princess Alix of Hesse and the Allen family album which accompanies it.

Two telephone lines are booked – one by the Virginia Museum of Fine Arts (who own the Rock Crystal Egg) and Wartski of Llandudno, the fabled royal jewellers. A battle ensues and when the hammer falls, Wartski is triumphant, winning the lot for £20,000.

It soon emerged that Wartski was bidding on behalf of a client in Harrogate. Both the album and the cutlery would be going home – not to Cathcart House, but to the Pump Room Museum where they can be seen today, alongside other items of jewellery given by the Tsarina to her godchildren.

They are extraordinary objects that commemorate a short time when the last Empress of all the Russias lived a relatively quiet life in a Yorkshire spa town and enjoyed that most precious commodity for royals: privacy.

CHAPTER TWELVE
THE BOYS WHO BEAT THE SHARK

It's 13 February 1945 in Lily Gardens, North Shields, near Newcastle. It's 2.30am and we are standing outside a house on fire. It is the home of Private Thomas Brown and his wife Maureen. Thomas is away at war, but Maureen and her children are at home.

'I heard a cracking in the wall and fancied I heard someone say "let's be out" but I could not be sure. I opened the kitchen door and saw the house was on fire,' she told the local paper.

Despite its small size, the house was full, with ten of the eleven Brown children at home. Thomas, the eldest, was only there because his ship was currently moored on the River Tyne and he had been given the privilege of sleeping at home.

❧ THE STUFF OF HISTORY ☙

Maureen raised the alarm with a neighbour and got eight of the children to safety, but there was no sign of Thomas, or little Maureen, aged four. A neighbour, wearing a gas mask, went into the house and found Maureen. She was taken to the hospital but was found dead on arrival.

Initially, the firemen could not get into the kitchen as the flames were too intense, but when they got them under control, they made a grim discovery: the body of Thomas Brown, known as Tommy to his family. He was just nineteen. Despite his short time on Earth, he made quite an impact.

The United Kingdom was shut off from Europe, vital trade routes were no longer available. The Atlantic convoys were a vital lifeline; but they were also fraught with danger. German U-Boats were everywhere and once France fell, they were on the doorstep. The convoys weren't just vital for food and fuel; when America entered the conflict, they were vital to bring American forces across the Atlantic in readiness for D-Day.

The *Unterseebooten* (U-Boats) had to be stopped, but there was a problem: the U-Boats encrypted communication using an apparently unbreakable code known as 'Triton' created by Enigma coding machines.

It's 23 February 1918. German engineer Arthur Scherbius has just filed a patent. The device he has created is called Enigma, from the Greek for 'riddle'. It looks like an old-fashioned cash register. Initially envisioned to

prevent industrial espionage, it is soon picked up by the German military.

So far as the Germans were concerned, the Enigma code was unbreakable. After all, it has 103 sextillion possible variations. But Enigma was broken and it all began in Poland in 1932. When Germany invaded Poland in 1939 and Britain entered the war, this vital work was passed onto their new allies. It would become the foundation of the work of Bletchley Park.

The combined and highly secretive work of Polish, French and British cryptologists saved many lives, but that changed in February 1942. The German navy introduced a new code which they called Triton. Given the code name Shark at Bletchley Park, this new and yet to be broken code left the Allies blindsided. Enemy submarines were once more the scourge of the Royal Navy.

This Shark had to be beaten.

Despite being called 'underhand, unfair and damned un-English' by Admiral Sir Arthur Wilson when the concept of the first Royal Navy submarine was put to him at the sunset of Victorian Britain, the navy's first sub, HMS *Holland 1* was launched in 1901, having been built in great secrecy. The Holland class submarine was named after its designer, John Philip Holland. Holland was born in 1841 at Liscannor, County Clare, where his father was the coastguard. From childhood, he was obsessed by dreams of flying, either in the sky or under the sea. He sketched out the design of his first sub in 1859 – a design that changed

THE STUFF OF HISTORY

very little from paper to reality. His mother, sister and two brothers had emigrated to Boston and in 1873, John Holland joined them. It was to be in America that Holland's dream of building a submarine would become a reality.

On arrival in his new home, Holland resumed his career as a teacher, but his dreams of undersea boats were never far from his mind. A teacher's modest salary might fund dreams but left nothing for realities. So John Holland approached the US Navy. They rejected it as: 'a fantastic scheme of a civilian landsman'.

This outright dismissal forced Holland to seek funding elsewhere. It was his younger brother Michael who came up with a possible, almost improbable source. Michael Holland was a Fenian – in other words, an Irish Republican. An early member of the Fenian Brotherhood, who ultimately sought to drive the British from Ireland. A group that was not afraid of a fight.

Today, we might call them terrorists.

Britain was the world's greatest sea power; perhaps a ship that could sail under the sea and attack British vessels was just what the early Republican movement needed?

Michael Holland arranged a meeting with Clan na Gael, a new umbrella group for Republicans. He proposed that some of the recently established 'skirmishing fund' – a war chest to further the cause of an independent Ireland – might be used to get his brother's invention off the drawing board and into reality. The trustees of the fund, which bore the code name of Jacobs and Co, could see the merit

of this stealth weapon, long before such things were even a concept. $6,000 was allocated after Holland had demonstrated a working model at Coney Island.

Launched in 1881, the Holland Boat II – considered by many to be the world's first modern submarine – soon became known as the 'Fenian Ram'. It's incredible to think that just twenty years later, the British government would be approaching Holland to build his 'Wrecking Boat' under licence. A boat seed-funded by terrorists.

It is 15 July 1942. The fitting-out of a P-class destroyer built at the High Walker shipyard of Vickers Armstrong has just been been completed and the ship is handed over to the Royal Navy. It was to be called HMS *Persistent* but has just been renamed HMS *Petard* – a curious name for a warship, as a 'petard' is a small bomb used to knock down a wall or a door.

For her maiden voyage, HMS *Petard* set sail from Gourock, Scotland, on escort duty protecting vital convoys around the Horn of Africa and on to the Middle East. This was essential work to keep the flow of goods and materiel for the home front and the war effort. German U-boats were never far away. Two hundred and eleven men, nine of which were officers, were packed into a ship that was just 388 feet long and 35 feet wide. Whilst the officers had their own cabins, the men slept in hammocks. The food was cooked in a tiny galley kitchen.

*

☙ THE STUFF OF HISTORY ❧

It's 30 October 1942 and we are in Port Said, Egypt. We are onboard HMS *Petard*, now a few months old. The crew is new: most are inexperienced, many are just young men. But youth and inexperience are no predictors of valour. Tonight, men from HMS *Petard* will change the course of the war and edge Britain and its allies towards victory.

Earlier that day, a Sunderland flying boat had seen something on its radar. It was probably a U-boat somewhere between Port Said and Tel Aviv. HMS *Petard* took to sea.

Petard took part in a coordinated bombardment, attempting to force U-boat U559 to the surface. HMS *Petard*, along with other destroyers *Pakenham*, *Hero*, *Dulverton* and *Hunworth* led by a squadron from the RAF spent the entire day attempting to seek out, locate and destroy the German sub. For ten hours, HMS *Petard* launched depth charges but no target was struck and the U-boat remained elusive. The men knew what a damaged U-boat smelt like – diesel. Not long after 10pm, the primitive detection equipment received a signal. The chase was back on and very soon the men of *Petard* could smell the leaking fuel from the lame boat carried to them on the sea breeze.

U559 was damaged and losing pressure. Its crew were sent to the bow to try to rebalance the submarine but it was no use. Her hull was cracked and several of her crew were dead. The chief engineer told the captain that the sub must surrender or all the men would die. The U-boat captain conceded, ordered the seacocks to be opened to scuttle the ship and gave the order to surface, As the stricken

submarine emerged from the inky black water, the hatch in the conning tower was opened and a white flag was raised. Desperate and bewildered, the German crew fled via the conning tower, spilling out like herrings from a net, as the U-boat filled with water.

But as the U-boat crew fled their sinking ship, the men on board *Petard* were hatching a daring and highly dangerous mission to save secret documents they knew must be onboard the U-boat. It was a mission they had planned for and rehearsed. They knew what they were looking for. When the captain asked for volunteers, his men did not hesitate, even in the face of great risk. First Lieutenant Tony Fasson and Able Seaman Colin Grazier stepped forward without thinking.

According to eyewitnesses, Fasson and Grazier stripped naked, dived into the dark waters of the Mediterranean and swam towards the sinking U-boat. Swimming through a shoal of German seamen, some fighting for their lives, Fasson and Grazier not only swam against the tide but against the enemy. A much younger man also jumped overboard from HMS *Petard* and scrambled into a small boat. His name was Tommy Brown, a non-combatant catering assistant with the NAAFI, providers of food and comforts to British troops. Tommy was sixteen years old and had lied about his age to join the NAAFI, who set a minimum age of seventeen.

As a non-combatant, he was under no obligation to volunteer, let alone for a mission which would likely end in

THE STUFF OF HISTORY

his own death. His colleagues down in the tiny galley tried to talk him out of it. His manager even tried to stop him physically – for his own good, he said – but Tommy escaped his clutches, determined to help his Royal Navy colleagues.

Tommy Brown had never learned to swim. Unlike those who joined Royal Navy, the NAAFI had no requirement to be able to swim. The only lesson Tommy Brown had received was when his father and brother threw him into the River Tyne and prayed he wouldn't drown. It's no wonder he took a boat.

By the time Tommy Brown reached the sub, Fasson and Grazier were already deep inside the sinking hulk in a frantic search for papers and equipment. Others from *Petard* came too, but only Brown, Fasson and Glazier went below. Tommy Brown made his way down the narrow ladders inside the conning tower in the pitch black and rank air; only the occasional glint of Tony Fasson's torch lit Tommy's way. At the foot, his feet in the water, he grabbed a handful of papers from Grazier. Somehow, a relay was formed. Fasson sought the papers, passed them back to Grazier, who passed them to Brown, who ran them up the tower and to the safety and dry of the boat. Brown had no idea of how vital the papers were to the war effort, nor what their true value was.

Speaking at a debrief, he later recalled:

> The lights were out – the First Lieutenant had
> a torch. The water was not very high but rising

gradually all the time. When I came up the last time it was about two feet deep. There was a hole just forward of the conning tower through which water was pouring. As I went down through the conning tower compartment I felt it pouring down my back. Water was also coming in where plates were stove in on either side of the conning tower.

The First Lieutenant was using a machine gun to smash open cabinets in the commanding officer's cabin. He then tried some of the keys hanging behind the door and opened a drawer, taking out some confidential books which he gave me. I put them at the bottom of the hatch, and after more books were found in a big cabinet just above the C.O.'s bunk. I took them and another lot up.

On his third and final trip below decks, Brown noted that the First Lieutenant was trying to break something from a bulkhead in the main control room:

We got it away from the bulkhead, but it was held fast by a number of wires and we gave up. The water was getting deeper and I told the First Lieutenant that they were all shouting on deck for us to leave. He gave me some more books and I took these up, and they were passed into the whaler.

❧ THE STUFF OF HISTORY ☙

Unbeknownst to these three brave men, the vital codes and ciphers were written on pink blotting paper with water soluble ink. Any seemingly innocuous scrap of paper could have been vital information for the codebreakers at Bletchley Park – but any papers the raiders dropped would be useless. It's a tribute to these three brave men that they were risking their lives for pieces of paper the significance of which they couldn't be sure of.

In the panic to abandon the U-boat, the German had crew rushed things and made two mistakes: the seacocks were not opened properly meaning the sub did not sink to the bottom quickly. And on the floor of the communications room where there ought to have been a bucket always kept full of water in order to erase vital secrets in the event of capture by the enemy, there was instead a dry, empty bucket. No one on board the U-boat thought to fill it. This one simple mistake changed history.

As Tommy Brown made his third trip up the conning tower, passing on the code books to the waiting boat, he could hear the crew up top shouting his name and that of Fasson and Grazier. In the debrief, he recalled: 'I saw Grazier and then the First Lieutenant also appeared at the bottom of the hatch. I shouted "you had better come up" twice, and they had just started when the submarine started to sink very quickly. I managed to jump off and was picked up by the whaler.' Fasson and Grazier did not make it out and went down with U-559. Three officers and eleven ratings survived from the U-boat crew and

were taken prisoner on board HMS *Petard*. The destroyer set sail for Haifa at full speed in order to hand over the vital code books to naval intelligence. The men were given forty-eight hours leave.

Lieutenant Commander Thornton lost no time writing up citations, recommending medals for his crew. Concerning Lieutenant Tony Fasson, he wrote:

> When the U-boat surfaced and surrendered he went over the side from the forecastle and boarded with great dash. He stayed below working in darkness with water rising, knowing the sub to be holed. He continued to get out books and instruments until the sub sank. He gave his life in his eagerness to get vital information.

The citation for Able Seaman Colin Grazier read:

> This excellent young seaman followed the First Lieutenant over the side from the forecastle and with him boarded the U-boat in the shortest possible time. He stayed below, working in darkness with water rising and knowing the sub to be holed until too late get out, thus giving his life in his eagerness to get vital information.

Lieutenant Commander Thornton also recognised the contribution of Tommy Brown. He wrote:

❧ THE STUFF OF HISTORY ☙

He unhesitatingly jumped on to the U-boat to assist Lieut. Fasson. He went below three times in darkness to bring up books knowing the U-boat was holed in two places steadily taking water. He was a fine example of coolness and courage in a hazardous situation, more especially in one so young (16 years).

What medal could recognise the sacrifice of two men who gave their lives for books of pink blotting paper containing codes they could not understand and certainly had no time to read? You would think, perhaps, that once the value of this intelligence was recognised, that this coupled with the brave actions of those who retrieved them would result in the highest decoration being awarded. Certainly, when news of *Petard*'s exploits and the actions of its brave men reached the Admiralty, there was little doubt that Fasson and Grazier were both eligible for the Victoria Cross – awarded 'For Valour' and the highest medal across all the services. And yet, the supporters soon encountered a problem. It was suggested, perhaps correctly, that awarding the VC would alert the Germans to the fact that vital documents were recovered from U-559. They would then be able to respond accordingly, issuing new codes and changing their processes. Which would, of course, render the recovered material useless and negate the sacrifice of Fasson and Grazier.

Months went by as various Whitehall mandarins and Sea Lords discussed how these heroes ought to be

rewarded. In a letter, Sir Robert Knox, First Lord of the Admiralty, wrote: 'This question, since it deals with getting vital information from the enemy, should be treated as most secret.' The work at Bletchley Park was so secret and so vital that it meant tough decisions – even those that looked callous or ungallant had to be made. Fasson and Grazier would eventually be awarded not the Victoria Cross, which they deserved, but the George Cross, the highest award for civilian action. It was a curious and very British fudge, an Establishment cover-up of sorts, but one that, by concealing the true nature of their heroism, meant the greater good was put before the proper recognition of two brave young men.

Likewise, a medal for Tommy Brown proved a difficult decision for the Establishment. As a civilian he was not eligible for the Victoria Cross. The George Cross was not only suggested, but deemed appropriate, but other voices called for the British Empire Medal. Eventually, over a year later, he was awarded the George Cross. The *London Gazette* announced: 'The KING has been graciously pleased to approve the award of the George Medal to: — Junior Canteen Assistant Thomas William Brown, N.A.A.F.I., for great bravery and devotion to duty in the face of danger.'

Tommy Brown would never receive his medal.

Within months of getting these vital documents rescued by three crew members from HMS *Petard*, the codebreakers at Bletchley Park had cracked the new 'Shark' code. The allies could once more read the secret U-Boat

❦ THE STUFF OF HISTORY ❧

messages. It is said that their work shortened the war by at least a year and saved countless lives. It remained top secret until 1974 and not fully disclosed until the 1990s.

Yet...

It's 6 July 1969, a Tuesday, and all across the UK, excited young boys are heading to the local newsagent's clutching a handful of copper coins to pick up a favourite comic and perhaps a penny mix-up. *The Hornet*, a 'picture story book for boys' priced at 5d is a strong contender for many with pocket money to spend. This week's edition, number 304, has a very bold cover. It shows an RAF plane divebombing an enemy submarine with the caption 'The Secret of the Sea Wolf', charting an incident in November 1942.

A tier of three panels continue the story, but it is in the third panel where things get weird. Here, two sailors are shown looking at a screen. One is named Anthony Fasson of HMS *Petard*. How did they know?

The story, which is continued on the back page, also mentions secret papers in the captain's cabin and AB Grazier, tells that both men lost their lives and were awarded the George Cross. Though *The Hornet* makes no mention of Tommy Brown. DC Thomson, the publishers, have broken the Official Secrets Act, perhaps unknowingly. All across the country, little boys with snotty noses are reading a story that is still highly classified, and would take decades to come out officially.

Had Tommy Brown not been able to scramble up

those ladders, handing the papers on, had a boat not been waiting, had a German submariner filled a bucket of water, the sacrifices of Fasson and Grazier would have been in vain and countless lives lost. The names of Anthony Fasson, Colin Grazier and Tommy Brown are hardly known, but they are the boys who beat the Shark.

CHAPTER THIRTEEN
SAVING CATHERINE'S TEAPOT

There is a good chance, if I were to hazard a guess, that a few of you might be reading this whilst sipping a cup of tea. If you are, I do hope it's from a china cup and saucer, neatly dressed with a biscuit. This simple, quiet and pedestrian act is such a familiar part of (British) life, that it seems hard to imagine a cuppa-less kingdom. Yet in the cavalcade of British life, tea is a tiny, tiny part of our timeline.

So how did a leaf from the other side of the world become so rooted in the life of these old islands?

The tea of today is a democratic cup enjoyed by all, but to go back just one hundred years and observe someone drinking a cup of tea would be to know their social class by just the vessel they drank from.

❦ THE STUFF OF HISTORY ❧

Delve back deeper, say 200 years, and drinking tea from a china cup would tell us that you are rich and a member of society. Your teacup would in fact be a 'tea-bowl' without a handle and you may well be drinking from the saucer.

Travel back 300 years and the very act of drinking tea from a china cup would tell us that you are not only rich but a member of the elite. Scroll back just another fifty years, to circa 1675, and if you are drinking tea in a china cup in your home, then it's safe to say that you are the king or queen!

How can we be so accurate? Well, tea, and teacups, have been so woven into British life that to unpick each thread of tea's history is to unpick the very threads of Albion.

It all began with a king – King Charles II. Restored to the throne in 1660, he had picked up a taste for tea whilst living in exile in Holland and France, both countries which, at that time, had a more developed tea culture than Britain. Perhaps one could say Charles II was the first tea influencer? Two years later, King Charles II married Catherine of Braganza, a princess from Portugal. And Portugal, with its trade route to the East, was tea central.

Like many marriages of the time, this was not a love match. Catherine was a pawn in a game played by both sides. From the arrangement, Portugal got the friendship of Britain and its navy; Britain got six islands off Bombay, Tangier and numerous trading privileges, plus a pile of cash. But Britain got something else too: tea.

The soon-to-be Queen of England brought two cases of

tea which were allegedly marked in Portuguese *'Transporte de Ervas Aromaticas'* ('transport of aromatic herbs') – which we later abbreviated to TEA. Sadly, pleasing though it is, it's just a tale. Our word 'tea' doesn't come from Portugal.

Portugal had a foothold in China since the mid-sixteenth century via Macau, where they spoke Cantonese. Tea in Cantonese is 'cha'. Britain first tasted tea via the Dutch who imported it via the Fujian region. In the Fujian dialect, tea is called 'tee', which is exactly what famous British diarist (and naval administrator) Samuel Pepys called it.

But here is the fascinating part. Armed with these two facts, you can work out where almost any European country originally got its tea from. If it's a version of 'tee', they dealt with the Dutch. Any variant of 'cha' means that the country's inhabitants first tasted tea via Portugal. So you can actually trace the trading routes via the name that a particular nation calls its cuppa. A cup of tea as a geography lesson.

Having come all that way, not only was tea expensive, but precious. Tea was kept safe in its own 'caddy' (from the Malay word 'catte', the name of the container tea was exported in), the key being kept by the lady of the house. The earliest ones were silver or gold and smaller than later examples. The high status afforded by tea meant that it became the custom for ladies to not only serve tea but make it themselves. Anyone who could afford to, served tea.

THE STUFF OF HISTORY

The expense of tea turned it into an act of hospitality as well as an expression of status. The serving of tea by the lady of the house added to this sense of welcome as in a wealthy household almost everything else was served to you by servants. Tea was intimate. Tea was special from the get-go. Plus, as it was closely associated with the Restoration monarchy, to take tea in late seventeenth-century Britain was a demonstration of loyalty to the crown.

Tea at this date would be served in a 'closet' – not a cupboard, but a small room, usually off a bedroom – the most private space of a home. In the days when the delineation between public and private space was blurred, these 'closet' rooms were a vital sanctuary, especially for ladies, who were thrilled at the privacy, lack of servants and the novelty of being served in person by their hostess.

It is from this tradition that the person serving tea may still say, 'Shall I be mother?' This style continued for centuries and many aristocratic women formed powerful alliances for themselves and their husbands over the serving of a cup of tea. To be invited to 'take tea' in the late seventeenth century was the hot ticket invite and thus to refuse tea when offered was the height of bad manners.

Very quickly an etiquette grew up to avoid this social pitfall. The teaspoon quickly became the friend of those who'd had too much tea, just as sugar worked for those who didn't like the taste. By placing the spoon in the cup, you indicated 'more tea please', whereas laying the spoon over the top of the cup politely said 'no thank you'.

SAVING CATHERINE'S TEAPOT

At this time and well into the eighteenth century, green tea was the most popular and it was almost always served with sugar. Black tea (often called 'bohea') was also drunk with sugar, but also milk or even cream, which is why even today milk jugs are often called 'creamers'.

Green tea faded from popularity in the middle of the eighteenth century when much of it was found to be contaminated with copper to make it look greener. Greenness was seen as a mark of quality and therefore more saleable. Black tea was seen as a safe haven and has since ruled supreme to this day.

Serving tea remained the realm of the elite not just due to the high cost of tea itself but all the things you needed to serve it. Not just the teapot. You'd need cups and saucers too. A cream jug. A sugar vase and a slop basin. And that's just the porcelain. Teaspoons of gold or silver. A tray. Elegant chairs for your guests. A fine silver kettle on a stand. The list was endless and the goods were costly and rare. At this point – if you remember – not only did the Chinese have a monopoly on tea but on porcelain too. Why was this important? Only porcelain would take the boiling water required to make tea and only the Chinese made 'hard paste' porcelain. In Europe, we only had tin-glazed earthenware and that would crack if it came into contact with boiling water. So tea and porcelain were locked in union out of necessity and both items were incredibly expensive.

*

THE STUFF OF HISTORY

It's 25 September 1660 and we are in an office on Seething Lane, London. It's a Tuesday morning. Four men have been engaged in business. When his guests leave, one sends out for a cup of tea which is delivered to his office. The man is Samuel Pepys. 'And afterwards I did send for a cup of tee (a China drink) of which I never had drank before,' he wrote in his diary. One wonders why, on this particular day, did he take to tea?

Was his meeting so awful that he decided to try tea as a means of reviving himself? Was it on the recommendation of one of his guests? Or perhaps he was celebrating the completion of a good bit of business. Despite 'tee' making its debut in Seething Lane that day, it had been around for some years; it wasn't the latest thing. So why had the well-known epicure Mr P taken so long? Well, while we know that 'tee' had been around for a while in the West, and in Britain specifically, by 1660, exactly how long has eluded us and the date keeps getting pushed back further.

In January 2018, curator Rachel Conroy was researching an exhibition about beer at Temple Newsham House, just outside Leeds in Yorkshire. What she discovered changed the history of tea in Britain. Amongst some family papers, she came across a household account dated 8 December 1644. Amongst the items listed was 'a bottle of China drink' priced at four shillings. A 'bottle' of tea? What was Sir Arthur Ingram, the house's owner at that time, doing with that? Well, the thing is when tea first arrived into Europe, no one really knew what to do with it.

SAVING CATHERINE'S TEAPOT

To many, this 'China drink' was seen as a medicine and this is most likely what the bottle of tea was intended for. They knew it was a herb and it was expensive, so therefore it was classed as a medicine. In the seventeenth century, tea was less the cup that cheers, more the cup that cures. It's a bit like how olive oil used to only be available in chemists before Elizabeth David taught us in Britain how to cook with it.

Even as late as 1658, this advert in the *London Gazette*, previously thought to be the earliest mention of tea in Britain, suggests it's a cure, and not a cuppa: 'That Excellent, and by all Physitians approved, China Drink, called by the Chineans, Tcha, by other Nations Tay, alias Tee, is sold at the Sultaness-head, a Cophee-house, in Sweetings Rents by the Royal Exchange, London.'

Now why did Pepys 'send for' his cuppa? Did London have a tea delivery service in the mid-seventeenth century? Well, yes, but there's a reason. Earlier that year, in April 1660, a new law was passed which taxed tea for the first time – but taxed it not as a loose leaf, but as a liquid. From April 1660 until 1689, tea was a controlled substance that had to be brewed up by the vat full and inspected by the Revenue. To sell tea, you had to hold a licence or you'd receive a fine for a whopping £500 a month, which is over £80,000 in today's money. Tea had clearly arrived, and Pepys knew it.

Taxing tea in this way meant it was virtually impossible to make a cup of tea at home, unless you were willing to

THE STUFF OF HISTORY

break the law or make an appointment with the tax office each time the kettle was boiled.

So Pepys could only get some 'tee' if he went to the coffee house in person, or sent someone to fetch some for him and what might have been fetched for him? 1660s London was full of places to get a coffee, then as now, but the takeaway cup had yet to be invented. A cup of tea carried across a road would find much split and, worse, it would arrive lukewarm. So it's much more likely that someone would arrive with a pot and a cup pour and wait whilst the contents were drunk. The pot in question, whilst a teapot in name, would look a bit different to what we'd expect now.

It's some time in 1670 and we are in the workshop of goldsmith Thomas Leys. A man has arrived, sent on an urgent matter on behalf of his employer. He has been given an explicit set of written instructions which he must follow without question. Thomas Leys knows the man: he is the agent of Lord Berkeley and it is likely he is here on an important commission.

'What say you, sir?' Leys says in welcome, nodding his head in acknowledgement.

'Pray, good sir, if I may be so bold, tis a matter for Milord, a most urgent matter upon which he was most specific and took to writing. There is also this package for your attention.'

He hands over the instructions to Master Leys and a

cloth-wrapped parcel, tied with string. 'Whence shall the matter be settled?' he asks the agent.

Leys looks down a ledger and makes a note. 'Two weeks hence and on the same day and hour. We shall have completed the work for Milord Berkeley then.'

Leys knows from experience that his noble client wants something copied – hence the parcel – no doubt the work of another goldsmith, but what could it be? He takes the letter and the unusual parcel and, rather than untying the string, he cuts it, keen to reveal what's inside. As Leys pulls back the wrapping, he finds a rather dirty, tall and conical copper vessel. He's surprised, though he knows exactly what it is – a coffee pot, the sort he'd see in his local coffee house.

Then he breaks the seal on the letter and reads it. Milord Berkeley is quite specific. Leys is to make an exact copy of the coffee pot – that seems simple enough – but it is the engraving that confuses him, and the quite specific instructions that he must follow to the letter, with a proviso that the engraver may foreshorten any words that are needed to fit the space in between the twin coats of arms: 'This silver tea potte was presented to ye Committee of ye East India Company by ye Right Honourable George Berkeley of Berkeley Castle. A member of that Honourable & Worthy Society and A true Hearty Lover of them 1670.'

Thomas Leys knows that he is copying a coffee pot, therefore he is making a coffee pot, but he also knows

that Lord Berkeley is not only an important client, but an important man, close to the King and Queen.

The simple conical shape of the vessel means the work is done in days, but it must be taken to the cordwainer to make a leather handle and to the engraver and the clock is ticking. Goldsmith Leys does not let down Lord Berkeley's man, nor the noble Lord himself, and the 'silver tea potte' is duly delivered. It's possibly the very first silver teapot made in England.

Why would George Berkeley copy a dirty old coffee pot in silver? Remember Samuel Pepys and how he 'did send for a cup of tee'? We can only surmise that Lord B did the same thing and was so perturbed by the burnt old copper pot the tea arrived in that he had a much more graceful version made, to less offend the eyes of his fellow company men. Whilst I have imagined the conversation in the goldsmith's shop, the 'tea potte' is real and can be found to this day in the collection of London's Victoria and Albert Museum.

Lord Berkeley's teapot may be Britain's first silver teapot, but it's not the oldest. That honour lies elsewhere.

It's the morning of 7 December 1911 and we are on board RMS *Medina*, soon to dock in Delhi. A man is called, or rather summoned, to a private cabin. 'Ah, Lee,' says the cabin's occupant, seated in the middle of the room. 'Do pay close attention to the beard, I need to look regal before we dock.'

❧ SAVING CATHERINE'S TEAPOT ☙

The man is HM king George V who is en route to the 1911 Delhi Durbar, a formal assembly held on the accession of the new king. George has just summoned his personal barber, Henry Morton Lee, of whom you've probably never heard. Not long after returning from his royal trip, Morton Lee retired from hairdressing. He sold his business and goodwill to his apprentice, a certain Mr George F Trumper, whose successors still operate today the premises at 9 Curzon Street London which HM Lee opened in 1909 to be closer to the palace.

But it is what he does next which concerns us. Henry Morton Lee not only opened an antiques shop but founded a dynasty of antiques dealers.

It's sometime in 1949 and we are at Langham House, Ham Common, London. Sir Lyonel Tollemache has invited antiques dealer Ronald A Lee over for a sherry. Lee knows it's not really a social call: the ninety-five-year-old lord doesn't go in for that kind of thing. Lee has visited him enough times to know that he may not even get a sherry.

Ronald Alfred Lee is the son of HM Lee and one of the top antiques dealers in Britain. He's known Lord Tollemache for a number of years and every once in a while, he's asked over when the 'ready cash' is running low, his lordship's rather vast wealth being tied up in rather less readily accessible land and property. Lee calls these his 'rescue missions' because he knows he is likely to be offered treasures previously at Ham House, the vast

୍ଷା THE STUFF OF HISTORY ଙ

and mostly untouched seventeenth-century Thameside mansion that Tollemache had given to the National Trust in 1948, but not before taking a few family mementoes with him.

Ronald Lee was excited and apprehensive. As he approached the front door, he noticed it was getting dark – not a good time to buy antiques, he thought to himself, especially as Lord Tollemache wasn't given over to lots of light. What might Lord T be looking to sell? It could be something amazing. It might even just be a glass of sherry.

As soon as the door to Lord Tollemache's study opened, he saw it. It was like it possessed a magnetic force: he was lured as by a siren's call. On a table was a teapot – small, cream coloured and old. Very old. He knew that it was Chinese, seventeenth century, and with European silver gilt mounts. A chain to the lid and – most importantly – another chain to hold a now lost cork that would have been inserted into the spout to help the water boil quickly. This curious technique existed only in the seventeenth century. Roland Lee knew immediately he had to buy it. Whatever the cost.

'Lee! My good fellow,' said the beady-eyed lord in his lair. 'Come! Sit! Good of you to come over!' Ronald Lee sat down, trying hard not to stare at his quarry and attempting to affect an air of nonchalance.

'You'll you take a sherry?' This wasn't a good sign. Lord T never offered him a sherry – only the mention of one as a pretension of civility.

ଈ SAVING CATHERINE'S TEAPOT ଈ

'Well, I don't mind if I do,' came the reply.

'Now then. I shan't shilly-shally. I wonder, would you cast your eye over this?' Lyonel Tollemache moved his arm slowly towards the teapot. Crane-like, his hand descended and his fingers enveloped the small teapot, to hand it to Lee.

Ronald Lee took the teapot. Instinctively, his hand caressed the surface: this wasn't an act of love, he was feeling for restoration. Unrestored porcelain feels smooth and cold. Any restored parts feel waxy and his fingers would find a less smooth surface. *Smooth all over*, he thought to himself – a good start.

He looked closely at the mounts – traces of gilt; no hallmarks. Then the base. It had that distinct staining and cracking you'd expect from a teapot of this era, when the water was boiled in the teapot over a burner or 'Indian furnace' as they described it then. No wonder the glaze of the whole teapot was crazed and its base brown.

An electric warmth swept through his entire body. He knew he held in his hand a teapot of great importance but one that would pivot on its provenance. Now, the game of cat and mouse that any dealer of secondhand goods will recognise. Ronald Lee knew he could not seem too keen lest the price go up; nor did he want to name a price, lest Lord Tollemache had a lower one in mind.

'Now, no doubt, you know the date, but can you guess whose pot it was?' said the lord, with a glimmer in his eye.

'Well,' said Lee, 'a lady of some status.'

☙ THE STUFF OF HISTORY ❧

Tollemache nodded.

'The Duchess of Lauderdale?'

'Well, yes! There's no point for that, Lee! But who gave it to her?'

'There can only be one person – the Queen!'

Lord Tollemache laughed. 'Why did I think you'd not have known? Yes! You are right. The Queen, Charles II's Queen gave it to her. I reckon she must have got herself a new one and gave her old pal the cast-off! What say you, Lee?'

'I'd heartily agree! This teapot is about 1650, Zhangzhou ware. Not made for export. Even at the earliest instance her gift would have been over twenty years old.'

Tollemache smiled. 'A second-hand rose! Now, sorry to talk of vulgarities, Lee, but what will you pay for it? It will have to be a swan price!'

Ronald Lee knew that he must buy the teapot, no matter the cost. The warmth began to fade as the chill of reality and cost filled his mind. Lee gulped. He hoped Lord Tollemache didn't notice.

'My Lord,' he replied, adopting a rare formality, 'I wonder, I don't wish to embarrass myself, nor damage our acquaintanceship, which I value, so might I suggest, for simplicity's sake, that you name the price of this particular swan and I shall pay it.'

'Very well,' Tollemache must have anticipated this kind of situation. He rose, went over to his desk and wrote something on a piece of paper. He rolled his blotter over

the ink and folded it in half before handing the paper to Lee, who opened it. He gulped again.

'Naturally,' he said with a casual air, 'I don't carry that amount in cash, but might I propose to call tomorrow morning, say at eleven? I can leave a deposit this evening.'

'Deposit? What rot! No need for that, Lee. Take the teapot, call tomorrow afternoon. We can have tea.' At this point, Lord T gripped Lee in a wily stare. Lee panicked slightly. Was he suggesting he brought the teapot back to use it?

Lord T must have seen the reaction because after a pause of seconds that seemed like minutes, he added, 'Tea from my own teapot, that one is now yours!'

It's safe to say that when Ronald A Lee left Langham Lodge that evening he was beaming from ear to ear. He had just saved Queen Catherine's teapot, England's oldest and most important teapot.

Ronald Lee did not sell the teapot. Like most of the 'swans' he rescued from Langham Lodge, it remained in his own collection. In 1994, the teapot returned to Ham House, when Ronald Lee donated it to the National Trust in memory of his late wife Betty.

The tea served in Queen Catherine's teapot would be very different to what we would serve today. It was very likely green tea and it would be served with a lot of sugar which was the normal way tea was taken for centuries. So what changed?

The taste for sugar in tea began to fade towards the end of the eighteenth century. Its fall from favour wasn't

THE STUFF OF HISTORY

linked to a change in taste, but because in the minds of many enlightened thinkers, sugar was too linked to slavery.

It's 1828 and we are in Camberwell, then a village south of London. Mrs Henderson is leaving the printing works of Mr John Vogel on her way back to her china warehouse in nearby Peckham. She is clutching a paper parcel under her arm. The parcel is heavy. Suddenly, she has an idea: rather than carrying the heavy load back to her shop – a good half hour's walk away – she can begin her campaign right here and now. She stops, takes a pair of scissors from her reticule and cuts her parcel open at one end.

Mrs Henderson takes out a handful of her leaflets and looks around for targets – ladies like her, educated women and fellow anti-saccharites. Rather than just handing out her leaflets willy-nilly, she decides to show them first, lest they be wasted. She knows that what she has in her hands is controversial to some, but she also knows that she is on the right side of history:

> Mrs B HENDERSON, China-warehouse, RYE-LANE, PECKHAM, Respectfully informs the Friends of Africa, that she has on Sale an Assortment of Sugar Basins, handsomely labelled in Gold Letters:
> "East India Sugar not made by Slaves."
> "A Family that uses 5 lb. of Sugar per Week, will, by using East India, instead of West India, for 21

⌘ SAVING CATHERINE'S TEAPOT ⌒

Months, prevent the Slavery, or Murder of one Fellow-Creature! Eight such Familles in 19 ½ Years, will prevent the Slavery, or Murder of 100!"

Mrs Henderson's message was stark but she knew her audience. Peckham was home to the 'free sugar ladies', better known as the Peckham Ladies African and Anti-Slavery Association. Formed around 1827, it was an early advocate of the power of the consumer to effect change on society.

The sugarless ladies of Peckham were not alone and during the years 1825 to 1829, many other anti-saccarite societies existed, eschewing West Indian sugar (made by slaves) and embracing sugar from the free workers of the East Indies, or giving up sugar in their tea altogether. Across the UK, it is estimated between 300,000 and 500,000 people gave up sugar. It was one of the first consumer boycotts.

We don't know if Mrs Henderson was a member or indeed even a supporter of this small-scale movement against slavery, but the various sugar bowls and jars that exist in museums today proclaiming the origin of the sugar intended to be held within, are likely the same ones from her shop. These rare and fragile testaments to small-scale social change wrought by activist women, who were yet to get the vote but still exercised power over the household.

CHAPTER FOURTEEN
THE DEVIL'S TOOL

It's October 1006 AD and we are in Venice. A comet has been seen in the night sky for three weeks now. People are terrified. They know it can mean only one thing: death. In Venice, death stalks the streets. The city is in mourning, families are decimated. No one is safe from the plague, not even the family of the ruler of Venice, Doge Giovanni Orseolo – when his wife and their young son die, their deaths are seen as a very bad omen.

Yet one man – a future saint no less, St Peter Damian – sees things differently. He rejoices in the death of Princess Maria Argyropoulina, the Doge's wife. In, fact he revels in it. He writes of how her decaying body is a clear testament to what he considers to be her crime: vanity.

What horrific act did the Dogaressa of Venice – the last Byzantine princess to marry a Venetian noble – commit to

shock this self-styled paragon of virtue? She was the first person in the West to use a fork.

Yes. A fork.

'Nor did she deign to touch her food with her fingers, but would command her eunuchs to cut it up into small pieces, which she would impale on a certain golden instrument with two prongs and thus carry to her mouth,' as the saintly Peter put it.

Although Peter Damian claimed to have witnessed this alleged affront to decency, he was in fact too young, but her crime clearly rankled and the false memory lingered.

So far as the pious Peter saw things, the hand was seen as God given, so not using it was an affront to God. He wasn't alone either. This act, apparently appalling and vain, set the widespread adoption of the fork back hundreds of years. In fact, forks were not commonplace in the West until the late eighteenth century.

Even today, the Italian word for a fork is *forchetta*, which comes from the Latin *furca* – in Italian a fork is, literally, a little pitchfork. An old Catholic priest friend of mine in Venice still contends that the *forchetta* – the little pitchfork – is the devil's tool and this is why you ought to have the tines facing down! He further suggests that this is why the French made the fork curved so there was no ambiguity about where the devil was – he was held down.

Conversely, in the Venetian language – Venessian – a fork is called a *prion*, stemming from the Greek. It seems

THE DEVIL'S TOOL

that the influence of the poor dead princess lives on; whilst Venetians didn't take to the fork immediately, they chose a name that she would recognise – a recognition and, indeed, memorial, of sorts. In the *prion*, her memory lives on every time you use the devil's tool.

Today, the fork is such a familiar thing that I wonder how many of you have googled something like 'what is the history of the fork?' If you have then you may be saying to yourself, 'But the Egyptians had forks, and so did the Greeks and the Romans, and I'm pretty sure that cavemen must have had some pointy stick thing to prod meat?' This is indeed true. Forks do exist in ancient history, but they were not used in the same manner as we now use them.

Until those delicate Byzantine princesses began to use a fork to convey food to their mouths, forks were used as a utensil to spear meat from a communal plate and bring it to your own plate. At this point, let's make something quite clear about eating in 'ye olde days'. They didn't eat as you'd imagine. Charles Laughton's depiction of King Henry VIII in the 1933 film *The Private Life of Henry VIII* has a lot to answer for. Meat was a status symbol but so were good manners. If you were part of the elite of society, you'd likely be a member of the king's court too – a courtier – so you'd be expected to behave in a 'courtly' manner.

Meat only regularly graced the tables of the rich and the royal. The cattle-farming classes did not view their livestock as meat for the table. A cow gave milk which could be sold.

❧ THE STUFF OF HISTORY ☙

A pig ate anything and could be fattened up for market. Likewise, chickens provided eggs. Meat was precious and expensive. Livestock was an investment, not a food. Unless, of course, you were at the top of the food tree.

For those that had the means, meat was very much the centrepiece of a formal meal. Even today, traces of its once much higher status remain. If you've ever put a joint of roast meat on a serving platter and carried it into a room full of waiting diners, placed it on the table and proceeded to carve, before serving the meat to the guests, you are mimicking the role of the mediaeval 'kerver', who made great show of his prowess with a carving knife.

Unlike today, the kerver didn't cut the meat into slices, but bite-sized pieces, which he would then present to those lucky enough to be sat at the top table on his 'presentoir', a sort of long and fancier version of a meat cleaver. Yes, the top table where the most important guests sat, just like at a modern-day wedding. Those who were sat on the other, lower tables did not receive such attention but instead would get a large sharing plate – a 'mess' – which would be piled with pre-cut meats to savour. No presentoir for them. This was a help-yourself sitting.

Life at the top table was complicated. It wasn't just the (lack of) cutlery. There were rules, lots of them, and it's highly likely that, should you be in the unlikely situation of waking up a monarch in the Middle Ages, it would be your lack of the correct manners at the table which exposed you as a time traveller. People, objects and food, and how you

THE DEVIL'S TOOL

interacted with them not only demonstrated your status but showed that you understood the status of others.

Though, to be fair, the newly transported time traveller would likely come a cropper long before their lack of period etiquette outed them. Being a stranger to the ways of society, the first thing you'd notice living with the castle class was that there was no dining room. They hadn't been invented – well, the Romans had them, but they'd been rather forgotten about, like many of the things the Romans did for us, such as central heating. On a day-to-day basis, the king in his castle would normally dine in his bedroom, either alone or with his queen. The other members of his family would dine in their own rooms. Safety was a concern, but also warmth and privacy mattered.

Of course, when we say 'alone' we mean no other diners, as there would be many servants coming and going. Though it was not only servants who attended to the royal needs. Proximity to the monarch was highly valued, then as now. Known as being 'in the presence', this was one of the greatest privileges of the court, so you would also find favoured courtiers attending to the king's needs.

These needs did not just mean food. One of the oldest and most highly sought-after roles at court was to be appointed as 'groom of the stool'. To our modern sensibilities, one might imagine this to be the man who places a stool for the king to get on his horse, but, no, it's a much more intimate role than that.

THE STUFF OF HISTORY

The 'stool' in question was the 'close stool', a somewhat luxurious and velvet-clad version of a PortaPotty, whereupon the monarch would 'ease' himself with the able assistance of his groom.

The full title of this most personal of royal services was 'groom of the close stool' and exactly what assistance was offered, no one is exactly sure. Whilst many are wont to suggest that this person attended – shall we say – most intimately to the cleansing of the royal posterior, it's much more likely that the groom of the stool merely monitored the monarch's bowel movements, reporting them back to the royal doctor. Even today, the monitoring of someone's 'stools' is a key indicator of health – and yes, this royal job is where the euphemism 'stools' comes from.

In the context of the period, when people often 'went' together, even the royal personage going whilst a companion hovered about was not seen as unusual. In fact, this was a plum job which evolved over the years.

The first British monarch known to have employed a groom to his stools was King Henry VI, who trusted one William Grymesby to monitor his motions. Grymesby is listed as 'Yoman of the Stoole' in 1455. Under the Tudor Dynasty, especially kings Henry VII and VIII, the role expanded. The groom of the stool was not only the person who was most intimate with the royal body, but often the holder of both their deepest secrets and confidences, as well as gatekeeper to who saw, or did not see – the king. The king's personal spending was overseen by the groom

THE DEVIL'S TOOL

as was the care of personal jewels and plate (items of silver and gold). The groom also had the right to the monarch's old clothes and furniture. It was quite the job.

Whilst the role existed until the reign of Edward VIII (1936), it is believed to have become more like the modern role of a private secretary by then than someone who handed the king his Andrex and offered to wash his hands afterwards.

It's 28 June 1952 and we are at the Palace of Holyroodhouse in Edinburgh. It's Royal Week and a twenty-two-year-old man is waiting in a corridor accompanied by two children. Beside them is a large silver jug and bowl, a salver and a linen towel. A door opposite them opens. The man stands straight and looks at the children who follow his lead. They enter the room and the door closes behind them. They all bow.

Inside the room is the new queen, Elizabeth II. Queen of just a few months, she is making her first visit to her official Scottish residence. This is why the man and two children are there: he is John Peter Houison-Craufurd, twenty-fifth Laird of Craufurdland Castle and the handwasher to the monarch.

This is not a job that you'll see advertised in the pages of *The Lady*; it's a wholly ceremonial and hereditary position. Whilst the exact date of these events is lost in the mists of time, apparently the twenty-fifth laird's ancestor unknowingly rescued King James V of Scotland from

brigands, tended to his wounds and fed him what food he had in his humble home. Before revealing his true identity, the King asked Jock Houison what he'd like more than anything in the world. When he replied that he'd love to own the land he tended, the King was supposedly so taken aback by both his hospitality and humbleness that he gave him the land on the condition that he was always ready to wash the King's hands if the King crossed Cramond Bridge or resided at Holyroodhouse.

To us, the symbolic washing of hands seems a somewhat quaint leftover from another era, but to our ancestors, especially those before the eighteenth century, it was a normal way of welcoming someone to your home.

The ewerer was in charge of washing hands – at large feasts, he might be helped by a number of grooms. The ewerer would, unsurprisingly, hold a ewer of water, often perfumed, and this would be poured over the hands into a bowl. Over his shoulder, he'd have a long napkin for the guests to dry their hands. It's for this same reason we see some old-school waiters with a napkin over their shoulder or arm to indicate rank. Of course, this cleaning was largely symbolic, an act of welcome and hospitality. Like the groom of the stool, the ewerer was likely a highly thought-of noble.

Once 'cleansed' and sat at the top table, you would be presented with your mouthful of roast, properly sliced and placed on your plate, before you used your fingers to pick it up. But which fingers? Before a mediaeval diner

THE DEVIL'S TOOL

used their own fingers – the thumb and first two fingers were seen as appropriate – they would have to make some 'bread fingers'. This involved breaking a bread roll in half and removing the crumb. A lump of crumb would be rolled into a little sausage. This 'bread-finger' would be placed over the bite-sized pieces of meat. They could then grab the meat by the bread and eat. Dining in the Middle Ages was basically eating juicy little beef sandwiches, or 'sliders' as I believe café society calls them.

The *pater familias* carving, or the waiter with a napkin over his shoulder, is not the only echo of dining from ages past that lingers. The very names of many of our meats are an echo of the past too. Why is beef a meat that comes from a cow, or pork from a pig, yet chicken is from, well, a chicken?

We can thank our Norman antecedents for that. The meats they ate maintain their old French names, whereas those eaten by the native Saxons have kept their old Saxon names. Thus beef was once *boeuf*, pork – *porc*. Chicken, popular at the Anglo-Saxon court, is plain old chicken, more diverse birds are 'poultry' after the French *poule*, meaning hen. So every time you eat a beef burger, you are actually eating a larger version of something William the Conqueror would recognise.

But long before any kind of eating could take place, much needed to be prepared – and we are not just talking about food. Before modern times, the ownership of 'stuff' meant that you had to maintain that 'stuff' and that could take an

army of servants. Imagine our most simple tasks, like the washing of a tablecloth after a dinner party. We just pop it into the washing machine, add some powder and press a button. A while later it's clean and just needs to be dried in our centrally heated homes and then ironed. I admit that 'just' is doing a bit of lifting there, but imagine what our Middle Ages counterpart – or rather counterparts – would need to do to achieve the same results before the washing machine was invented?

There is a reason that table linen was a status symbol: it took so much effort to maintain. The whiter and more vast your linen collection, the more status you had. To maintain whiteness and remove stains, linens were boiled up in vats with ashes from the fire and urine. After a good 'rinse cycle' – often in free-flowing water – they were stretched out on frames to dry naturally in sunlight on 'bleaching greens' – even then they understood the cleansing power of the sun.

Once washed, stretched and bleached, you had a problem – what do you do with the large, valuable and easily stained cloth? We would iron it, fold it and put it away in a cupboard. Such irons that existed 500 years ago were too hot for precious linens. Our antecedents came up with elaborate ways of folding linens before they were placed into a linen press to squash down before careful storage. This left patterns of 'creasing' on the cloths. The creases were celebrated as another mark of status.

Whilst several women were attending to the linen, other

THE DEVIL'S TOOL

servants would be laying the tables, literally. Without a permanent dining room, a fashion which did not emerge until the eighteenth century, dinners – or rather, 'feasts' – would occur in the 'great hall'. Trestles would be laid out and boards set upon them. Great attention was paid to making sure these were clean so as not to soil the precious coverings. First the top table was set. This was often on a slightly raised dais to emphasise the status of those at the top – the 'high table' at an Oxbridge college is the remnant of this.

Behind this table, a rich silk or velvet 'cloth of honour' would be set on the wall, perhaps centred by a coat of arms or with a canopy. Similarly rich and expensive cloths may grace the top table, and these would always be protected by a linen 'surnap' or over-cloth, because whilst the linen could be boil washed, the silks could not! This linen surnap, which we now call a tablecloth, would likely only cover the top of the table and hang down a little, all the better to make a contrast to show off your expensive silk.

Only now would the table be 'set', as we understand it. Few people would be seated at the high table and for much of history, very little would actually go on it. The king sat in the middle, alongside his heir(s) and perhaps a bishop if it was a saint's day, aka a holy day, or another monarch, though this would be rare. The king would get a chair, then known as a 'back stool', and the rest individual stools. Yes, even what you sat upon was about status, as those on the lower tables sat on benches.

Each top table guest would get a plate of gold or silver – oblong in the early Middle Ages, round later – plus they'd all get a small round loaf. This would be placed directly on the cloth or would be wrapped in a napkin.

There would be no flowers on the table – they came later, much later. Flowers were seen as transient and therefore a reminder of fleeting life and death. The only other item likely to be on the table would be a salt. Because salt was expensive and the best salt was as white as your linen cloth, it needed help to show it off. Thus 'the salt' was born. They began simply as a gold or silver-gilt pedestal, but soon grew into flights of fancy and, yes, showing off. The evolution of the salt began with the 'nef.' The 'nef' was originally a golden ship's hull-shaped dish on a pedestal that would be ceremonially carried into a feast holding the king's personal plates and his salt. It was less about keeping royal plates from poisoners and more about marking out the royal personage as distinct and separate, above others.

Very soon these nefs – after the old French for boat – morphed into less practical but more impressive objects, still called nefs but more about show than salt. They became 'objects of state' that defined and magnified monarchy.

Perhaps this is the moment to explain and classify the 'show off' aspect of life back then. To our sensibilities it seems vulgar, but it was the opposite in their eyes. It was an embodiment of an ancient concept that we've lost: magnificence. The idea of the magnificent man goes back

❦ THE DEVIL'S TOOL ❧

to Plato. Basically, if you were rich, it was your duty to extol the virtue of magnificence. This meant patronising the best artists and goldsmiths. Building the best buildings, often for public use, and educating yourself in the arts and sciences. So having flashy things on your table was, if it was showing off anything, about showing off how cultured or 'magnificent' you were.

It's Christmas Day 1585 and we are in Augsburg, Bavaria. A man is saying goodbye to his family. A carriage is waiting outside his home/workshop. His name is Hans Schlottheim and he's on his way to Dessau, a journey of several days.

He's packed clothes, his tools and a very important item, something Schlottheim is well known for: a clock. He's left plenty of time because he must get to Dessau well before 3 January when his client expected to be not only delighted with his new clock, but surprised too.

Schlottheim's clocks are unlike anyone else's – apart from telling the time, they are musical and they move. Schlotheim has reinvented the nef of old into something quite new: a musical clock galleon, the perfect centrepiece for a royal wedding feast. But will it work? Will it survive the hazardous journey from Augsburg to Dessau? This is the weight playing on Schlottheim's mind as the carriage trundles through the muddy roads of Bavaria.

After days that seemed like weeks, Dessau is in sight, the weather is merciful and he is a few days early. He may even have time to celebrate New Year. Hans Schlottheim has

❦ THE STUFF OF HISTORY ❦

been given a room at the palace – such is the importance of his mission – as he begins to unpack his tools, then the galleon. 'Pray God she is safe,' he mutters to himself as he begins to prise open the wooden crate. As he removes each part of the crate lid, he repeats his prayer – he is a good Protestant.

Finally, the lid is removed. His ship has been carefully wrapped in cloth and then firmly attached to the crate – but has its delicate mechanism survived the journey? There is only one way to see.

Hans Schlottheim takes a key out of his pocket, inserts it into his clock and winds the mechanism. But as soon as he begins to turn, he stops; he realises the table in his room is not nearly big enough, he needs to test the clock on the actual table where his client, Augustus I of Saxony, will be seated. He needs to find the Great Hall.

It should come as no surprise that a well-dressed man carrying a golden ship should attract attention, and by the time he reached the Great Hall, quite a crowd was following him. The hall was already in chaos and the throng that Schlottheim had attracted only made things worse. The people hanging tapestries stopped, as did those weaving garlands of greenery. All eyes were fixed on the clockmaker, each one wondering what this new clock would do.

The table was already set, covered with a floor-length red silk from Venice, but where was the linen cloth that would go over it for the banquet? It was essential that his trial run was taken under the same conditions. Word

THE DEVIL'S TOOL

was sent to the mistress of the royal napery, but word came that the cloth was still not dry as it had been used for Christmas.

Hans Schlottheim was not happy with this. He thought about the problem, arguing with himself in silence. Surely, if it works on a silk cloth, then with the extra traction afforded by the linen, it would work in front of the elector and his new wife? He had to try, despite being terrified.

Hans placed the clock at the end of the table, its prow pointing to the other end. Next Hans stood in front of the table and shuffled back, aligning his rear with the rear of the galleon. He then placed his left foot directly in front of his right, the heel touching the toe. Muttering to himself, he proceeded to walk in this peculiar manner until he was central with the cloth of honour, marking where the throne would be. He was counting feet. The room was silent, a mixture of expectation and bemusement. Surely now, he was ready, they all thought, but the impromptu audience was to be disappointed.

Hans took a small tool out of his pocket and proceeded to open a panel of his galleon. He adjusted what appeared to be a stack of metal disks, each with portions cut out of them. He closed the panel and then dripped some kind of liquid into the tiny cannons along each side of the golden galleon. With a few turns of the key, he flicked a switch on the back and the galleon began to move. There were gasps in the silenced room but there was more to come. The assembled crowd could hear a pipe organ

and drums. The tiny men in the crow's nest revolved, a trumpet at their lips. Schlottheim just stood and smiled; he knew what was still to come.

The ship stopped – there was another gasp and a few mutterings of failure. But wait, this wasn't a stop, it was a pause. Suddenly, tiny men began to move on deck; it was the seven electors paying homage to a Roman emperor. Just when you thought nothing more was possible, the tiny cannons fired, which set off a fuse. The ship began to once more trundle along the table, the fuse still burning. The organ music now drowned out by the crackling of the fuse.

Schlottheim had one final trick up his sleeve. Just as his ship came to the centre of the table; the 'place d'honor' where the elector would be sat, the ship stopped.

Drums sounded once more and the dragon-mouthed cannon on the prow fired! The gasps in the room were drowned out by rapturous applause. Everyone in the Great Hall knew that Elector Augustus would be delighted with his new 'clock' – his magnificent clock which survives to this day in the British Museum, although it has not been near a well-napped table for some time.

Despite the glitter and the gold, one thing that would not be on the table when it was finally set for the wedding breakfast would be a fork. Despite being known in Europe for over 500 years, forks were still treated with suspicion or, worse, seen as effeminate.

Many histories credit Catherine de Medici with introducing the fork to France from Italy in 1533, but the fork

❧ THE DEVIL'S TOOL ☙

she likely took with her would not have been a normal fork; it would have been what antiquarians call a 'sucket fork'. This was very much the 'gateway' fork and one was even found in the possession of Edward I as early as 1300: *'unum par cultellorum cum manicis argenti aymellat cum uno furchetto de Cristallo'* (one pair of knives with silver handles and one fork made of crystal).

Clearly a rock crystal fork would be of little use for even the moistest morsel of peacock, so what was this early fork for?

'Suckets' originally described citrus fruits preserved in syrup, but went on to describe all fruits in syrup and eventually fruit of any kind, especially soft and squishy ones. Even the most accomplished of eaters would find sticky fruits in syrup a challenge, so slowly, bit by bit, the sucket fork got people used to the rather vulgar concept of stabbing your food and popping it into your mouth.

Interestingly, by 1304, the 'wardrobe list' of King Edward I listed: 'two forks silver and two handles of crystal'. Slowly but surely, the fork was making its mark. It was beginning to come out of the closet, but it was slow to go mainstream. *The Boke of Kervyng*, an early guide to manners, published in 1577, does not mention them when advising how to set a table: 'Laye the knyves and set the brede one lofe by the other the spones and napkyns fayre folden besyde the brede.'

Even Elizabeth I, who delighted in novelty, disliked forks; she found the stabbing action rather uncouth and

❧ THE STUFF OF HISTORY ☙

it would take until the end of the seventeenth century for them to become almost acceptable.

These early forks still had two prongs (like the earlier sucket forks), which are properly called 'tines', but they still weren't abundant. Unless you were a guest at the top table, you'd probably be expected to bring your own cutlery. With such a multitude of forks, you could easily be exposed as being old fashioned. In fact, there was a marked distinction between the people at the top table and those on the lower ones.

Not only were you 'below the salt' but treated quite differently. As well as your own cutlery, you'd be expected to bring your own napkin too. Here was your opportunity to display your magnificence. Yes, you'd be judged on how white your napkin was and how fashionable (or not) your cutlery was.

A fork was a fashion risk.

Even as late as 1663, Samuel Pepys complained in his diary how he had attended a dinner at London's Guildhall where only the Lord Mayor and privy councillors got a napkin. His table had none, nor a change of trencher. There were at least '10 good dishes to a messe' and plenty of wine, but drunk from 'earthen pitchers'.

A messe?

Trenchers?

Allow me to explain. A 'messe' or 'mess' was a portion of food that would be set between two-to-four diners at a table. These were communal plates of portioned food that

were shared and likely to be less rare fare. Less peacock, more old cockerel.

A 'trencher' was a proto plate, which by Pepys's time was likely to be turned wood, but originally a trencher was made from bread, special trencher bread. This was solid and it needed to be. A trencher loaf would be sliced horizontally into inch-thick slabs and these would be used as plates. Smaller loaves would be made and similarly sliced to make a small 'plate' for your salt. This is why an open salt is still known as a 'trencher' salt. The solid bread would hopefully hold the juices – at this time, there was no gravy.

Until the invention of the cast iron range oven in the late eighteenth century, meat was spit-roasted. Rotating the meat meant that the juices – the basis of gravy – remained in the joint; all that came out was the fat, which is why we call that 'dripping', as the fat dripped out of the meat. In fact, smaller roasts like birds were often 'larded' with pieces of animal fat to keep the meat moist.

Despite the lack of gravy, the bread trencher would get a bit soggy, so one can sympathise with Mr Pepys. Soggy or not, the trencher was never eaten by the guests – they were given to the 'poor' after a dinner. Gradually, the bread trencher became a more practical wooden trencher and finally a ceramic plate, whose round shape you have to thank a loaf of bread for.

A third tine on a fork became the norm around 1700 and the fourth later. The fourth tine came – appropriately for a

THE STUFF OF HISTORY

fork – from Italy, or rather Naples. During the later part of the eighteenth century, pasta, having hitherto always been considered a peasant dish, became fashionable at court. Slippy spaghetti, which was then known as 'maccheroni di Napoli', proved something of a challenge for the fork with three long rounded tines. A clever courtier came up with the idea of a fourth tine and a more stubby and flat profile in order to spear and wrap the maccheroni into an edible portion. If you are wondering how the peasants managed to eat their maccheroni without the help of a silver fork, well, they used their hands – how very mediaeval!

As the fork became more and more something to eat with, rather than merely hold food in place, the fourth tine became customary. Towards the end of the eighteenth century, a fork that we might even recognise had become the norm.

It's 6 October 1760 and we are at Hofburg Palace's Redoutensaal, the great hall, in the heart of Vienna. The vast hall has taken months to decorate and no expense has been spared. Despite a reputation for overspending, decorator Giovanni Niccolò Servandoni has travelled from Brussels to create a spectacle worthy of the upcoming marriage of Archduke Joseph to Isabella of Parma.

Any royal marriage at this time was dynastic, but this particular coupling was the result of years of machinations by Joseph's mother, Empress Maria Theresa, that culminated in a peace treaty between old enemies France

❧ THE DEVIL'S TOOL ☙

and Austria, sealed by the marriage of her son and heir to Louis XV's favourite granddaughter. Nothing was to be left to chance; even the china had a part to play.

The Redoutensaal was vast. Remodelled between 1744 and 1748, it was inaugurated with a ball in 1748 and renamed 'Redoutensaal' after these 'Redoutes', or masked balls, for which it became famous. Despite the opulence of the hall, which could accommodate 3,000, for this important wedding, it was given a glow-up of Kardashian proportions.

Chevalier Servandoni was ambitious in his creativity, especially when money was no object. He had designed a vast carved and gilded baldacchino, or canopy, surmounted by the eagle of Austria, its head proud and wings outstretched, its feet holding a laurel wreath. Beneath its rococo frame, a huge pelmet hung, 'galooned' in gold-work tassels. All of this framed a vast gold cloth of honour, which stretched down from almost the ceiling, stopping at the floor.

Dozens of crystal chandeliers hung from silken ropes decorated with hand-painted paper, with silk flowers and leaves. Between each rope was a similar garland. The already magnificent architecture was further accented with more garlands; a dias was raised and dressed in a fine carpet. On it, a U-shaped table was set for just fourteen diners.

With all those candles, the heat must have been unbearable.

A linen cloth was laid, still stiff with starch and showing

off its square folds from the linen press. Imagine, all this majesty even before we get to what's on the table, let alone the food. There will be two savoury courses, followed by dessert, but there were to be no 'messes' here. The old style of communal platters had evolved and the lucky fourteen diners would be sitting down to what we would call a buffet.

During the seventeenth century, the style of dining began to morph into what we now call *'service à la Francaise'*. In this French style, the food was laid on the table just before diners arrived and was set out in elaborate, symmetrical patterns. Guests helped themselves, but only to the food nearest to them. The establishment of various porcelain manufacturers across Europe at this time aided and abetted this fashionable style of dining.

There was more than one course to this buffet, however. Each course was known as a 'remove' and there were generally four or five removes for a dinner, two for a supper. There was no distinction between sweet and savoury, and they could often be found as part of the same remove.

It is the dessert course that returns us to the Redoutensaal because, remarkably, we have a highly detailed painting of it – you can see it online. To commemorate the marriage, court painter Martin van Meytens created a series of works including his 'Wedding Supper'. Often criticised for his obsession with detail, van Meytens allows us to gaze back to that October evening as though we were there.

By contrast, the local paper was somewhat scant in

❧ THE DEVIL'S TOOL ❦

details of the setting. *Wienerisches Diarium* reported on 11 October: '[The] excellently decorated and most magnificently lit Redoute Hall . . . and the table was set for the first time with the newly made, precious and artfully crafted gold service.' Yet Mytens' keen eye and faithful rendition allows us to even identify the china. It's the Sevres 'Green Ribbon service', a gift from King Louis XV to Empress Maria-Theresa which was delivered the previous May. The two entwined ribbons are said to represent France and Austria. It was the King's most expensive diplomatic gift of the century, at least in porcelain.

What is perhaps more fascinating is that the painting also shows the placement of cutlery on a table of this time. It's not how you'd imagine. A spoon, a knife and a (two-pronged) fork are set in that order to the right of the plate. Not either side as we'd expect.

When faced with a multitude of foods, you simply helped yourself to what was nearby and used whatever cutlery you needed in whatever hand suited you. This is why in America it's seen as fine to swap the fork from left hand to right. It is exactly what the first immigrants from Europe did when they arrived stateside because they took the old style with them.

Whilst France may have been the losing side in many eighteenth-century battles, it won, hands down, the battle of table manners and dictated how we ate well into the late nineteenth century.

ACKNOWLEDGEMENTS

If you are reading this then I thank you for not only buying my book, but for being curious and not missing a thing – just like me.

Those who deserve particular thanks, have already received that in person from me and I hope it will not offend anyone else by not making a list here. Truth is, so many have helped me along the way that they are too numerous to list, but they know who they are and I am eternally thankful for them. I must, however, thank Ben Dunn, my literary agent who made this happen. Thank you to my publisher Matthew Phillips, assistant editor Lucy Tirahan, Eleanor Stammeijer and Tamara Douthwaite in PR and Marketing, and Charlotte Brown in Audio at Bonnier who have worked tirelessly to bring my vision to the page.

I also must thank my Instagram family for joining me on this journey which is only just beginning. Hold on tight!